# Canon® EOS 7D

## FOR

# DUMMIES®

# Canon® EOS 7D

## FOR

## DUMMIES®

## by Doug Sahlin

WILEY

Wiley Publishing, Inc.

**Canon® EOS 7D For Dummies®**

Published by
**Wiley Publishing, Inc.**
111 River Street
Hoboken, NJ 07030-5774
www.wiley.com

Copyright © 2010 by Wiley Publishing, Inc., Indianapolis, Indiana

Published by Wiley Publishing, Inc., Indianapolis, Indiana

Published simultaneously in Canada

WILEY

# About the Author

**Doug Sahlin** is an author and photographer living in Venice, Florida. He's written 21 books on computer applications, such as Adobe Flash and Adobe Acrobat. He's also written books on digital photography and coauthored 13 books on various applications, such as Adobe Photoshop and Photoshop Elements. Recent titles include: *Building Flash Web Sites For Dummies, Digital Photography Workbook For Dummies,* and *Digital Portrait Photography For Dummies.* Many of his books have been bestsellers on Amazon.

Doug is president of Superb Images, Inc., a wedding and event photography company. Doug teaches Adobe Acrobat to local businesses and government institutions. He uses Flash and Acrobat to create Web content and multimedia presentations for his clients. He also hosts *Pixelicious* (www.pixelicious.info), a weekly podcast on digital photography, Photoshop, and Lightroom.

# Dedication

This book is dedicated to my soulmate Roxanne.

# Author's Acknowledgments

Thanks to all the talented people at Wiley for putting this book together. Special thanks to Steve Hayes for making this project possible. Kudos to Nicole Sholly for overseeing this project and lending a helping hand when needed. Many thanks to Dave Hall for an awesome job reviewing the technical stuff in the book. I am grateful to agent extraordinaire Margot Hutchison for ironing out the fine details between me and the publisher.

As always special thanks to my friends, family, and mentors. Extra special thanks are reserved for Karen, Ted, and Roxanne. And I would be remiss if I didn't recognize my social secretary, Niki the Cat and her new buddy, Micah the Madman.

## Publisher's Acknowledgments

We're proud of this book; please send us your comments through our online registration form located at `http://dummies.custhelp.com`. For other comments, please contact our Customer Care Department within the U.S. at 877-762-2974, outside the U.S. at 317-572-3993, or fax 317-572-4002.

Some of the people who helped bring this book to market include the following:

### Acquisitions and Editorial

**Project Editor:** Nicole Sholly

**Executive Editor:** Steven Hayes

**Copy Editor:** Jennifer Riggs

**Technical Editor:** David Hall

**Editorial Manager:** Kevin Kirschner

**Editorial Assistant:** Amanda Graham

**Sr. Editorial Assistant:** Cherie Case

**Cartoons:** Rich Tennant
(`www.the5thwave.com`)

### Composition Services

**Senior Project Coordinator:** Lynsey Stanford

**Layout and Graphics:** Claudia Bell, Samantha K. Cherolis, Christine Williams

**Proofreaders:** Laura Albert, Melissa D. Buddendeck

**Indexer:** Christine Karpeles

### Publishing and Editorial for Technology Dummies

**Richard Swadley,** Vice President and Executive Group Publisher

**Andy Cummings,** Vice President and Publisher

**Mary Bednarek,** Executive Acquisitions Director

**Mary C. Corder,** Editorial Director

### Publishing for Consumer Dummies

**Diane Graves Steele,** Vice President and Publisher

### Composition Services

**Gerry Fahey,** Vice President of Production Services

**Debbie Stailey,** Director of Composition Services

# Contents at a Glance

# Table of Contents

# Introduction

*Y*our Canon EOS 7D is the latest and greatest digital camera on the market with a stunning 18-megapixel capture, Live View, high-definition video, and much more. But all this technology can be a bit daunting, especially if this is your first real digital SLR (single-lens reflex). You no longer have modes like Portrait, Sport, Landscape, and so on. You've graduated to the big leagues. All you have to do is master the power you hold in your hands.

I've been using Canon digital SLRs since the EOS 10D, and I've learned a lot about the cameras since then. I also own an EOS 5D MKII, which has a lot of the features found on your EOS 7D. My goal is to show you how to become one with your camera. I don't get overly technical in this book even though your camera is very technical. I also do my best to keep it lively. So if you want to master your EOS 7D, you have the right book in your hands.

## About This Book

If you find the buttons and menus on your shiny new EOS 7D a tad intimidating, this book is for you. In the chapters of this book, I take you from novice point-and-shoot photographer to one who can utilize all the bells and whistles your camera offers. You'll find information about every menu and button on your camera as well as when to use them. I also cover what settings to use for specific picture-taking situations. I also show you how to use the software that ships with your camera.

## Foolish Assumptions

Ah yes. Assume. When broken down to its lowest common denominator . . . Okay, I won't go there. But as an author, I have to make some assumptions. First and foremost, you should now own, or have on order, a Canon EOS 7D. If you own one of those cute little point-and-shoot Canon cameras, good for you, but this book won't help you with that camera. You should also have a computer to download your images to. A basic knowledge of photography is also helpful. I know, you probably meet all assumptions. But my editor assumes I'll put this section in this part of the book.

## Conventions Used in This Book

To make life easier, this book has several conventions that are used to identify pertinent information — stuff you should know. So to help you navigate this book easily, I use a few style conventions:

- ✓ Terms or words that you might be unfamiliar with in the context of photography, I have *italicized* — and I also define these.

- ✓ Web site addresses, or URLs, are shown in a special monofont typeface, `like this.`

- ✓ Numbered steps that you need to follow and characters you need to type are set in **bold.**

- ✓ Margin art is used to identify camera menu icons and camera buttons. When you see one of these icons, it shows you what button to push, or what menu tab to navigate to.

- ✓ The Canon EOS 7D menu has pretty little icons for each tab, but no text to describe what each tab does. I name the tabs to make things easier for you, dear reader, and for me and my editor. You'll find a table with tab names in Chapter 2.

## The Long and Winding Road Ahead

I divide this book into four parts with each devoted to a specific aspect of your camera. The chapters flow logically from one subject to the next to take you from shooting in Full Auto mode to becoming a seasoned photographer who knows what mode to choose and what settings to use for taking pictures of specific subjects. You can read the book from cover to cover or if you need quick information about a specific topic, peruse the Table of Contents or Index until you find the desired topic. Most of the sections in this book don't require reading additional material.

The following sections offer a brief overview of each part of the book.

### Part 1: Getting to Know Your Canon EOS 7D

Part I contains four chapters that help you get up and running with your EOS 7D:

- ✓ Chapter 1 introduces you to the camera and shows you how to do some basic tasks.

- ✓ Chapter 2 shows you how to take pictures using the two Automatic modes. I show you how to go fully automatic and how to use the Creative Auto mode.

✔ Chapter 3 shows you how to specify the image format. I show you how to choose JPEG and RAW format, discuss different sizes, and offer my recommendation for the ideal format.

✔ Chapter 4 shows you how to use the LCD monitor for a myriad of purposes. I show you how to review your images, use the histogram, and more.

## Part II: Beyond Point-and-Shoot Photography

In this part of the book, I cut to the chase and show you how to master the advanced features of your camera.

✔ Chapter 5 shows you how to use Live View mode. I show you how to take pictures with Live View, change autofocus modes, and more. I also show you how to capture movies with Live View. So you're live in Chapter 5.

✔ Chapter 6 shows you how to use the creative shooting modes. In this chapter, I also show you how to modify camera exposure, bracket exposure, and more.

✔ Chapter 7 shows you how to use the advanced features of your camera. I show you how to set ISO, set white balance, and much more. I also show you how to use your EOS 7D flash unit wirelessly to trigger off-camera Canon Speedlites.

✔ Chapter 8 shows you how to use your EOS 7D in specific shooting situations. I discuss sport photography, wildlife photography, landscape photography, and more.

## Part III: Editing and Sharing Your Images

This part of the book shows you how to organize and edit your images with Canon's ZoomBrowser EX and Digital Photo Professional.

✔ Chapter 9 introduces you to Canon's ZoomBrowser EX and Digital Photo Professional. I show you how to download and organize your work, plus show you how to do some basic editing tasks.

✔ Chapter 10 shows you how to print your images from ZoomBrowser EX and Canon Digital Photo Professional. I also show you how to make contact sheets in both applications.

## Part IV: The Part of Tens

The book concludes with two top ten lists, written by yours truly, who happens to have a gap between his teeth like David Letterman, who happens to

be famous for his top ten lists. The lists are grouped according to subject matter, and a splendid time is guaranteed for all. And tonight Mr. Kite is topping the bill.

- Chapter 11 shows you how to create a custom menu and register your favorite settings. I also show you how to add copyright information to the camera and much more.

- Chapter 12 shows you how to create wallpaper from your images, create a screensaver, attach images to e-mail, create a makeshift tripod, and more.

## Icons and Other Delights

*For Dummies* books have icons that contain important bits of information. You can hopscotch from icon to icon and discover a lot. But when in doubt, read the text associated with the icon. In this book, you find the following icons:

- A Tip icon contains information designed to save you time and in some instances, your very sanity.

- This icon warns you about something you should not do; something your fearless author has already done and decided it's not a good thing to do again.

- When you see this icon, it's the equivalent of a virtual piece of string tied around your finger. This is information you want to commit to memory.

- When you see this icon, it's for the geeks in the group who like to know all manner of technical stuff.

You'll also find icons in the margin that show you controls on your camera, and menu tabs.

## *Shoot Lots of Pictures and Enjoy!*

Your EOS 7D is a digital photography powerhouse; use it and use it often. The old adage of "practice makes perfect" does apply though. The only way to become a better photographer and master your equipment is to apply what you know and shoot as many pictures as you can. While you're working your way through this book, keep your camera close at hand. When your significant other pokes his or her head into the room, grab your camera and start practicing your craft. Take one picture, then another, and another, and so on. With practice, you'll know your camera like the back of your hand. You'll also know which rules of photography and composition work for you and you'll start to develop your own style. For that matter, you'll probably amaze yourself, too.

# Part I
# Getting to Know Your Canon EOS 7D

The 5th Wave          By Rich Tennant

CAMERAS

ikon 60          Canon EOS Digital Camera

"The 'EOS' stands for Electro Optical System, or Eos, the Titan goddess of dawn. Depends on who you talk to."

*I*n this part, I show you the lay of the land and familiarize you with the controls of your EOS 7D. I also show you how to take great pictures automatically and show you how to specify image size and format. If you're curious about how to get around in the menu, I show you that as well. I also show you how to master your LCD monitor. In short, this part shows you everything you need to do to get up to speed with your new toy.

# Exploring the Canon EOS 7D

*T*he Canon EOS 7D has all the latest bells and whistles Canon has to offer. It's a technological marvel that enables you to take great pictures and capture high-definition (HD) video. The camera has a new processor that gives you the ability to capture great images in low light and at a blindingly fast speed of up to 8 images per second, which is ideal for action photography. The camera has an improved, highly customizable autofocus system that gives you more control over autofocus than in the past. And Canon finally offers a camera with a viewfinder that shows you 100 percent of what the lens captures: What you see is what you get. A *dual-axis level* (the equivalent of a spirit level in a tripod) you can display in the viewfinder lets you capture pictures with horizon lines that are level. The camera also has a built-in flash system that can be used to control external Canon Speedlites. Woohoo!!! Smart flash technology.

Getting familiar with all this new technology can seem daunting even to a seasoned photographer. I was impressed, albeit a tad flummoxed, when I saw the first reviews. Even though I'm a seasoned Canon digital single-lens reflex (SLR) user — my first digital SLR was the EOS 10D — I still had a bit of a learning curve when I first had the camera in hand, chomping at the bit

to take some pictures. But it's my job to get down to brass tacks with new technology and show you how to master it. The fact that you're reading this probably means that you want to know how to use all the bells and whistles Canon has built into the camera. In this chapter, I familiarize you with the controls, the camera lens, the battery, and the memory cards you use to capture images with the camera.

# Getting to Know the Controls

If you're a longtime Canon user, you know that you can do an awful lot with the camera by using external controls, which saves you from poking around inside pesky menus. The camera controls are easy to reach and give you access to many powerful features. Although you may think it seems like a daunting task to know which button does what, after you use the camera for a while, you'll automatically know which control gives you your desired result and then reach for it instinctively, without taking your eye from the viewfinder. But first, you need to know what each control does. I explain the controls you find on the outside of the camera in the upcoming sections.

## Exploring the top of your camera

The top of the camera (as shown in Figure 1-1) is where you find the controls you use most when taking pictures. The top of the camera is where you change settings like ISO (International Organization for Standards) and shutter speed, choose a shooting mode, and press the shutter button to take a picture. You can do lots of other things from the top of the camera, which in my humble opinion, is the most important real estate on it, with the possible exception of the lens. I suggest you get to know the controls on the top of your camera intimately, like the back of your hand. Many photographers, including me, make it a point to memorize where the controls are and access them without taking an eye off the viewfinder. Here's what you find on the top of the camera:

- ✔ **Shutter button:** This button prefocuses the camera and takes a picture. I discuss this button in greater detail in Chapter 2.

- ✔ **Multi-function button:** This button changes the function of a multi-purpose button, and is used extensively when specifying which autofocus point or zone is used to achieve focus. I show you how and when to use this button when related to a specific task.

- ✔ **Main dial:** This dial changes a setting after you press a button. For example, after you press the ISO speed button, you move this dial to change the ISO speed setting. I show you how to use this button as it relates to a specific task.

- ✔ **LCD Panel Illumination button:** Press this button when you're in dim or dark conditions and you need to shed a little light on the LCD panel.

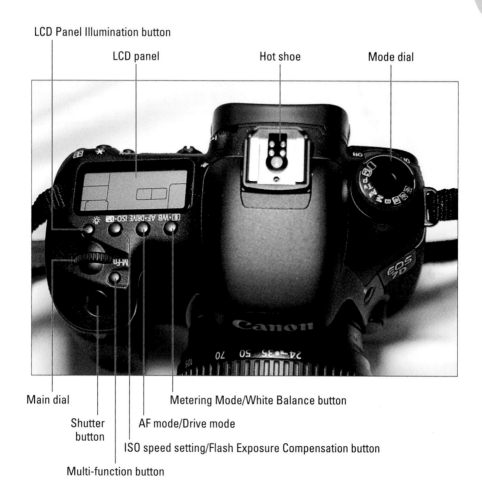

LCD Panel Illumination button

LCD panel

Hot shoe

Mode dial

Main dial

Shutter button

AF mode/Drive mode

Metering Mode/White Balance button

ISO speed setting/Flash Exposure Compensation button

Multi-function button

Figure 1-1: Get to know these controls like the back of your hand.

✐ **ISO speed setting/Flash Exposure Compensation:** This button sets the ISO speed setting or the flash exposure compensation (see Chapter 7 for more on the ISO speed setting and flash exposure compensation).

✐ **AF mode/Drive mode button:** This button sets the autofocus mode. You can choose from three autofocus modes. (I give you the skinny on auto-focus modes in Chapter 7.)

✐ **Metering Mode/White Balance button:** This button changes the meter-ing mode or the white balance (see Chapter 7 for more on the metering mode and white balance).

✐ **LCD panel:** This panel shows you all the current settings. I show you how to read the information in this panel in the section, "Deciphering the LCD Panel," later in this chapter.

> ✔ **Hot shoe:** Slide a compatible flash unit (a Canon flash unit is dubbed a *Speedlite*) that's compatible with this camera into this slot. The contacts in the hot shoe communicate between the camera and the flash unit. (I discuss flash photography in Chapter 7.)

> ✔ **Mode dial:** This button determines which shooting mode the camera uses to take the picture. (I show you how to use this dial to choose specific shooting modes in Chapter 6, and in Chapter 8, I show you how to choose optimal settings for specific picture-taking situations.)

## Exploring the back of the camera

The back of the camera is also an important place. Here you find controls to power up your camera, access the camera menu, and much more. The following is what you find on the back of your EOS 7D (see Figure 1-2):

> ✔ **AF Point Selection/Magnify button:** This button changes from multiple autofocus points to a single autofocus point (see Chapter 7). You also use this button to zoom in on images when reviewing them (see Chapter 4).

> ✔ **AE Lock/Index/Reduce button:** This button locks exposure to a specific part of the frame (see Chapter 6). When reviewing images, use this button to view multiple thumbnails or to zoom out when viewing a single image (see Chapter 4).

> ✔ **AF-On button:** This button, in certain shooting modes, establishes focus (see Chapter 6).

> ✔ **Live View/Movie Shooting switch:** This switch shoots in Live View mode or shoots movies, which I explain in detail in Chapter 5.

> ✔ **Start/Stop button:** When you switch to movie shooting mode, this button starts and stops recording (see Chapter 5).

> ✔ **Multi-controller button:** Use this button for a myriad of tasks, such as changing the autofocus point, selecting an option when using the Quick Control menu instead of the camera menu, or switching from one camera menu to the next. (I explain this button in detail when it's associated with a specific task throughout this book.)

> ✔ **Light sensor:** Used when shooting in Auto mode to determine metering. Be careful not to block this sensor when shooting in Auto mode.

> ✔ **Quick Control dial:** This button selects a setting or highlights a menu item. This dial is used when performing various tasks, and I discuss it throughout this book as needed.

> ✔ **Set:** Press this button to confirm a task, such as erasing an image from your card or setting a menu option. I show you how to use this button to perform a specific task throughout this book.

> ✔ **Access lamp:** Flashes when the camera writes data to the inserted memory card.

Picture Style Selection     Live View/Movie Shooting switch

RAW+JPEG     Start/Stop button

Dioptric adjustment knob     AF-On button

Power switch     Eyepiece cup     AE Lock/Index/Reduce button

Quick Control     Viewfinder     AF Point Selection/ Magnify button

Menu     Hot shoe

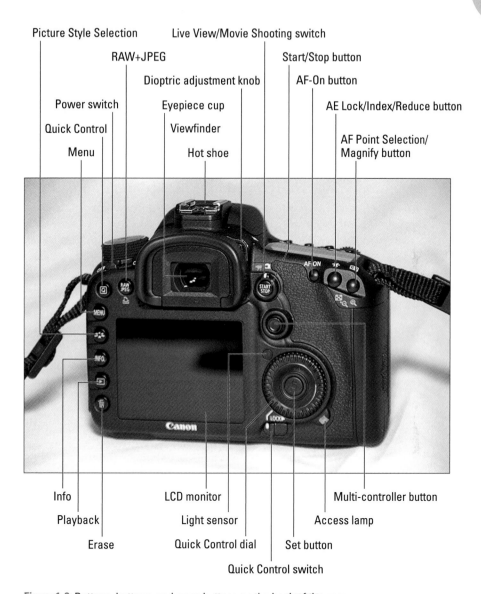

Info     LCD monitor     Multi-controller button

Playback     Light sensor     Access lamp

Erase     Quick Control dial     Set button

Quick Control switch

**Figure 1-2:** Buttons, buttons, and more buttons on the back of the camera.

✔ **Power switch:** Okay, so this is a no-brainer. This switch powers the camera on and off.

✔ **Quick Control switch:** This switch enables the Quick Control dial. Move the switch left to enable the Quick Control dial, right to lock the dial. Locking the Quick Control dial prevents you from accidentally changing a setting.

✓ **Dioptric adjustment knob:** This control fine-tunes the viewfinder to your eyesight.

✓ **Viewfinder/eyepiece:** Use the viewfinder to compose your pictures. Shooting information, battery status, and the amount of shots that can be stored on the memory card is displayed in the viewfinder. The eyepiece cushions your eye when you press it against the viewfinder and creates a seal that prevents ambient light from having an adverse effect on the exposure.

✓ **LCD monitor:** Used to display images, movies, camera menus, and the Quick Control menu. (I tell you everything you ever wanted to know about the monitor in Chapter 4, and in Chapter 5, I show you how to use the monitor to compose pictures and movies while shooting in Live View mode.)

✓ **Speaker:** Plays audio when you play back movies.

✓ **Quick Control button:** Press this button to display the Quick Control menu on the LCD monitor. (I show you how to use the Quick Control menu in Chapter 4.)

✓ **Menu button:** Press this button to display the last used camera menu on the LCD monitor. (I introduce you to the camera menu in Chapter 2 and refer to the menu throughout this book.)

✓ **Picture Style Selection button:** This button selects a picture style. (I show you how to select a picture style in Chapter 2.)

✓ **Info button:** Press this button to display shooting information on the LCD monitor. You can choose from many different information screens. (I inform you about the different screens in Chapter 4.)

✓ **Erase button:** This button deletes an image. (I show you how to delete images in Chapter 4.)

## Exploring the front of the camera

The front of your camera (see Figure 1-3) has a couple controls you can use and other gizmos that the camera uses. Here you'll find a couple buttons that you use every day and some features you rarely use. The following is on the front of your camera:

✓ **Remote control sensor:** Senses the light from an RC-1 or RC-5 remote (sold separately) to actuate the shutter.

✓ **DC coupler cord hole:** Plug the cord from the ACK-E6 power adapter (sold separately) into this hole to use the camera without a battery.

✓ **Body cap:** Use the body cap to protect the interior of the camera when the lens isn't attached.

✓ **EF index mount:** Align an EF lens with this mark when attaching it to the camera (see the section, "Attaching a Lens," later in this chapter).

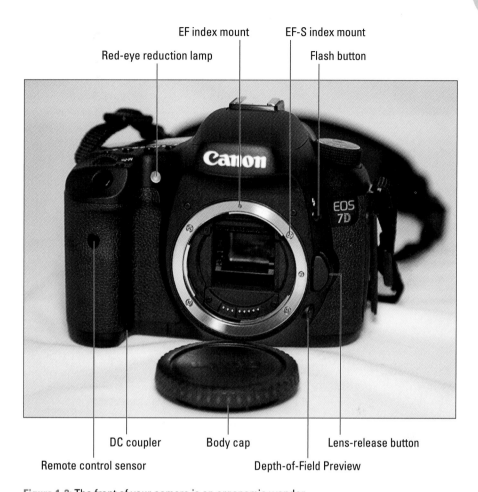

EF index mount    EF-S index mount

Red-eye reduction lamp    Flash button

DC coupler    Body cap    Lens-release button

Remote control sensor    Depth-of-Field Preview

Figure 1-3: The front of your camera is an ergonomic wonder.

✔ **EF-S index mount:** Align an EF-S lens with this mark when attaching it to the camera (see the section, "Attaching a Lens," later in this chapter). EF-S lenses can be used only by a camera with an APS-C (Advanced Photo System Type-C) sensor like the one on your EOS 7D.

✔ **Flash button:** Press this button to pop up the camera flash unit. (I show you how to use flash on your subjects in Chapter 7.)

✔ **Lens-release button:** Press this button when releasing a lens from the camera. I show you how to attach and remove lenses in the sections "Attaching a Lens" and "Removing a Lens," later in this chapter.

✔ **Depth-of-Field Preview button:** Press this button to preview the *depth of field* (the amount of the image in front of and behind your subject that's in apparent focus) at the current f-stop.

## Finding the perfect camera bag

Your EOS 7D is a marvelous camera. Canon has more lenses than the law allows, and then there are other options such as Speedlites, the stuff you use to clean your camera, camera bags, and so on. Speaking of camera bags, here are some tips for finding the perfect one:

- Get a bag that's big enough for the gear you now own and any additional equipment you anticipate buying in the near future.

- Purchase a bag that's comfortable. Make sure you try the bag on for size in the camera store. Place your camera in the bag and put it over your shoulder. If the bag isn't comfortable, ask the salesperson to show you a different bag. Nothing is worse than a chafed neck after a daylong photography adventure.

- Make sure the bag has enough pockets for your stuff. The bag should have a place where you can pack extra memory cards, spare batteries, and other accessories.

- Make sure the bag is sturdy enough to protect your gear.

- Make sure the bag is made so that you can get to your gear quickly. Nothing is worse than fumbling for a piece of equipment when your digital Kodak moment disappears.

- If you have a lot of gear, consider purchasing a hard-shell case that's big enough for all your equipment and a soft bag for day trips.

- Consider purchasing a customizable camera bag. These bags come with removable partitions that are held in place with Velcro.

- If it rains a lot where you live, purchase a water-resistant camera bag or one with built-in rain cover.

- Consider purchasing more than one bag. I have one bag that has gobs of space for when I go on a hike in search of wildlife to photograph. The bag has outside pockets for water bottles. I also have a bag that's big enough for two small lenses. I use this bag when I go on a photo walkabout in search of interesting things to photograph.

## Deciphering the LCD Panel

The LCD panel on the top of the camera displays a lot of information, such as the shutter speed, aperture, ISO speed setting, and more. Figure 1-4 shows all the possible options that can appear on the LCD panel. However, you'll never see this much information when you photograph a picture. I show you the type of information you can expect to see on the LCD panel during specific picture-taking scenarios I discuss throughout this book. With the LCD panel, you can see the current settings for white balance, ISO, metering mode, and much more. Here's a road map for the information you'll find on the LCD panel:

- **White balance setting:** Displays the current white balance setting. You view the panel when choosing a white balance option. The icon for auto white balance is shown in Figure 1-4. (I discuss how to set white balance in Chapter 7.)

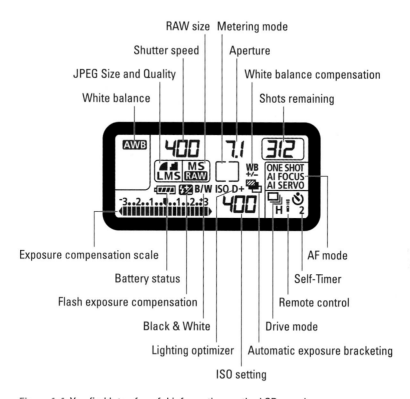

**Figure 1-4:** You find lots of useful information on the LCD panel.

✔ **JPEG image size and quality:** If you choose the JPEG image format from the camera menu, the size and quality display here. (I show you how to choose image format, size, and quality in Chapter 3.)

✔ **Shutter speed:** Displays the shutter speed, as metered by the camera or set by you, that will be used to shoot the next picture. If you're taking pictures with Shutter Priority mode or Manual mode (see Chapter 6), you can use the LCD panel to set the shutter speed.

✔ **RAW format:** If you choose the RAW image format, the icon indicates whether the image is full-resolution RAW, Medium RAW (MRAW), or Small RAW (SRAW). (For more information on the RAW image options, see Chapter 3.)

✔ **Aperture:** Displays the f-stop that will be used to take the next picture. You can use this information to change the aperture when shooting in Manual mode or Aperture Priority mode (see Chapter 6).

✔ **White balance adjustment:** This icon is displayed when you're fine-tuning the white balance (see Chapter 6).

- **Shots remaining/Self-Timer countdown:** This spot on the panel does double duty. When you're using the Self-Timer, the time remaining until the picture is taken displays here. Otherwise, the display shows the number of shots remaining that you can fit on the CF (CompactFlash) card you insert in the camera to capture your images. (A *CF card* is the digital equivalent of reusable film. But you probably already know that, don't you?)

- **Autofocus mode:** Displays the currently selected autofocus mode (see Chapter 7).

- **Drive mode:** Displays the icon for the currently selected Drive mode (see Chapter 6).

- **Automatic exposure bracketing:** This icon displays when you enable automatic exposure bracketing (see Chapter 6).

- **Highlight tone priority:** This icon displays when you enable the Highlight Tone Priority custom function setting (see Chapter 6).

- **ISO speed setting:** The currently selected ISO speed setting displays here. You can also use this information when setting the ISO speed (see Chapter 7).

- **Black & White:** The B/W icon displays when you choose the Black and White picture style.

- **Flash exposure compensation:** This icon signifies that you've enabled flash exposure compensation (see Chapter 7).

- **Battery status:** This icon displays the amount of charge remaining in the battery.

- **Exposure compensation:** This icon indicates whether exposure compensation or autoexposure bracketing has been enabled; it's also used to set flash compensation. (See Chapter 6 for more on autoexposure bracketing and see Chapter 7 for flash compensation.)

You see examples of different scenarios on the LCD panel throughout this book as I discuss various picture-taking situations.

## Decoding Viewfinder Information

The viewfinder, or *information central* as I like to call it, is another place you find a plethora of information. In the viewfinder, you see the image as it will be captured by your camera (see Figure 1-5). Your EOS 7D has a very smart viewfinder that enables you to see 100 percent of what you'll capture — a first for Canon digital SLRs. Use the viewfinder to compose your picture and view camera settings while you change them. Figure 1-5 shows all the possible icons that can be displayed while taking a picture and displays all the autofocus points. You never see this much information displayed while taking a picture. (I show you different viewfinder scenarios when I discuss different picture-taking

scenarios throughout the book.) When you peer into the viewfinder, you find the current shooting settings, icons for battery status, shots remaining, and much more. Here's the info displayed in your viewfinder:

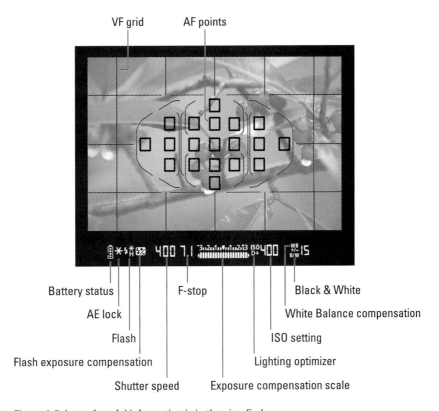

Figure 1-5: Lots of useful information is in the viewfinder.

- ✔ **Battery status:** This icon shows you the amount of charge left in your battery.
- ✔ **AE lock/AEB in progress:** This icon indicates that you've locked the autoexposure to a specific point in the frame or that autoexposure bracketing is being performed (see Chapter 6).
- ✔ **Flash ready:** This icon indicates that the flash has recycled to full power and is ready for use (see Chapter 7).
- ✔ **Flash exposure lock/FEB in progress:** This icon indicates that you've locked the flash exposure to a specific point in the frame or that flash exposure bracketing is being performed (see Chapter 6).
- ✔ **High-speed sync:** This icon indicates that you've changed the Flash mode to highspeed sync (see Chapter 7).

- **Shutter speed:** Displays the shutter speed that will be used to take the next picture. You can also use this information to manually set the shutter speed when shooting in Shutter Priority mode or Manual mode (see Chapter 6).

- **Aperture:** Displays the f-stop that will be used to take the next picture. You can use this information to manually set the aperture when shooting in Aperture Priority mode or Manual mode (see Chapter 6).

- **Exposure compensation:** This icon indicates whether exposure compensation or autoexposure bracketing has been enabled; it is also used to set flash compensation. (See Chapter 6 for more on autoexposure bracketing and see Chapter 7 for flash compensation.)

- **Highlight tone priority:** This icon displays when you enable Highlight Tone Priority (see Chapter 6).

- **ISO speed setting:** This icon shows the currently selected ISO speed setting. You can also use this information when setting the ISO speed (see Chapter 7).

- **White balance adjustment:** This icon displays when you've enabled white balance correction (see Chapter 7).

- **Black & White:** This B/W icon displays when you've selected the Black and White picture style (see Chapter 7).

- **Max burst:** Shows the maximum number of shots you can take when shooting in Continuous mode. If fewer shots are remaining on the card than the maximum burst, the shots remaining display.

- **Focus confirmation light:** Lights when you achieve focus.

## Attaching a Lens

The beauty of a digital SLR is that you can attach lenses with different focal lengths to achieve different effects. Your EOS 7D accepts a wide range of lens from super wide-angle lenses that capture a wide view angle, to long telephoto lenses that capture a narrow view angle and let you fill the frame with objects that are far away. Your camera can use EF lenses and EF-S lenses. The latter are specially made for cameras, such as the EOS 7D, that have a sensor smaller than the size of a frame of 35mm film. To attach a lens to your camera:

1. **Remove the body cap from the camera.**

   Twist the cap counterclockwise to remove it. Alternatively, you'll remove the lens currently on the camera with the steps I outline in the upcoming "Removing a Lens" section.

2. **Remove the rear cap from the lens you're attaching to the camera.**

   Twist the cap clockwise to remove it.

3. **Align the dot on the lens with the mounting dot on the camera body (see Figure 1-6).**

EF index mount

EF-S index mount

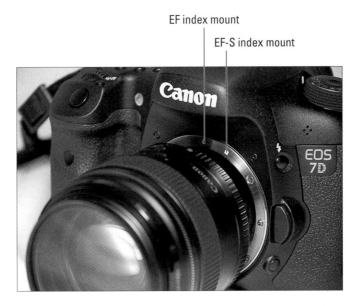

Figure 1-6: Aligning the lens.

If you're using an EF lens, the dot on the lens is red and you align it with the red dot on the camera body. If you're using an EF-S lens, the dot on the lens is white and you align it with the white dot on the camera body.

4. **Twist the lens clockwise until it locks into place.**

Don't force the lens. If the lens doesn't lock into place with a gentle twist, you may not have aligned it properly.

## Removing a Lens

When you want to use a different lens or store the camera body, remove the lens. Removing a lens and attaching another lens can be a bit of a juggling act. To remove a lens from your camera:

1. **Press the lens-release button.**

This button unlocks the lens from the camera.

2. **Twist the lens counterclockwise until it stops and then gently pull the lens out of the body (see Figure 1-7).**

To minimize the chance of dust getting on your sensor, always turn off the camera when changing lenses. If you leave the power on, the sensor has a slight charge that can attract dust floating in the air. Do not change lenses in a dusty environment because dust may inadvertently blow into your camera. I also find it's a good idea to point the camera body down when changing lenses. Dust on the sensor shows up as little black specks on your images, which is not a good thing.

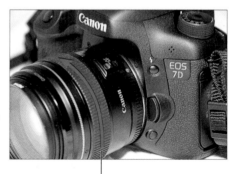

Rotate counterclockwise

**Figure 1-7:** Removing a lens from the camera.

Never store the camera without the lens or body cap attached because pollutants may accidentally get into the camera, harming the delicate mechanical parts, and possibly fouling the sensor.

## Using Image Stabilization Lenses

Many Canon and third-party lenses that fit your camera feature image stabilization. *Image stabilization* is a feature that enables you to shoot at a slower shutter speed than you'd normally be able to use and still get a blur-free image. The actual number of stops you can gain depends on how steady you are when handling the camera. To enable image stabilization:

1. **Locate the image stabilization switch on the side of your lens.**

   On Canon lenses, you'll find the switch on the left side of the lens when the camera is pointed toward your subject (see Figure 1-8). If you're using a third-party lens, look for a switch that reads IS, or refer to the lens manual.

2. **Push the switch to On to enable image stabilization.**

   Image stabilization uses the camera battery to compensate

**Figure 1-8:** Slide this switch to enable image stabilization.

for operator movement. Therefore, a good idea is to shut off this feature when you need to conserve battery power and don't need image stabilization. Note that some lenses have two image stabilization switches: one that stabilizes the lens in a horizontal and vertical plane, and another switch that stabilizes the lens when you pan to follow a moving object.

# What's my focal length multiplier?

The sensor on your EOS 7D is smaller than the frame size of 35mm film. Therefore the resulting image incorporates a smaller area than you'd capture with a 35mm film camera or a digital SLR with a sensor that's the same size as a frame of 35mm film — also known as a *full-frame sensor*. When you use a camera that has a sensor smaller than the 35mm film frame size, you can zoom in closer with a telephoto than would be possible with a camera with a full-frame sensor. Imagine looking through a window that's 4 feet × 6 feet. You see a large field of view including the sky. If the window is shrunk to 2 feet × 3 feet, you see less of the scene and sky, which is the same thing that happens when you use

a camera with a sensor smaller than the 35mm film frame. Photographers who have previously shot film with 35mm cameras like to know how their lenses will behave on a camera without a full-frame sensor. They find out by multiplying their camera's focal length multiplier by the focal length of the lens. The focal length multiplier for your EOD 7D is 1.6. Therefore a 50mm lens captures the same field of view as an 80mm (50mm × 1.6) lens does on a 35mm film camera or full-frame digital SLR. When I suggest a focal length, I refer to it as the *35mm equivalent*. For example, if I specify a telephoto focal length that is the 35mm equivalent of 80mm, this is a 50mm lens on the EOS 7D.

## Using a Zoom Lens

The kit lens that comes with the EOS 7D has a focal length range from 28mm (wide angle) to 135mm (telephoto). You can purchase additional Canon or third-party zoom lenses from your favorite camera supplier. Zoom lenses come in two flavors: twist to zoom, or push/pull to zoom in or out, respectively.

To use a zoom lens with a barrel that twists to change focal length:

1. **Grasp the lens barrel with your fingers.**

2. **Twist the barrel to zoom in or out.**

To use a push/pull zoom lens:

1. **Grasp the lens barrel with your fingers.**

2. **Push the barrel away from the camera to zoom in; pull the barrel toward the camera to zoom out.**

## Adjusting Viewfinder Clarity

If you wear glasses, or your vision's not perfect, you can adjust the viewfinder clarity, which makes it easier to compose your images and focus manually. After all, if what you see in the viewfinder isn't what you get, you won't be a happy camper. To adjust viewfinder clarity:

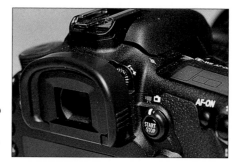

1. **Attach a lens to the camera.**

2. **Look into the viewfinder and turn the dioptric adjuster knob (see Figure 1-9) left or right until the autofocus points look sharp and clear.**

If the knob is hard to turn, remove the eyepiece cup.

Figure 1-9: A clear viewfinder. The better to see you with, my dear.

## Modifying Basic Camera Settings

Your camera ships with default settings for the country in which the camera was purchased. You also have default settings for the amount of time it takes the camera to power off when no picture taking or menu activity has

occurred. You can modify these settings to suit your taste, as I show you in the upcoming sections.

## Changing the date and time

Chances are your camera isn't set up for the right date and time when you get it. You can easily change this to the proper date and time by using a camera menu. Yes, consider this your baptism by fire if you've never worked with your camera menus before. To change the date and time:

**1. Press the Menu button.**

The previously used menu appears on the LCD monitor.

**2. Press the multi-controller button to navigate to the Camera Settings 2 tab.**

The menu with the date and time options is displayed on your LCD monitor (see the top image of Figure 1-10).

**3. Rotate the Quick Control dial to highlight Date/Time and then press the Set button.**

The month is highlighted.

**4. Press Set to highlight the number.**

Arrows appear on the top and bottom of the number.

**5. Rotate the Quick Control dial to change the number and then press Set.**

The change is applied.

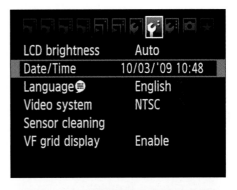

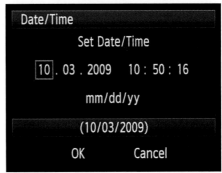

Figure 1-10: Changing the date and time.

**6. Rotate the Quick Control dial to highlight the date.**

**7. Repeat Steps 4 and 5 to set the date.**

**8. Continue in this manner to change the year, hour, minute, and seconds to the current time.**

**9. Rotate the Quick Control dial to highlight OK and then press Set.**

Your changes are applied.

## Changing the auto power-off time

Your camera powers off automatically after a certain period of nonoperation. You can specify a period of time from 1 minute to 30 minutes, or you can disable power-off. However, your camera will automatically power off after 30 minutes of nonactivity, even if you choose Off. If you choose a power-off time that's of a short duration, you'll conserve your battery. After your camera powers off, press the shutter button and the camera powers on again. To change the power-off time:

**1. Press the Menu button.**

The previously used menu appears on the LCD monitor.

**2. Press the multi-controller button to navigate to the Camera Settings 1 tab (chosen in Figure 1-11).**

**3. Rotate the Quick Control dial to highlight Auto Power Off (see the top image of Figure 1-11) and then press the Set button.**

The Auto Power Off options display (see the bottom image of Figure 1-11).

**4. Rotate the Quick Control dial to select the desired setting and then press Set.**

The change is applied.

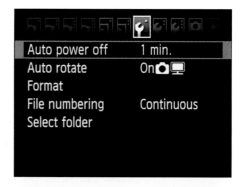

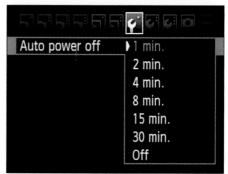

Figure 1-11: Changing the power-off time.

I recommend that you choose the shortest duration for auto power-off that you're comfortable with. This helps conserve battery power. As long as the power button is in the On position, your camera wakes almost instantaneously when you press the shutter button halfway.

To restore the camera to its default settings, press the Menu button, and then use the multi-controller button to navigate to the Camera Settings 3 tab, choose Clear All Settings, and press Set.

# Working with CF Cards

Your camera uses CF (CompactFlash) cards to store the pictures you take. A *CF card* is a mechanical device similar to a hard drive. You insert a new CF card when you begin shooting and remove the card when it's full.

To insert a CF card:

1. **Open the CF card cover on the right side of the camera as you look from the back.**

   To open the cover, slide it away from the camera until it stops and then rotate it away from the camera.

2. **Insert the card in the slot.**

   As shown in Figure 1-12, the card label is facing you and the end with the small holes is facing the camera slot.

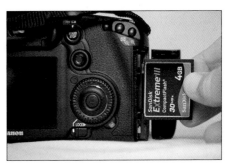

3. **Gently push the card into the slot.**

Figure 1-12: Inserting a CF card.

   Never force a card because you may damage the pins in the camera and the card. The card slides easily into the camera when aligned properly.

4. **Close the CF card cover.**

   You're ready to shoot up a storm.

When a CF card is full, remove it from the camera and insert a new one. To remove a CF Card:

1. **Open the CF card cover.**

   To open the cover, slide it away from the camera until it stops and then rotate it away from the camera.

2. **Push the white button toward the rear of the CF card cover.**

   The CF card pops loose from the pins.

3. **Gently pull the CF card from the slot.**

   You're now ready to insert a new CF card and start shooting.

You may be tempted to pick up an 8GB or 16GB card, thinking you can store a gazillion images on one card and not worry about running out of room. But memory cards are mechanical devices that are subject to failure and will fail when you least expect it. If a large card fails, you lose lots of images. I carry a

couple 4GB CF cards in my camera bag. Although I hate to lose any images, I'd rather lose 4GB worth of images than 8 or 16GB. I advise you to purchase smaller memory cards.

## Formatting a CF Card

After you download images to your computer and back them up (see Chapter 9), you format the card so you can use it again. A good idea is to format your cards before using them again, even if you didn't fill them. Doing this ensures you'll have a full card to work with and won't download duplicate images. To format a CF card:

1. **Insert the card in the camera, as I outline in the preceding section.**

2. **Press the Menu button.**

The last used camera menu displays on the LCD monitor.

3. **Press the multi-controller button to navigate to the Camera Settings 1 tab.**

4. **Turn the Quick Control dial to select Format.**

The Format option is selected (see the top image of Figure 1-13).

5. **Press the Set button.**

The menu changes to show the amount of data on the card and displays a warning that all data will be lost (see the bottom image of Figure 1-13).

6. **Rotate the Quick Control dial to highlight OK and press Set.**

The card is formatted. After formatting, you have a blank card that's ready to capture images from the camera.

You can't undo formatting a card. Make sure you've downloaded all images to your computer before you format a card.

7. **Press the shutter button halfway to exit the menu and resume taking pictures.**

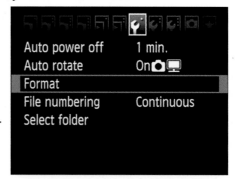

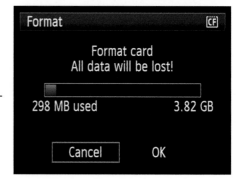

Figure 1-13: Formatting a card.

# Charging Your Camera Battery

When you notice the battery status icon is blinking, it's time to charge the battery. Charge the battery using the charger supplied with the camera. To recharge the battery, follow these steps:

1. **Plug the battery charger into a wall outlet.**

   If you live in North America, your charger works in a 110 volt outlet. If you travel overseas with your camera, make sure you bring a converter. If you insert the charger into an outlet with the wrong voltage, you'll ruin it.

2. **Insert the battery (see Figure 1-14).**

   After you insert the battery, three lights may flash. This indicates the battery has less than 25 percent of a full charge.

3. **Continue charging the battery until the light is green.**

   The battery has a 100 percent charge.

4. **Leave the battery in the charger for another hour to top it off.**

   An extra hour seems to give you a bit more life. I learned this a long time ago. However, do *not* leave the camera in the charger and connected to a power outlet for more than two hours after the battery achieves a full charge because you may damage the battery.

5. **Replace the protective cover over the battery (see Figure 1-15).**

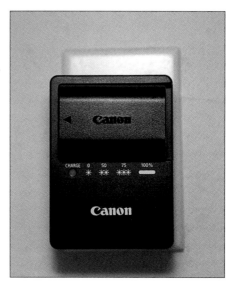

Figure 1-14: Charging the battery.

Figure 1-15: Replacing the battery cover.

Here are a few recommendations for camera batteries:

- **After you charge a battery, replace the cover so you can see blue through the battery icon.** This signifies that you have a fully charged battery under the cover, useful information if you own more than one battery.

- **Remove the battery from the camera after you've finished shooting for the day.** The battery loses a bit of its charge if you store it in the camera.

- **When replacing the cover over a partially used or fully discharged battery, place the cover so that the blue does not show through the battery icon.** This is your indication that the battery is partially discharged.

- **In cold conditions, place the spare battery in your coat pocket.** This keeps it warm and extends the life of the battery charge.

- **Beware of third-party batteries that fit your EOS 7D.** They may not be compatible with your camera's battery information system, which means you won't know how much charge remains in the battery. If the battery runs out of charge while the camera is writing data to the memory card, you may damage the memory card, the battery, or both. Batteries that don't work with your camera typically come with their own charging units.

# 2

# Automatically Capturing Great Photographs

Your EOS 7D can do some pretty amazing things. You have lots of control over the camera to get ideal pictures. But if all the control seems a bit daunting when you're getting to know your new toy, you can let the camera make most of the decisions for you. If you're thinking point and shoot, yup, that's what you get when you let the camera take the reins. However, you can still get some great pictures with your EOS 7D when you take pictures using one of the automatic modes.

If you're an experienced photographer, breeze through this chapter and you can show someone else how to get great pictures with your high-tech camera — that is, if you can part company with it long enough for someone else to use it. In this chapter, I show you how to get the most out of your camera's auto modes. I also show you how to use the Self-Timer in case you want to take a self-portrait, and show you how to use the on-camera flash automatically.

One of the exciting features of the EOS 7D is *Live View mode,* which lets you compose your image with the LCD monitor. This mode is available only on the latest digital SLRs. In this chapter, I deal exclusively with taking pictures through the viewfinder. If you're chomping at the bit to find out how to shoot with Live View, fast-forward to Chapter 5.

# Ordering from Your Camera Menu

Some of your picture-taking tasks involve using the camera menu. For example, when you format a CF card, you use the menu. You also use the menu to specify image size and quality as well as set the parameters for tasks, such as automatic exposure bracketing. I give you a brief introduction to the camera menu in Chapter 1 when I show you how to format a CF card and change the date and time. In this section, I give you a brief overview of the menu system. Throughout this book, I show you how to use the menu to perform a specific task. To access the camera menu:

1. **Press the Menu button.**

   The last used menu displays.

2. **Rotate the Mode dial to P (see Figure 2-1).**

   *P* on the Mode dial stands for *Programmed Auto Exposure mode.* When you access the menu in one of the creative shooting modes (P, Tv, Av, M, or B), you have access to all the menu items.

3. **Press the multi-controller button left or right to access the Shooting Settings 1 tab on the left (see the left side of Figure 2-2).**

   This tab, which I dub Shooting Settings 1, is your first set of shooting options. Canon doesn't give a name to each tab. In Table 2-1 after these steps, I name all these tabs for easy reference. You also have access to many of these menu options when you shoot in Creative Auto mode. Certain menu options, such as changing image format, aren't available when taking pictures with the Full Auto mode.

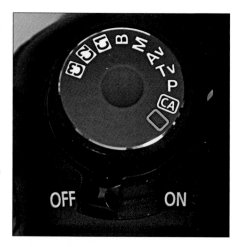

Figure 2-1: You have access to all menu options when you shoot in Programmed Auto Exposure mode.

When you access a menu, the first option is selected by default. In this case, Quality is selected.

4. **Press the Set button.**

   Your menu display changes to reveal the image quality options (see Figure 2-2). Notice the icon to the right of the RAW options. This signifies that you use the Main dial to specify this setting. Notice the icon to the right of the JPEG settings. This signifies that you use the Quick Control dial to specify this setting.

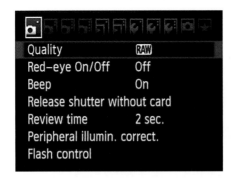 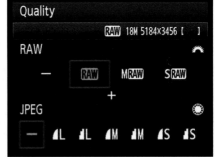

Figure 2-2: This menu has shooting options.

5. **After changing a menu option, press Set.**

   This commits the change and returns you to the previous menu.

6. **To highlight another option in the current menu, rotate the Quick Control dial to the desired item.**

   This highlights the menu option.

7. **To access the menu option, press Set.**

   You can now change the menu option. Sometimes you use a combination of the multi-controller button, the Quick Control dial, and the Main dial to make a setting. In most instances, you commit the change by pressing Set, although the Menu button is used on some occasions. An icon appears on each menu, indicating the button to press to apply the change.

8. **Press the multi-controller button right.**

   This displays the Shooting Settings 2 tab. The amount of tabs you have depends on the mode in which you're shooting. If you followed my instructions in Step 2, you see 11 tabs. Throughout the rest of the book, I show you how to use options in these tabs to perform various tasks.

**9. Press the Menu button or press the shutter button halfway to exit the menu.**

Either operation returns you to shooting mode. I prefer pressing the shutter button halfway.

| Table 2-1 | | The Camera Menu Tabs |
|---|---|---|
| *Icon* | *Menu Tab Name* | *Description* |
| | Shooting Settings 1 | Used to specify image format, review time, and similar options. |
| | Shooting Settings 2 | Used to set exposure compensation, picture style, and similar options. |
| | Shooting Settings 3 | Used to set the One Touch RAW+JPEG options and Dust Delete Data. |
| | Shooting Settings 4 | Used to enable Live View shooting, display a grid during Live View shooting, and similar options. |
| | Playback Settings 1 | Used to protect images, erase images, and similar options. |
| | Playback Settings 2 | Used to set autofocus point display options, set the histogram option, play images as a slide show, and similar options. |
| | Camera Settings 1 | Used to format cards, specify file numbering, and similar options. |
| | Camera Settings 2 | Used to choose LCD brightness option, set date and time, and similar options. |
| | Camera Settings 3 | Used to display battery information, add photographer's copyright information to each image, and similar options. |
| | Custom Functions | Used to select and set custom functions. |
| | My Menu Settings | Used to create a custom menu with your most frequently used options. |

## Where did all the cute icons go?

If you've upgraded from an earlier Canon camera, such as the EOS 50D, and have explored your EOS 7D's Mode dial, you may wonder where all the cute little icons are. You may be thinking that the icon with the mountain, the girl with the floppy hat, and so on are present on every Canon camera. Not so. You graduated into the big leagues when you bought this camera; it has professional features, and pros don't use cameras with funny icons that designate shooting modes that, er, rank amateurs use. Having said that, your EOS 7D has two powerful modes that enable you, or someone who doesn't have a lot of photography experience, to still get good photos automatically.

## Taking Your First Picture

You can easily get great results with your EOS 7D automatically. In Full Auto mode, all you have to do is compose the picture, achieve focus, and press the shutter button. The camera literally takes care of everything. You don't have to mess with choosing the shutter speed, aperture, ISO setting, or anything else for that matter. The camera meters the amount of light coming to the camera and makes all the heavy decisions for you.

When you're shooting in Full Auto mode, the camera chooses the actual shutter speed, aperture, and ISO used, which is determined by the amount of available light. The camera chooses a shutter speed and aperture to ensure a properly exposed image (see the "Understanding Exposure and Focal Length" section later in this chapter). When you're taking pictures in dim lighting or at night, the camera will attempt to choose a shutter speed that ensures a blur-free image (see the "Shutter speed and image sharpness" sidebar later in this chapter). If the shutter speed is too slow, you need to mount the camera on a tripod to ensure a blur-free image.

Depending on the lighting conditions, the camera may have to increase the ISO setting, which makes the camera more sensitive to light. An ISO setting above 800 may result in digital noise in the darker areas of the image. When you shoot in Full Auto mode, the camera also determines the aperture, which, combined with the focal length of the lens you're using, determines how much of the image is in apparent focus from front to back (see the "Understanding Exposure and Focal Length" section of this chapter).

When you unpacked your camera and started exploring the controls, you probably noticed the Mode dial on the top-left side of the camera as you look at it from behind — the same position from which you take pictures. The default setting for this dial is *A,* which of course, means *Automatic.* These instructions are generic and don't assume you've bought the camera with the kit lens. To take a photograph automatically, follow these steps:

1. **Insert a memory card, power on the camera, and attach the desired lens to the camera.**

   If you're not familiar with attaching a lens to the camera, check out Chapter 1.

2. **If you're using a lens with image stabilization, move the switch to IS.**

   If you bought the camera kit with the 28–135mm lens, you'll find this switch on the left side of the lens with the camera in front of you.

3. **Make sure the lens is set to AF (autofocus).**

   If you're using a Canon lens, you'll find a switch labeled AF on the left side of the lens when the camera is pointed toward your subject.

4. **Rotate the Mode dial to the A (Full Auto) setting.**

   It's the first setting, the green rectangle on the Mode dial (see Figure 2-3).

5. **Look through the viewfinder and compose your scene.**

   When you look through the viewfinder, you'll see a lot of black squares, 19 to be exact. These are the *autofocus points,* the points your camera uses to focus. In Full Auto or Creative Auto mode, the focus points are selected automatically based on the information the camera gathers through the lens. In essence, the camera looks for objects with well-defined edges.

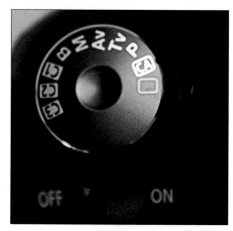

Figure 2-3: Shooting pictures in Full Auto mode.

You can customize the way the autofocus system works to suit your style of photography when shooting in one of the creative modes, something I show you in Chapter 6.

Make sure your subject is under one of the autofocus squares. If you're photographing a person, make sure the person is in the center of the frame. You can compose the image so that the person isn't centered in the frame. I show you how to do that in the "Focusing On an Off-Center Subject" section later in this chapter.

### 6. Press and hold the shutter button halfway.

When your camera achieves focus, a green dot appears on the right side of the viewfinder. If the camera can't achieve focus, the dot flashes. If this occurs, switch to manual focus (see the "Focusing Manually" section later in this chapter). The autofocus points that the camera uses to focus your subject are also illuminated (see Figure 2-4).

Figure 2-4: Taking your first picture.

If your subject is moving, after the camera achieves focus, it automatically switches to another focus mode (AI Servo, which I cover in Chapter 7) and keeps your subject in focus. On the LCD panel on top of the camera and in the viewfinder, you see the shutter speed, aperture, and ISO setting the camera uses for the picture. If the shutter speed flashes, the speed is too slow to ensure a blur-free image while hand-holding the camera. If this is the case, mount your camera on a tripod.

### 7. Press the shutter button fully.

The camera takes the picture.

When the camera records data to the memory card, the red light below the Quick Control dial illuminates. Do not turn off your camera while the light is on. If you do, the image isn't recorded to the memory card. Powering off the camera while the light is illuminated may also damage the memory card, the camera, or both.

### 8. Review the image on the LCD monitor.

You can view other information regarding the image on your LCD monitor. You can view exposure information, a histogram, and much more. I show you how to display image information on the LCD monitor in Chapter 4.

In most situations, you get a beautifully exposed image with Full Auto mode. If, however, you're photographing a scene with tricky lighting conditions or photographing a fast-moving object, the image may not be to your liking. If this is the case, Creative Auto mode gives you options for modifying the automatic settings to get an image that suits your taste. I show you how to use Creative Auto mode in the "Shooting Pictures in Creative Auto Mode" section later in this chapter. Or maybe now that you've had a taste of the camera's brilliance, you want to get the most out of your camera. If this is the case, fast-forward to Chapters 6 and 7.

## ...sure and Focal Length

...e in any of the
...mera deter-
...and aperture
...tter speed
...e shutter
...use a fast
...er is open for
...which stops
...eed keeps
...ng time and
is needed when you don't have a lot
of available light. The *aperture* deter-
mines how much light enters the
camera. Each aperture equates to an
f-stop number.

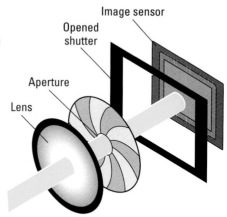

Figure 2-5: The shutter speed and aperture
determine the exposure.

The f-stop number is a value. A
small f-stop number, such as f/2.8,
designates a large aperture, which
lets a lot of light into the camera. A
large f-stop number, such as f/16,
is a small aperture that lets a small
amount of light into the camera.
Figure 2-6 shows a comparison of
apertures and the amount of light
they send to the camera.

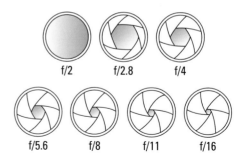

The f-stop determines another
important factor, the depth of field.
The *depth of field* is the amount of
the image that's in apparent focus in
front of and behind your subject:

Figure 2-6: The aperture opening determines
how much light enters the camera.

- **Small depth of field:** A large aperture (small f-stop number) gives you
  a shallow depth of field, especially when you're shooting the image
  with a telephoto lens. A telephoto lens has a narrow angle of view,
  which gets you closer to your subject and results in an even shallower
  depth of field. Telephoto focal lenses are the 35mm equivalent of
  70mm and greater. Large apertures and telephoto lenses are ideal for
  portrait photography.

- **Large depth of field:** On the other hand, a small aperture (large f-stop
  number) gives you a very large depth of field, especially when you're
  using a wide-angle focal length. A wide-angle focal length has a large
  angle of view. Wide-angle focal lengths have a range that is the 35mm
  equivalent of 18mm to 35mm.

## Shutter speed and image sharpness

When you take a picture with the camera cradled in your hands, a certain amount of motion is transmitted to the camera, which is caused by movement made by the camera operator. When you take pictures with a high shutter speed, the shutter isn't open long enough for any operator movement to affect the sharpness of the image. However, when you shoot at a slow shutter speed, the shutter is open long enough for operator movement to be apparent in the image, which shows up as an image that isn't tack sharp. The clarity of your images depends on how steadily you hold the camera and the shutter speed used to capture the image.

The rule of thumb for handheld photography is to shoot with a shutter speed that's the reciprocal of the 35mm equivalent of the lens focal length. For example, if you're using a lens with a focal length that measures 50mm, the 35mm equivalent for your EOS 7D is 80mm. Therefore, you should use a shutter speed of 1/100 of a second or faster to get a blur-free image. If the camera chooses a slower shutter speed, you need to steady the camera with a tripod. If you use a lens with image stabilization, you can shoot at a slower shutter speed than normal. Even without image stabilization, if you hold the camera very steady, you may be able to shoot at a slower shutter speed than the rule of thumb listed here. The best way to find out how steady you are is to experiment with different shutter speeds on each lens you own. Due to the narrow angle of view, you'll find that operator movement is very apparent when you take pictures with telephoto lenses.

As you can see, a large number of factors determine what your image will look like.

The following list explains what action the camera takes when you take pictures in various modes:

- **Full Auto mode:** The camera determines the shutter speed and f-stop.

- **Creative Auto mode:** You can apply some settings to blur the background, which in essence, gives you a shallower depth of field, brightens the image, and so on.

- **Creative modes:** These include P (Programmed Auto Exposure), Av (Aperture Priority), Tv (Shutter Priority), M (Manual), or B (Bulb). Choosing a creative mode enables you to take complete control by manually setting aperture and/or shutter speed.

- **Aperture Priority mode:** You supply the aperture (f-stop value), and the camera calculates the shutter speed needed for a properly exposed image.

- **Shutter Priority mode:** You supply the shutter speed, and the camera provides the aperture (f-stop value) to create a properly exposed image.

The decisions the camera makes regarding shutter speed and aperture are determined by lighting conditions. If you're taking pictures in low-light situations or at night, the camera may choose a shutter speed that's too slow to ensure a blur-free picture (see the earlier "Shutter speed and image sharpness" sidebar). If this is the case, you have to mount the camera on a tripod to ensure a blur-free picture. But if you want complete control over the exposure, use one of the creative modes: Programmed Auto Exposure, Aperture Priority, Shutter Priority, Manual, or Bulb, which I outline in detail in Chapter 6.

## Focusing On an Off-center Subject

There are lots of rules for composing photographs, and many of them can be broken. However, one useful rule says that when you're photographing a person, she shouldn't be in the center of the frame. A photograph with your subject to the right or left of center is more interesting than one where she's smack-dab in the center of the frame. You can easily focus on an off-center subject by following these steps:

1. **Compose your scene through the viewfinder.**

   Move the camera until you achieve the desired composition.

2. **Move the camera until the center autofocus point is positioned in the middle of your subject.**

3. **Press the shutter button halfway.**

   When the camera achieves focus, the green dot on the right side of the viewfinder appears. If the dot is flashing, the camera hasn't focused on your subject.

4. **With the shutter button held down halfway, move the camera to recompose your picture.**

   By holding down the shutter button halfway, the focus locks on your subject, even as you move the camera.

5. **Press the shutter button fully.**

   The camera records the image.

## Focusing Manually

You can have the greatest camera and lens in the world, but if your images aren't in focus, nobody — including you — will care to look at your pictures. Your EOS 7D has a sophisticated multi-point focus system. In Chapter 7, I show you how to modify the autofocus system to suit particular photography situations.

When you shoot images with the lens set to autofocus (AF on Canon lenses) mode, the camera looks for areas of changing contrast *(edges)* or objects that are under autofocus points, and then uses these areas to focus the scene. However, in low light or when you're taking a picture of a scene with lots of detail in the foreground and background, the camera may not be able to achieve focus. The green focus indicator light in the viewfinder flashes when you achieve focus, and you may also notice the autofocus motor on the lens is quite active as the camera tries to achieve focus. When you can't achieve focus, you have no choice but to manually focus the lens. Canon lenses and most third-party lenses give you the option of switching to manual focus.

To manually focus the lens, follow these steps:

1. **Move the Focus switch to MF (see Figure 2-7).**

Figure 2-7: Focusing manually.

On most lenses, you'll find this switch on the left side when the camera is facing your subject.

2. **Press the viewfinder to your eye and twist the lens focus ring until your subject is in clear focus.**

   Concentrate on areas with contrast or sharp lines. This makes it easier for you to see when your subject is in focus. Remember to focus on the center of interest in your scene. If you're photographing a person, focus on the eyes. The curve of your subject's eyelid should be in focus in the resulting image; it's also an easy area to focus on.

3. **Take the picture.**

   Switch the lens back to autofocus (AF) when lighting conditions permit the camera to focus automatically.

## Shooting Pictures in Creative Auto Mode

If you like having control but you're not ready to walk on the wild side and shoot in one of the creative modes, Creative Auto mode is right up your alley. When you take pictures in Creative Auto mode, you can control *depth of field* (the amount of the image in front of and behind your subject that's in apparent focus), image brightness, picture style, image format, and shooting mode. When you shoot in Creative Auto mode, all your options display on the camera's LCD monitor. To shoot pictures in Creative Auto mode:

1. **Select CA from the Mode dial (see Figure 2-8).**

   *CA* on the Mode dial stands for *Creative Auto mode.* After switching to Creative Auto mode, the camera LCD displays your options.

2. **Press the Quick Control button.**

   This button gives you access to the first set of options: Flash Firings (see Figure 2-9).

3. **Rotate the Quick Control dial to choose the desired option.**

   Choose from the following options:

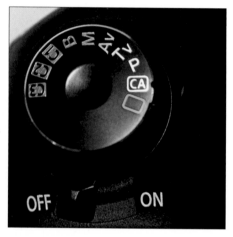

Figure 2-8: Shooting in Creative Auto mode.

   • *Auto Flash:* The flash pops up and fires when needed.

   • *Flash On:* After selecting this option, the flash pops up when you press the shutter button halfway and fires when you press the shutter button fully. This option is handy when you want to use flash to fill in the shadows.

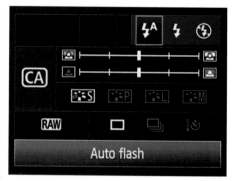

   • *Flash Off:* The flash doesn't fire when the shutter button is pressed.

Figure 2-9: Choosing a Flash Firing mode.

4. **Press the multi-controller button right to highlight the Background section (see Figure 2-10).**

5. **Rotate the Quick Control dial to the right to make the background sharper or to the left to blur it.**

   As you move the dial, the indicator moves to show how much you've sharpened or blurred the background.

6. **Press the multi-controller button right to highlight the Exposure section (see Figure 2-11).**

   When you increase the exposure, you get a brighter image. But if you go too far, you may blow out highlight areas to pure white, which means the image is overexposed. If you decrease exposure, the image is darker, but the resulting image may render some shadow areas to pure black, which means you've lost detail in those areas and underexposed the image.

7. **Rotate the Quick Control dial to the right to make the image brighter or to the left to make it darker.**

   As you move the dial, the indicator moves to indicate how much you've brightened or darkened the background. This adjustment is only applied to the midtones (the middle brightness range), which means you can't overexpose or underexpose the image with this setting.

8. **Press the multi-controller button right to highlight the Image Effects section (see Figure 2-12).**

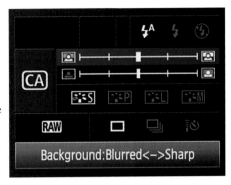

Figure 2-10: Controlling background blur.

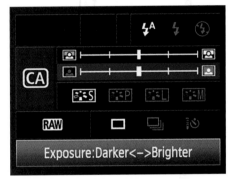

Figure 2-11: Controlling the exposure.

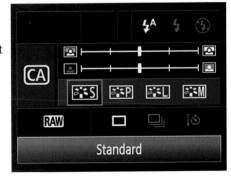

Figure 2-12: Choosing an image effect.

9. **Rotate the Quick Control dial to choose one of the following options:**

   - *Standard:* The default picture style renders an image that is sharp and clear. This picture style is ideal for most scenes.

   - *Smooth Skin Tones:* This picture style is ideal for shooting portraits. The style renders a soft image that's ideal for close-up portraits of women or children.

   - *Vivid Blues and Greens:* This picture style is ideally suited for landscapes. The style renders extremely sharp and crisp images and as the title implies: vivid blues and greens.

   - *Monochrome:* This picture style renders a black and white (grayscale if you're a purist) image.

10. **Press the multi-controller button right to highlight the Image Recording Quality section (see Figure 2-13).**

11. **Rotate the Quick Control dial to choose the desired image size and quality.**

    I explain the image quality and size options in detail in Chapter 3.

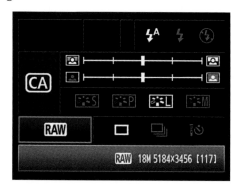

Figure 2-13: Choosing image quality.

12. **Press the multi-controller button right to highlight the Drive Mode section (see Figure 2-14).**

13. **Rotate the Quick Control dial to choose one of the following Drive mode options:**

    - *Single Shooting:* The camera captures a single shot each time you press the shutter button.

    - *Low Speed Continuous Shooting:* The camera captures images at a maximum rate of 3 fps (frames per second) for as long as you hold down the shutter button.

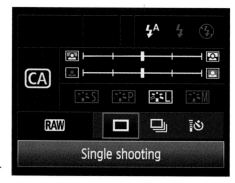

Figure 2-14: Choosing a shooting mode.

    - *10-Second Countdown Timer:* The camera captures the image 10 seconds after you press the shutter button. You can also capture images with the Canon RC-1 or RC-5 remote control.

**14. Compose your scene with the viewfinder and then press the shutter button halfway.**

The green dot on the right side of the viewfinder appears when you achieve focus.

**15. Press the shutter button fully to take the picture.**

The image appears on your LCD monitor almost instantly.

# Using the Flash in Auto Modes

Your camera features a built-in flash unit, but it's no ordinary built-in flash unit. This one has the power to command other Canon flash units that support the EOS series and shed lots of light on your subject. However, when you shoot pictures using one of the auto modes, you don't have access to those bells and whistles, which by the way, I cover in Chapter 7.

When you take pictures in Full Auto mode, the flash automatically pops up when the camera senses there's not enough light to properly expose the picture. Don't expect miracles from the on-camera flash; it's effective only for a distance of about 16 feet at f/3.5 with an ISO setting of 200. After that the on-camera flash falls off so much, it's not usable. Other issues you'll find with on-camera flash is red-eye when you're photographing people. The camera does have a built in red-eye reduction system.

## Using red-eye reduction

When you enable red-eye reduction, the camera fires a preflash that causes your subject's pupils to constrict, thereby reducing red-eye. The effectiveness of red-eye reduction varies from subject to subject. The alternative is using an auxiliary flash that can bounce the flash off a large surface, such as a wall, which diffuses the light and doesn't beam it directly into your subject's eyes. To enable red-eye reduction:

**1. Press the Menu button.**

This displays the last used menu on your LCD monitor.

**2. Press the multi-controller button left or right to navigate to the Shooting Settings 1 tab.**

These are your first set of shooting settings.

**3. Rotate the Quick Control dial to highlight the Red-Eye On/Off option (see the left side of Figure 2-15) and then press the Set button.**

The Red-Eye On/Off options display (see the right side of Figure 2-15).

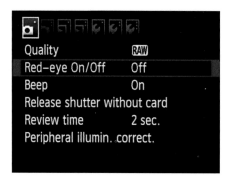
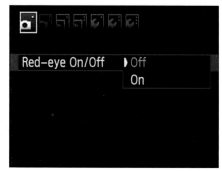

Figure 2-15: Specifying red-eye options.

### 4. Turn the Quick Control dial to highlight On and then press Set.

Red-eye reduction is enabled.

To take a picture when red-eye reduction is enabled:

### 1. Enable red-eye reduction, as I outline in the preceding steps.

### 2. Press the Flash button.

The flash unit pops up.

### 3. Compose your image in the viewfinder.

You'll get your best results if your subject looks directly at the red-eye reduction lamp on the front of the camera (see Figure 2-16).

### 4. Press the shutter button halfway.

The red-eye reduction lamp lights. When the green light on the right side of the viewfinder appears, your subject is in focus.

### 5. Wait until the exposure compensation display at the bottom of the viewfinder disappears.

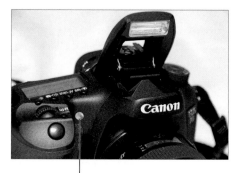

Red-eye reduction lamp

Figure 2-16: The red-eye reduction lamp.

This is your signal that the red-eye reduction lamp is functioning optimally. Figure 2-17 shows the disappearing act you'll see. The compensation display disappears on the LCD panel as well. When the display disappears completely, the red-eye reduction lamp has done its thing.

6. **After the display disappears, press the shutter button.**

   In a few seconds, the image displays on the LCD monitor. Review the image to make sure no red-eye is visible. If necessary, take the picture again.

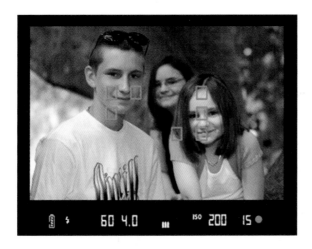

Figure 2-17: Red-eye reduction is in effect when this icon disappears.

## Using flash when shooting in Creative Auto mode

When you take pictures using the Creative Auto mode, you have more flash options. You can

- ✔ **Have the flash fire automatically when needed:** This option works identically to when you shoot pictures in Full Auto mode.

- ✔ **Disable the flash:** If you opt to disable the flash, ambient light is the only source of illumination for your pictures.

- ✔ **Leave the flash on all the time:** If you're taking pictures of people with a strong light source, such as the setting sun behind them, leaving the flash up provides light to fill in the shadows, also known as *fill light.* You can also leave the flash up all the time to add a splash of light to your images and warm them up.

To read more about flash photography while shooting in Creative Auto mode, check out the "Shooting Pictures in Creative Auto Mode" section earlier in this chapter.

# Using the Self-Timer

Your camera has a built-in Self-Timer that you use whenever you want to delay the opening of the shutter. This option is useful when you want to take a self-portrait or you want to be in a picture with other people. The Self-Timer is also handy when you're taking pictures on a tripod, especially when the shot requires a long exposure. The countdown allows time for any camera shake that was caused by pressing the shutter to subside. Your camera has a Self-Timer that counts down from 2 seconds and one that counts down from 10 seconds. To enable the Self-Timer:

1. **Press the AF-Drive button.**

2. **Look at the LCD panel and then turn the Quick Control dial to select either the 2-Second or 10-Second Timer.**

   The image on the left of Figure 2-18 shows the LCD panel with the 2-Second Timer selected, and the image on the right shows the 10-Second Timer selected.

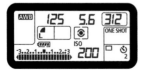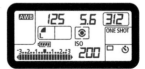

Figure 2-18: Selecting one of the Self-Timer modes.

3. **Compose your scene in the viewfinder.**

   If you're shooting a self-portrait or will be in the picture, mount your camera on a tripod. If you're not looking through the viewfinder when you used the Self-Timer, you'll also have to remove the eyecup and place the eyepiece cover over the viewfinder. This little piece slides into the same slots as the eyecup. The eyepiece cover is somewhere in the box your camera shipped in. That is unless you realized what the piece is used for and put it in your camera bag. The eyepiece cover prevents stray light from changing the exposure.

4. **Press the shutter button halfway to achieve focus.**

   The green light on the right side of the viewfinder shines when focus has been achieved.

5. **Press the shutter button.**

   The camera begins to count down. As the camera counts down, you hear a beeping sound and a light on the front of the camera flashes. Two seconds before the end of the countdown, the light stays on and the beeping sounds faster. If you're taking a self-portrait, say "cheese" when the red light is solid.

## Triggering the Shutter Remotely

You can trigger the camera shutter remotely using the RC-1 or RC-5 remote control, which is sold separately. You use the remote controllers in conjunction with the timer. This option is handy when you're creating still-life photos. Instead of walking between the camera and your subject, you can make subtle changes to the composition and then trigger the camera remotely. To trigger your camera remotely:

1. **Mount the camera on a tripod.**

2. **Switch the lens to manual focus and focus on your subject.**

   For more information on manually focusing the camera, see the "Focusing Manually" section earlier in this chapter.

3. **Press the AF-Drive button.**

4. **While looking at the LCD panel, rotate the Quick Control dial to select the desired remote mode.**

   You can trigger the camera remotely and have it count down from 10 or 2 seconds. The left side of Figure 2-19 shows the LCD panel with a 2-second remote, and the right side of the panel shows 10-second remote.

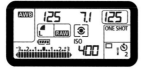 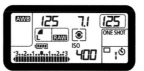

Figure 2-19: Taking a picture with a remote control device.

5. **Compose your scene through the viewfinder and then focus on your subject.**

6. **Point the remote controller at the camera's remote sensor and then press the remote's trigger button.**

   The remote sensor is located near the handgrip on the left side of the camera as you look at it.

   The Self-Timer counts down, the shutter actuates, and the picture is taken.

# 3

# Specifying Image Size and Quality

*In This Chapter*

▶ Determining image size, format, and quality

▶ Comparing image formats and file sizes

▶ Creating folders and a file-numbering method

*Y*our camera captures images with a resolution of 18 megapixels, which is humongous, ginormous, or any other adjective you prefer to indicate something that's big. The good news: This gives you a tremendous amount of flexibility. You can print images as large as 21.6 x 14.4 inches. Thinking of the possibilities of decorating your house with your photographs? The bad news: The large size takes up lots of room on your memory card and lots of room on the hard drive that you store your images on. Fortunately, you can specify different sizes by using camera menu options if you have memory cards and hard drives with small capacities.

In addition to concerning yourself with image size, you also have the file format you choose to worry about. Your camera can capture images in the RAW or JPEG format. When you capture images in the RAW format, you must process them. Think digital darkroom, and you get the idea. The RAW format gives you a tremendous amount of flexibility. After you download RAW images to your computer, you process the images with software included with your camera or with third-party software, such as Adobe Lightroom or Adobe Photoshop.

If you capture images in the JPEG format, the camera does the processing for you. Think of this as the digital equivalent of a Polaroid image. You get instant gratification but can't do much with the image except crop it and perform minimal image editing. If you capture images in the JPEG format, you also have to think about image quality. The setting you choose determines the image quality and the file size.

If you're new to digital photography, file format, image size, and quality may seem a tad overwhelming. But hey, don't worry — be happy. I show you how to specify image size, quality, and a whole lot more in this chapter.

## Understanding Image Size and Quality

Your camera can capture large images. The default option captures images at a size that most photographers — except professionals — won't ever need or use. But before you specify sizes, you need to understand the relationship between the image size and the resolution. The default image size your camera can capture measures 5184 x 3456 pixels. If you do the math:

$5184 \times 3456 = 17915904$ pixels

$17915904 \div 1,000,000 = 17.91$.

Round up to get 18 megapixels.

The default resolution for your camera is 240 pixels per inch (ppi). If you do a little more math, the default image size and resolution equate to an image size of 21.6 x 14.4 inches:

$5184 \div 240 = 21.6$ inches

$3456 \div 240 = 14.4$ inches.

Please don't try this math at home unless you own a well-lubricated abacus.

Another factor to consider is the final destination of the images. If you're going to edit the images with Canon or third-party software and then print them, you need to factor this into the choices you make when specifying image size and quality. You can get high-quality prints with the 240 ppi default resolution. However, some printers prefer 300 ppi. If you're capturing images that will be displayed on a Web site only, you can get by with a much smaller image and a resolution of 72 or 96 ppi. When you use images on the Web, you'll rarely need one with a dimension that's wider than 640 pixels. You can resample images to a higher resolution with third-party software, such as Photoshop Elements, Photoshop, or Photoshop Lightroom.

The default image size is great if you're printing images and have gobs of space on your hard drive and a pocket full of 4GB memory cards. However, if your storage capacity is at a premium or you're running out of room on your last memory card with no computer readily available to download to, it's important to know how to change image size and quality, a task I show you how to do in the upcoming sections.

# Specifying Image Format, Size, and Quality

Your EOS 7D has many options that determine the dimensions, image format, quality, and file size. You can choose from two image formats — JPEG and RAW. You have three different sizes for each image format. If you capture images with the JPEG format, you can also specify image quality. You can capture both formats when you shoot an image, or choose either format. If you choose to capture images in one format and decide you want to record an image with both formations, your camera features a RAW+JPEG button that lets you capture both formats on the fly.

Your decisions regarding format, image size, and quality determine the crispness of the resulting images, the file size, and the amount of flexibility you have when editing your images. To give you an idea of the difference in file sizes, you'll end up with a file size of 6.6MB when you capture an image using the JPEG format with Fine quality compared to a file size of approximately 25MB when you capture an image using the RAW format. I explain the differences between the two formats in an upcoming "JPEG or RAW? Which is right for you?" sidebar. I also give you my take on which options you should choose in the "My recommendations" sidebar later in this chapter. The following sections show you how to choose options from the camera menus.

## Choosing the file format, image size, and quality

One of the first decisions you make regarding your images is the file format. You can capture JPEG or RAW images. When you choose the file format, you also specify the image size. If you choose the JPEG format, you specify the quality as well. You even have an option to capture both formats simultaneously. If you're curious about the difference between the formats, check out the "JPEG or RAW? Which is right for you?" sidebar in this chapter. To specify the image format:

1. **Press the Menu button.**

   This displays the last used menu on your LCD monitor.

2. **Press the multi-controller button left or right to access the Shooting Settings 1 tab.**

3. **Rotate the Quick Control dial to highlight Quality (see Figure 3-1).**

4. **Press the Set button.**

   Your image format, size, and quality options display (see the right side of Figure 3-1).

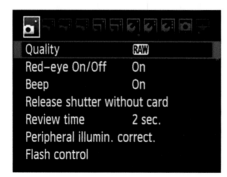
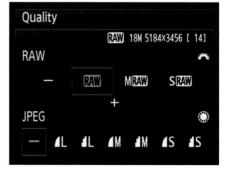

Figure 3-1: Setting Image format, size, and quality options.

5. **Rotate the Main dial to specify a RAW setting.**

   Choose this option to capture RAW images, or perform this step with
   Step 6 to capture JPEG images simultaneously when you press the shut-
   ter button. Your options are RAW (5184 x 3456 pixels), MRAW (3888 x
   2592 pixels), or SRAW (2592 x 1728 pixels). When you select an option,
   the file size, image dimensions in pixels, and the number of images that
   can be captured on your memory card in the camera display in the
   upper-right corner of the Quality menu.

6. **Rotate the Quick Control dial to specify a JPEG setting.**

   Choose this option to capture JPEG images, or perform this step with
   Step 5 to capture RAW images simultaneously when you press the shut-
   ter button. Your options are Large with Fine, Large with Normal, Medium
   with Fine, Medium with Normal, Small with Fine, or Small with Normal.
   The dimensions, respectively, are 5184 x 3456 pixels, 3888 x 2592 pixels,
   or 2592 x 1728 pixels.

7. **Press Set to apply the change.**

   The selected image information displays next to Quality on the Shooting
   Settings 1 tab.

## Using One Touch RAW+JPEG

Many photographers capture JPEG and RAW photographs simultaneously.
With this option, you have images that are processed and ready for viewing
(the JPEG file), and an image that can be tweaked to perfection with Canon
or third-party software (the RAW file). However, capturing images in two for-
mats takes up a lot of room on your memory card. With your EOS 7D, you can
capture images in the JPEG or RAW formats, as well as capture both formats

simultaneously when you need to. After you configure the RAW+JPEG button using menu commands, you can capture both formats with the press of a button.

To configure how the RAW+JPEG button records images when you press it:

1. **Press the Menu button.**

   The last menu you used displays on your LCD monitor.

2. **Press the multi-controller button left or right to access the Shooting Settings 2 menu.**

3. **Rotate the Quick Control dial to highlight One Touch RAW+JPEG (see the left side of Figure 3-2).**

4. **Press the Set button.**

   The One Touch RAW+JPEG options display on your LCD monitor (see Figure 3-2). Simultaneous RAW is highlighted.

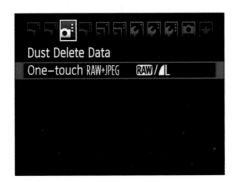 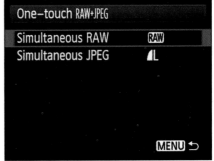

Figure 3-2: Configuring the RAW+JPEG button.

5. **Press Set.**

   The options display for the size of the RAW file captured simultaneously with a JPEG file when the RAW+JPEG button is pressed (see the left side of Figure 3-3). For more information on RAW size options, see the "Choosing the file format, image size, and quality" section earlier in this chapter.

6. **Rotate the Quick Control dial to select the desired RAW format and then press Set.**

   You return to the previous menu.

7. **Rotate the Quick Control dial to highlight JPEG and then press Set.**

   The size and quality options for the JPEG image captured simultaneously with a RAW file display (see the right side of Figure 3-3). For more information on JPEG size and quality options, see the "Choosing the file format, image size, and quality" section earlier in this chapter.

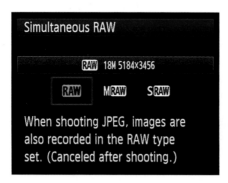 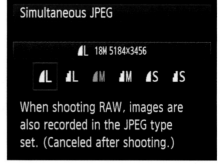

Figure 3-3: Choosing the RAW size and JPEG size as well as quality options for the RAW+JPEG button.

8. **Rotate the Quick Control dial to select the desired JPEG size and quality, and then press Set.**

   You return to the previous menu.

9. **Press the Menu button.**

   The options for the RAW+JPEG button remain in effect until you use the menu to specify different options.

After you configure the RAW+JPEG button, you can capture both formats simultaneously. Follow these steps:

1. **Press the RAW+JPEG button.**

2. **Compose the image in the viewfinder and then press the shutter button halfway to achieve focus.**

   The green dot on the right side of the viewfinder glows solid when you achieve focus.

3. **Press the shutter button fully.**

   The camera simultaneously captures a RAW and JPEG image. The button works only for one shot. To capture RAW and JPEG images simultaneously again, press the RAW+JPEG button.

## JPEG or RAW? Which is right for you?

The answer to those questions depends on how serious you are about your photography. Before you decide, let me point out the differences between the two formats. When you capture an image in the JPEG format, the camera processes the image. The camera also compresses the image based on the quality option you specify in the camera menu. You can store more images on a card when you specify a smaller image size and quality. However, you'll notice the difference when you print your images.

When you choose the RAW format, you have the ultimate in flexibility. The camera sensor transmits the RAW data to your memory card. Yup. What the sensor captures is what you get. You do have to process RAW images with either the Canon software provided with your camera or with third-party software such as Photoshop Elements, Photoshop, or Photoshop Lightroom. The software lets you fine-tune virtually everything about the photo.

## Comparing Image Formats and File Sizes

When you capture images with a higher resolution, the file size is bigger and they take up more room on your memory card. The image format also enters into the equation, and if you choose to capture images with the JPEG format, the image quality is a factor. Photographers also like to know the maximum number of images they can capture when shooting in Continuous (Burst) mode. The number of images depends on the image dimensions and quality, which equates to the file size. When you capture smaller images in the JPEG format that have been compressed, the file size is smaller; therefore, the maximum number of images you can capture before the card is filled is greater. Table 3-1 shows you how many images you can fit on a 4GB card for each available format and quality option. The information is based on capturing images with an ISO speed setting of 100. This table is only for reference. Your results will differ based on the subject and ISO speed setting.

| Table 3-1 | How Many Images Fit on a Card? | | | |
|---|---|---|---|---|
| *Image Format and Quality* | *Megapixels* | *File Size* | *Number of Shots* | *Maximum Burst* |
| JPEG Large Fine | 17.9 | 6.6MB | 593 | 94 |
| JPEG Large Normal | 17.9 | 3.3MB | 1169 | 469 |
| JPEG Medium Fine | 8.0 | 3.5MB | 1122 | 454 |
| JPEG Medium Normal | 8.0 | 1.8MB | 2178 | 2178 |

*(continued)*

**Table 3-1** *(continued)*

| Image Format and Quality | Megapixels | File Size | Number of Shots | Maximum Burst |
|---|---|---|---|---|
| JPEG Small Fine | 4.5 | 2.2MB | 1739 | 1739 |
| JPEG Small Normal | 4.5 | 1.1MB | 3297 | 3297 |
| RAW | 17.9 | 25.1 | 155 | 15 |
| MRAW | 10.1 | 17.1 | 229 | 24 |
| SRAW | 4.5 | 11.4 | 345 | 38 |

## My recommendations

When I take a photograph, I think of all possible uses. My first option is to post an image I like to my blog. Eventually I'll make prints of my best images. Some of those prints may be 4 x 6 inches for a small album, or I may have the image printed on a 30-x-20-inch canvas to decorate my home. Therefore, I always capture images with the RAW option. This enables me to do anything I want with the image. Yes, they take up a lot of room, but memory cards and hard drives are fairly inexpensive. My second hard drive is 1TB (terabyte), and I store only images on it.

Sometimes I photograph events that require me to produce images quickly, yet I still want to edit them to perfection at some point in time. When I run into a scenario like this, I capture RAW and JPEG images simultaneously. If the images that need to be turned around quickly are for the Web, I use the Small JPEG option with Normal quality in addition to the RAW setting. If the images will be printed, say for example in a local newspaper or magazine, I use the Large JPEG option with Fine quality and capture RAW images simultaneously. Both options enable me to give the client a JPEG image almost immediately and then edit RAW images for other outputs at a later date.

I also have the One Touch RAW+JPEG button configured to capture Large JPEG images with Fine quality and full-size RAW images. I still shoot with the RAW format, but when I run across a scene that I want to see the light of day quickly in JPEG format, I press the RAW+JPEG button.

If you photograph an event, such as a wedding, you have other options. In this case, I recommend that you use the RAW format for all the standard wedding images, such as exchanging vows and rings, marching down the aisle, and so on. I also recommend you use RAW when shooting the formal shots of the family members with the bride and groom. However, when you're photographing the reception, use RAW for the first dances, and then switch to MRAW or SRAW for the candid shots of the couples at tables and the guests dancing. These photographs are generally ordered as 4-x-6-inch images. Therefore, you don't need a full 18-megapixel capture for a high-quality print. Switching to SRAW or MRAW for the less important shots conserves room on your card.

If you prefer to capture your images in the JPEG format, the quality you choose determines what the final image looks like. If you compare the Normal quality to the Fine quality, you'll notice a difference when you print the image at the largest size possible. The Normal quality image won't be as crisp and sharp as the Fine quality image. On the left side of Figure 3-4 is an enlargement of an image captured with the JPEG Fine quality. The image on the right side of Figure 3-4 was captured with the JPEG Normal quality. The images have been magnified so you can more clearly see the difference in sharpness and detail.

Figure 3-4: Comparing the JPEG Normal and Fine qualities.

# Managing Image Files

By default, your images are numbered continuously until 9999 and then the file number is reset to 0001. Your images are also stored in a single folder on your memory card. You can, however, create folders in which to store your images and then change the file-numbering method. I show you how in the following sections.

## Creating folders

By default, your camera creates the 100EOS7D folder on your memory card where images are stored. You can, however, create as many folders as you want. A folder can hold a maximum of 9,999 images. When you exceed the maximum allowable images in a folder, a new one is created automatically. You can have a maximum of 999 folders on a card. Organizing your work in folders is a good idea if you work with large memory cards and want to store images from multiple shoots in separate folders. To create a folder:

 **1. Press the Menu button.**

2. **Use the multi-controller button to navigate to the Camera Settings 1 tab.**

3. **Rotate the Quick Control dial to highlight Select Folder (see the left side of Figure 3-5).**

4. **Press the Set button.**

   The Select Folder menu appears showing you the current folders on the card and the number of photos in each folder (see the right side of Figure 3-5).

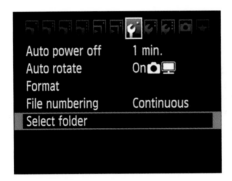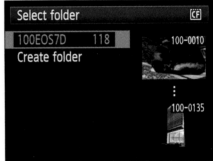

Figure 3-5: Creating a folder.

5. **Rotate the Quick Control dial to highlight Create Folder and press Set.**

   The menu refreshes, and a command to create a folder appears with the next available folder number (see Figure 3-6).

6. **Rotate the Quick Control dial to highlight OK and then press Set.**

   The new folder is created.

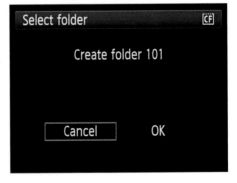

Figure 3-6: Creating a new folder.

## Selecting a folder

Folders are convenient when you want to separate images from different photo shoots. When you have more than one folder, you can choose the folder to store your images. To select a folder:

1. **Press the Menu button.**

2. **Use the multi-controller button to navigate to the Camera Settings 1 tab.**

3. **Rotate the Quick Control dial to highlight Select Folder and then press the Set button.**

   The folders you've created display.

4. **Rotate the Quick Control dial to highlight the desired folder and then press Set.**

   The next images you shoot will be stored in that folder.

## Choosing a file-numbering method

Your camera automatically names and numbers each image you take. The name isn't all that descriptive, and the numbers are consecutive. Some photographers stay with the default numbering system because it helps keep track of the number of shutter actuations. But your EOS 7D is rated for 150,000 shutter actuations so that's a moot point. To change the file-numbering system:

1. **Press the Menu button.**

2. **Use the multi-controller button to navigate to the Camera Settings 1 tab.**

3. **Rotate the Quick Control dial to highlight File Numbering (see the left side of Figure 3-7) and then press the Set button.**

   A menu appears with your file-numbering options (see the right side of Figure 3-7).

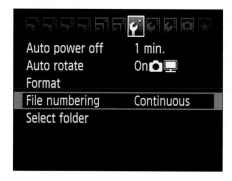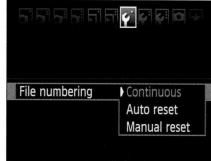

Figure 3-7: Selecting a file-numbering option.

**4. Rotate the Quick Control dial to highlight one of the following options:**

- *Continuous:* Numbers files in sequence, even when you insert a new card or store images in a different folder. Images are numbered to 9999 and then start over at 0001. When you use this option, start with a newly formatted card each time. If you use multiple cards that already have images on them, you may run into problems with duplicate filenames because file numbering may continue from the last image captured on the card. Duplicate filenames isn't a good thing if you're storing all your images in the same folder.

- *Auto Reset:* Numbers the first image with 0001 each time you insert the card in the camera or when images are stored in a new folder. This option works well if you store images from each shoot in their own folder when you download them to your computer, or as I strongly suggest, rename the images when you download them to your computer.

- *Manual Reset:* Creates a new folder and resets the numbering to 0001 after you press the Set button. After manually resetting file numbering, the numbering system reverts to the last option you specified, Continuous or Auto Reset.

**5. After highlighting the desired option, press Set to commit the change.**

The file-numbering option remains in effect until you change it with this menu command.

# 4

# Using the LCD Monitor

**D**igital photography is all about instant gratification. You snap a picture, and it appears on your LCD monitor almost instantaneously. This gives you a chance to see whether you captured the image. But your LCD monitor can do much more than just display your picture. You can get all sorts of useful information, such as the shutter speed, aperture, and other pertinent information about the image. You can even display a spiffy graph known as a *histogram* that shows the distribution of pixels from shadows to highlights.

The information you can display on the camera LCD monitor gives you the opportunity to examine each image and make sure you got it right in the camera. Photographers should always do their best to get it right in the camera and rely as little as possible on programs like Photoshop to correct exposure problems and other issues that could have been avoided when taking the picture. After all, Photoshop is a noun,

not a verb. So instead of taking the picture and saying you'll Photoshop it, rely on the information your camera supplies to determine whether you got the exposure right. Programs like Photoshop are designed to enhance images, not fix them.

In this chapter, I show you how to use your LCD monitor to review images, display image information, and much more. I also show you how to erase, rotate, and protect images.

# Displaying Image Information

When you take a picture, you see it almost immediately on your LCD monitor. When you want the big picture, you view the image with the exposure information. The large image lets you evaluate things like composition and image sharpness, which enables you to decide whether the image is worth keeping. However, if you can deal with a smaller image, you can view all sorts of information about the image that can tell you whether you nailed the shot. If you're shooting in one of the Auto modes, examining this information helps you become a better photographer.

Getting camera information on the camera LCD monitor is easy. All you need to do is press the Info button. Each time you press the button, the display changes to reveal different information. The image size changes depending on the information shown.

Each time you press the Info button a different set of information appears, as shown in Figure 4-1. The default information shows the shutter speed, aperture, and folder number (in the upper-left corner of Figure 4-1). Press the Info button again to add the file format and the image number out of the total number of images recorded on the card to date (upper right). Press the Info button again to display a histogram with the image, the shooting mode, and other information such as the metering mode, the color profile, and the date and time (lower left). Press the Info button yet again to display a histogram for each color channel (lower right).

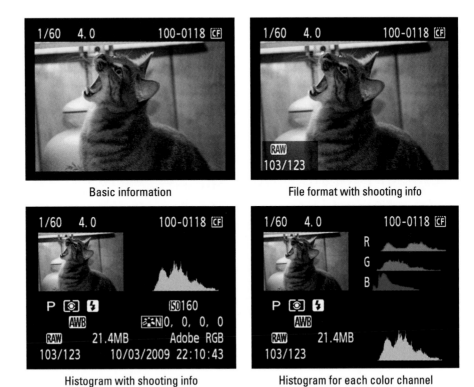

Basic information          File format with shooting info

Histogram with shooting info        Histogram for each color channel

**Figure 4-1:** Press the Info button to review exposure information.

## Using the Histogram

Even though your EOS 7D is a very capable camera, it can get it wrong when you're shooting under difficult lighting conditions. That's why your camera lets you display a histogram (see Figure 4-2) alongside the image on your camera LCD monitor. A *histogram* is a wonderful thing: It's a graph — well actually it looks more like a mountain — that shows the distribution of pixels from shadows to highlights. Study the histogram to decide whether the camera — or you, if you manually exposed the image — properly exposed the image. The histogram can tell you whether the image was underexposed

or overexposed. Notice the sharp spike on the right side of the histogram in Figure 4-2. This indicates that all detail has been lost in some of the highlights. In the case of this image, the setting sun was too bright for the camera settings, even though I used exposure compensation to decrease the exposure by one stop. Your camera can display a single histogram or display a histogram for the red, green, and blue channels (see Figure 4-3).

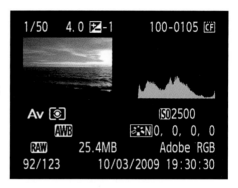

Figure 4-2: Deciphering a histogram.

A peak in the histogram shows a lot of pixels for a brightness level. A valley, however, shows fewer pixels at that brightness range. Where the graph hits the floor of the histogram, you have no data for that brightness range.

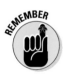

When analyzing a histogram, look for sharp peaks at either end of the scale. If you have a sharp peak on the shadow (or left) side of the histogram, the image is underexposed. Also, if the graph is on the floor of the histogram in the highlight (or right) side, the image is underexposed. However, if a large spike is

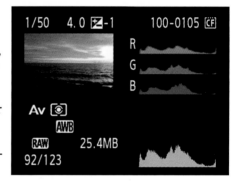

Figure 4-3: Displaying a histogram for each color channel.

right up against the highlight (right) side of the histogram, the image is overexposed and a lot of the details in the image highlights have been blown out to pure white. You can correct for overexposure and underexposure to a degree in your image-editing program, but it's always best to get it right in the camera. If you analyze a histogram and notice that the image is overexposed or underexposed, you can use your camera's exposure compensation feature to rectify the problem. For more information on exposure compensation, see Chapter 6.

 The histogram is a tool. Use it wisely. When you're analyzing a scene that doesn't have any bright highlights, you may end up with a histogram that's relatively flat on the right side. When that happens, judge whether the image on the camera LCD monitor looks like the actual scene. If you rely on the histogram when you see a flat area in the highlights and add exposure compensation, you may make the image brighter than the scene actually was.

## Previewing Your Images

In addition to displaying information with your images, you can display multiple images on the monitor, zoom in to study the image in greater detail, or zoom out. This flexibility makes it easier for you to select a single image from thumbnails, to study the image up close to make sure the camera focused properly, and to ensure that you have a blur-free image.

To preview images on the camera LCD monitor:

1. **Click the Playback button to preview an image.**

   The last image photographed or reviewed displays on the monitor (see Figure 4-4). You can change the information displayed with the image or video by pressing the Info button, as I outline in the "Displaying Image Information" section earlier in this chapter. A movie is designated by an old-fashioned movie camera icon with the duration of the movie shown above the icon. For more information on playing movies, refer to Chapter 5.

   Figure 4-4: Displaying a single image.

2. **Click the AE Lock/Index/Reduce button.**

   Four thumbnails appear on the LCD monitor (see the left image in Figure 4-5). A filmstrip icon appears around a movie when it's shown in thumbnail view.

Figure 4-5: Displaying multiple images as thumbnails.

**3. Click the AE Lock/Index/Reduce button again.**

Nine thumbnails appear on the camera LCD monitor (see the right image in Figure 4-5).

**4. Rotate the Quick Control dial to navigate between images.**

**5. Press the Set button to fill the monitor with the selected image.**

If the image was shot with the camera held vertically, the image doesn't fill the screen unless you enable the menu option to rotate images (see the section, "Rotating Images," later in this chapter).

To modify the view of a single image:

**1. Click the Playback button to preview an image.**

The last image photographed or reviewed displays on the monitor.

**2. Press the AF Point Selection/Magnify button.**

The image is magnified. Each time you press the button, the image zooms to the next highest magnification. A white rectangle indicates the part of the image to which you've zoomed (see Figure 4-6).

**3. Press the multi-controller button to pan to different parts of the image.**

With this button, you can move left, right, up, or down.

Figure 4-6: Zooming in on an image.

**4. Press the AE Lock/Index/Reduce button to zoom out.**

Each time you press this button, you zoom out to the next lowest level of magnification. Eventually you can zoom out until the image fills the monitor. If you press the AE Lock/Index/Reduce button after that, thumbnails display.

# Modifying Image Review Time

You can modify the amount of time the image displays on the LCD monitor after the camera writes it to your memory card. You can set the preview time from 2 to 8 seconds or display the image until you turn off the camera. To modify the image review time:

**1. Press the Menu button.**

**2. Press the multi-controller button right or left to navigate to the Shooting Settings 1 tab.**

**3. Rotate the Quick Control dial to highlight Review Time (see the left side of Figure 4-7).**

**4. Press the Set button.**

The Review Time menu appears showing the options for image review (see the right side of Figure 4-7). The Hold option displays the image until you press the shutter button halfway, navigate to another image, or power off the camera.

When you increase image review time, you decrease battery life.

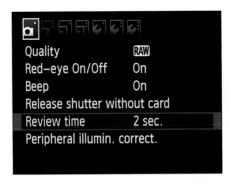
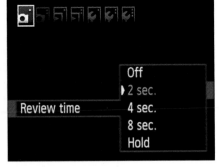

Figure 4-7: Changing image review time.

5. **Highlight the desired option and then press Set.**

The new review options take effect the next time you take a picture.

## Changing Monitor Brightness

Camera LCD monitors have come a long way, baby. The monitor on your EOS 7D offers a brilliant display with lots of pixels; the better to see images with, my dear reader. However at times, the monitor isn't bright enough; for example, when the setting sun is shining brightly waiting for "Sister Moon" (thank you, Sting). You can get some help by shading the monitor with your hand or the brim of a baseball cap. You can also get some assistance from the camera by changing the monitor brightness. You can increase or decrease the default brightness of your monitor in Auto mode. This option is handy when the monitor is too dark or too bright for your taste. You can also adjust the brightness manually.

To change the default monitor brightness in Auto mode:

1. **Press the Menu button and then use the multi-controller button to navigate to the Camera Settings 2 tab (see the left side of Figure 4-8).**

2. **Rotate the Quick Control dial to highlight LCD Brightness and then press the Set button.**

The LCD Brightness menu displays (see the right side of Figure 4-8). In most instances, Auto is perfect, and it's the default selection. You can, however, increase or decrease the relative brightness of your monitor to suit your vision and taste.

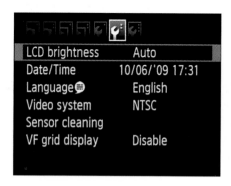
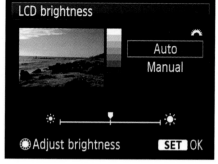

Figure 4-8: LCD brightness options.

**3. Rotate the Quick Control dial to increase or decrease brightness.**

Use this option if the default brightness of the LCD display is too dark or too bright.

**4. Press Set.**

Your changes are applied.

Auto brightness relies on a sensor in front of the camera that monitors the ambient brightness. If you cover this sensor with your finger, the camera adjusts the monitor brightness to compensate for what is perceived as a dark ambient lighting, and the end result probably isn't desirable.

You can also manually change the brightness of your monitor. When you choose the Manual option, the camera doesn't automatically increase or decrease monitor brightness to compensate for ambient lighting. To manually change the brightness of your monitor:

**1. Press the Menu button and then use the multi-controller button to navigate to the Camera Settings 2 tab.**

**2. Rotate the Quick Control dial to highlight LCD Brightness and then press the Set button.**

The LCD Brightness menu displays (see the left side of Figure 4-9).

**3. Rotate the Main dial to highlight Manual and then press Set.**

The options for manually increasing or decreasing monitor brightness display (see the right side of Figure 4-9). You can choose from seven brightness levels.

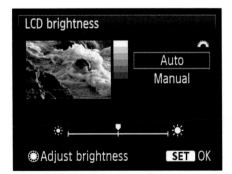 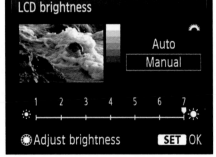

Figure 4-9: Changing the LCD brightness.

4. **Rotate the Quick Control dial to select the brightness level.**

   As you rotate the dial, the thumbnail image gets brighter or darker. As you look at the back of the camera, rotate the dial to the right to make the image brighter, or left to make it darker.

5. **When the thumbnail is easy to see in the current lighting conditions, press Set.**

   Your changes are applied. You may have to manually adjust the monitor again if you take pictures in a brighter or darker environment than what you manually adjusted brightness in.

Making the monitor brighter does sap more juice from your battery, so unless you have a spare battery, increase monitor brightness at your discretion.

# Deleting Images

When you review an image, you decide whether it's a keeper. If while reviewing an image, you don't like the image for any reason, you can delete it. However, deleting images needs to be done with extreme caution because the task can't be undone. After you delete an image from your card, it's gone forever.

To delete a single image:

1. **Press the Playback button repeatedly to navigate to the image you want to delete.**

   Each time you press the button, you display a different image. Sometimes you'll just know that an image is a clunker as soon as it appears on the LCD monitor, which is usually what happens to me. Unless I'm really pressed for time, I examine each image immediately after I shoot it.

   You can also review the images as thumbnails and delete an image. If you decide this is faster, I recommend you press the Set button to fill the monitor with the image before you delete it.

2. **Press the Erase button.**

   The Erase menu appears at the bottom of your monitor (see Figure 4-10). At the risk of being redundant, deleting an image can't be undone. At this stage, you still have the chance to stop this action by highlighting Cancel and then pressing Set.

3. **Rotate the Quick Control dial to highlight Erase and press the Set button.**

The image is deleted.

You can also mark multiple images for deletion. This is similar to deleting a bunch of images in an image-editing program. My opinion: Images should be reviewed on a computer in which you have a bigger screen and it's easier to examine images in detail. Deleting in the camera should be used only for obvi-ous clunkers, such as out-of-focus

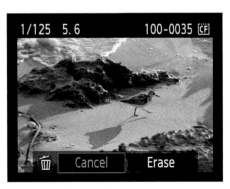

Figure 4-10: Delete images with extreme caution.

images, or when you photographed a moving target like a bird in flight and cut off half his body. But some may find deleting multiple images useful, and you can do so with your EOS 7D. To delete multiple images:

1. **Press the Menu button.**

The last used camera menu displays on the camera LCD monitor.

2. **Rotate the Quick Control dial to highlight the Playback Settings 1 tab.**

3. **Rotate the Quick Control dial to highlight Erase Images and then press the Set button.**

The options for erasing images display on the camera LCD monitor (see the left side of Figure 4-11).

4. **Rotate the Quick Control dial to highlight Select and Erase Images (see the right side of Figure 4-11).**

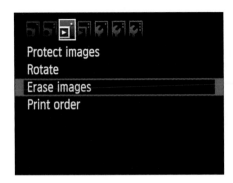

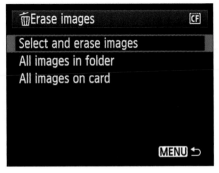

Figure 4-11: Erasing images.

**5. Press Set.**

A single image displays (see the left side of Figure 4-12) on the camera LCD monitor unless you're viewing multiple thumbnails while reviewing. If you are reviewing single images and prefer to view thumbnails while marking images for deletion, press the AE Lock/Index/Reduce button to view three images as thumbnails.

**6. Press Set to mark an image for deletion.**

After you mark an image for deletion, a check mark appears (see the right side of Figure 4-12).

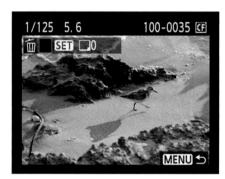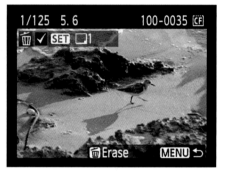

Figure 4-12: Marking images for deletion.

If you're viewing three images as thumbnails, rotate the Quick Control dial to highlight an image and then press Set to mark it for deletion. After you mark a thumbnail for deletion, a check mark appears above it. I prefer to view one image at a time. The thumbnails are too small to give you enough information to determine whether an image needs to be deleted.

If you accidentally select an image for deletion that you don't want to delete, press Set to deselect the image.

If you're viewing thumbnails and want to see the bigger picture before you mark an image for deletion, press the AF Point Selection/Magnify button to display a single image on the monitor. Press the button again to zoom in and then use the multi-controller button to pan to different parts of the image.

**7. Review other images and mark the duds for deletion.**

A check mark appears on the display when you mark an image for deletion. The total number of images you've marked for deletion appears to the right of the word *Set* in the LCD monitor.

8. **Press the Erase button to delete the images.**

   The Erase Images menu displays (see Figure 4-13). At this stage, you still have the chance to back out if you navigate to the Cancel button and press Set.

9. **Rotate the Quick Control dial to highlight OK and then press Set.**

   Faster than a bullet from a gun, the images are toast.

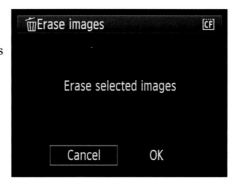

Figure 4-13: Deleting selected images.

Your camera also has menu options to erase all images in a folder or on the card. This type of heavy lifting needs to be done with your computer and not in the camera because erasing images uses battery power. I always review my images after I download them to my computer and do wholesale deletion there. My computer has a bigger monitor in better light and most important, I'm seated in a comfortable chair. After all the heavy work is done on the computer, format the camera card and then you're ready to shoot up a storm.

If you do a lot of work away from your main computer and need to download cards after a day of shooting, consider investing in one of the small netbook computers. You can install your image-editing software on the netbook, download images from a card, and then do some preliminary winnowing and editing. As of this writing, you can purchase a fairly potent netbook for less than $300.

## Rotating Images

Many photographers — me included — rotate the camera 90 degrees when taking a picture of an object that's taller than it is wide. When these images are displayed on the camera LCD monitor, you must rotate the camera 90 degrees to view them in the correct orientation. If you don't like doing this, a menu command will rotate the images for you. After you invoke this command, images display on your monitor in the proper orientation. You can also use a camera menu command to rotate the images when they are downloaded to your computer. To have the camera rotate images automatically:

1. **Press the Menu button and then use the Quick Control dial to highlight the Camera Settings 1 tab.**

2. **Rotate the Quick Control dial to highlight Auto Rotate (see the left side of Figure 4-14) and then press the Set button.**

   The Auto Rotate options display (see the right side of Figure 4-14).

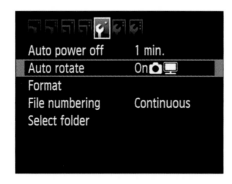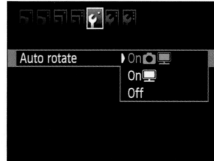

Figure 4-14: Auto-rotating images.

3. **Rotate the Quick Control dial to highlight one of the following options:**

   • *Monitor and computer:* Rotates the image automatically on the camera monitor and when downloaded to the computer.

   • *Monitor only:* Rotates the image automatically on the computer monitor, but not on the camera.

   • *Off:* Images are not rotated.

4. **Press Set.**

   All images taken from this point forward are rotated. Vertical images photographed before invoking this command are not rotated. If you choose to rotate the image when downloaded to your computer and it doesn't rotate, your software can't automatically rotate images from this command. If the camera is pointed up or down, an image photographed with the camera rotated 90 degrees may not rotate automatically.

## Protecting Images

When you photograph a person, place, or thing, you're freezing a moment in time, a moment that may never happen again. Therefore you need to be very careful when you delete images from a card because when deleted, an image is lost forever. That's why I recommend doing the majority of your *winnowing*

(photographer-speak for separating the duds from the keepers) in an image-editing program. However, if you decide to delete lots of your images with camera erase options, you can protect any image to prevent accidental deletion. *Note:* This also protects the image in Canon's image-editing software. This option, however, doesn't protect the image when you format the card. To protect an image:

1. **Press the Menu button and use the multi-controller button to navigate to the Playback Settings 1 tab.**

   Protect Images is the first menu option (see the left side of Figure 4-15).

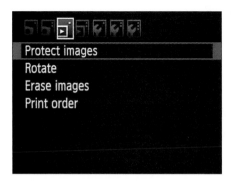

Figure 4-15: Protecting an image from accidental deletion.

2. **Press the Set button.**

   The last viewed image displays on the LCD monitor, with the last display view you selected. Remember, you can view images as thumbnails by pressing the AE Lock/Index/Reduce button.

3. **Rotate the Quick Control dial to navigate to an image you want to protect and then press Set.**

   The image is protected and can't be deleted. A lock icon appears on the screen when an image is protected (see the right side of Figure 4-15). Press Set again to unprotect a protected image.

   You can also protect images while viewing them as thumbnails. Press the AE Lock/Index/Reduce button once to view four thumbnail images or twice to view nine thumbnail images. Rotate the Quick Control dial to navigate to the next set of thumbnails and then use the multi-controller button to navigate to an individual thumbnail. Press Set to protect the highlighted image.

4. **Repeat Step 3 to protect additional images.**

5. **Press the Menu button to return to the main menu.**

The images you've marked enter into the Pixel Protection Program.

Third-party software is available that can rescue images that were deleted accidentally or when a card becomes corrupt. In fact, SanDisk includes rescue software with some of its cards. If you do accidentally delete a keeper, you have to use the software immediately.

## Using the Quick Control Screen

A good idea is to know what all the dials and buttons on your camera do. However, at times in the heat of battle you need to make one or more changes quickly, such as when you want to change image size, enable the 10-second Self-Timer when shooting in Full Auto mode, or change multiple options quickly when shooting with one of the creative shooting modes. So if you're in a New York state of mind and want to change camera settings in a New York minute, follow these steps:

1. **Press the Quick Control button.**

The Quick Control menu appears on your LCD monitor. The display varies depending on which mode you've selected from the Mode dial. Figure 4-16 shows the Quick Control screen when taking pictures in Aperture Priority mode.

2. **Press the multi-controller button right or left to navigate between shooting options, and then rotate the Quick Control dial to change the setting.**

As you rotate the dial, the setting changes. Alternatively, you can press the Set button after you select an option to display a screen showing all options. Figure 4-17 shows the screen that appears for changing ISO speed with the Quick Control screen.

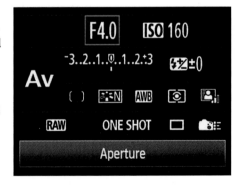

Figure 4-16: Changing shooting options with the Quick Control screen.

3. **Repeat Step 2 for any other setting you want to modify.**

4. **Press the shutter button half-way to exit the Quick Control menu and begin taking pictures with the new settings.**

   Now that was quick and easy, wasn't it?

When you choose Creative Auto from the Mode dial, a similar menu appears on the LCD monitor. For more information about taking pictures in Creative Auto mode, refer to Chapter 2.

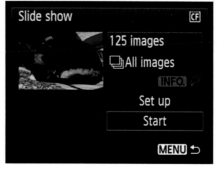

Figure 4-17: Accessing an option for a setting from the Quick Control screen.

## Viewing Images as a Slide Show

If you're the type of photographer who likes to razzle and dazzle yourself and your friends by viewing images you've just shot on the camera LCD monitor — also known as *chimping* because of the noises photographers sometimes make when they see a cool image — you'll love viewing images on the camera LCD monitor as a slide show. To view images as a slide show:

1. **Press the Menu button and use the multi-controller button to navigate to the Playback Settings 2 tab.**

2. **Rotate the Quick Control dial to highlight Slide Show (see the left side of Figure 4-18) and then press the Set button.**

   The Slide Show menu appears (see the right side of Figure 4-18). The default slide show displays all images with a 1-second delay, and the show loops until you exit the slide show. To accept the default slide show options, fast-forward to Step 6.

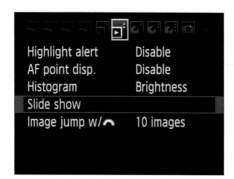

Figure 4-18: Slide show settings — popcorn optional.

3. **To select a different viewing option, rotate the Quick Control dial to highlight All Images and then press Set.**

   Two arrows appear indicating that you have options.

4. **Rotate the Quick Control dial to scroll through the options.**

   The options vary depending on what you've captured on the card and whether you've put images into a different folder. If you have multiple folders, they appear on this menu. Rotate the Quick Control dial to select the desired photos. If you have movies on the card, you can view movies on the camera monitor. You can also view stills in the slide show only.

5. **After choosing an option, press Set.**

   The images or movies display as a slide show after you set up the slide show.

6. **Rotate the Quick Control dial to highlight Set Up and then press Set.**

   The menu changes to display the playback options (see the left side of Figure 4-19).

7. **Highlight Play Time and press Set.**

   The menu changes to show the options for the duration of each slide (see the right side of Figure 4-19).

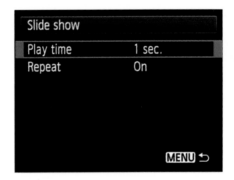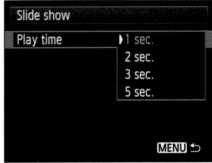

Figure 4-19: Setting playback options for the slide show.

8. **Rotate the Quick Control dial to select a Play Time option and press the Menu button.**

   The previous slide show menu displays.

9. **Rotate the Quick Control dial to Repeat and press Set.**

The Repeat options display (see the left side of Figure 4-20). The default On option repeats the slide show until you press the shutter button halfway or press the Menu button. The Off option plays the slide show once.

10. **After choosing Play Time and Repeat options, press Menu.**

The previous screen displays.

11. **Rotate the Quick Control dial to highlight Start and press Set (see the right side of Figure 4-20).**

The slide show begins.

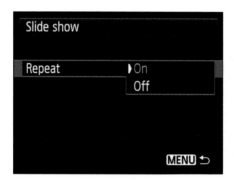 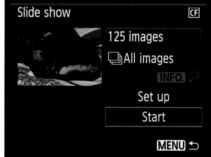

Figure 4-20: Finalizing slide show options.

12. **Press Set to pause the slide show.**

Use this option to examine a single image. You can't magnify an image while in slide show mode. When the slide show is paused, you can rotate the Main dial or Quick Control dial to view a different image. You can press the Info button to show a different display with the image. Pressing Set also pauses a movie that's part of the slide show.

13. **Press Set to continue the slide show.**

When you're tired of watching the slide show or your battery starts running low (auto power-off is disabled when you view a slide show), press the shutter button halfway to return to picture-taking mode. Alternatively, you can press the Menu button to specify different slide show options or to view images in a different folder.

## Viewing Images on a TV Set

You have a digital camera capable of capturing colorful images with an impressive resolution of 18 megapixels. Your television set is a grand medium on which to display your images. You can display still images or a slide show on your TV screen. And if you have a high-definition (HD) television set, you can knock your socks off — and for that matter, the socks of your friends and anybody else within viewing distance — by viewing your precious images onscreen. Video also looks awesome on a television set.

To view your images on a regular TV set:

1. **Open the AV slot on the side of your camera (see Figure 4-21).**

2. **Insert the AV cable supplied with your camera into the AV/Video Out terminal.**

   The Canon logo needs to face the back of the camera for proper insertion.

3. **Connect the other end of the AV cable to your TV set.**

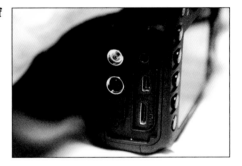

Figure 4-21: Accessing your camera's AV slot.

   The plugs are color-coded. Connect the red and white plugs to the Audio In ports and the yellow plug to the Video In port on your TV set. Refer to your television manual to choose video as the input source.

4. **Press the Playback button.**

   An image displays on your television set.

5. **Rotate the Quick Control dial to view the next image.**

   You can also set up a slide show, as I outline in the section, "Viewing Images as a Slide Show," earlier in this chapter.

To view images on an HD television set:

1. **Open the AV slot on the side of your camera (see Figure 4-21).**

2. **Connect the HDMI cable HTC-100 (sold separately) to the HDMI Out terminal on your camera.**

   The HDMI mini logo needs to face the front of the camera for proper insertion.

3. **Connect the HDMI mini cable to your TV set and then press the Playback button.**

   An image displays on your television set. Images are adjusted for optimal viewing on an HD television set. If your set can't display the captured images, unplug the HDMI cable from the camera and TV set; then connect the AV cable, as I outline in the preceding steps.

4. **Rotate the Quick Control dial to view the next image.**

   You can also set up a slide show, as I outline in the "Viewing Images as a Slide Show" section earlier in this chapter. In fact, if you're viewing single images and decide you want to view them as a slide show, press the Menu button to display the camera menu on your TV screen and then follow the steps in that section.

# Part II
# Beyond Point-and-Shoot Photography

*Y*our EOS 7D is a very advanced camera. If all you do is stay in Full Auto mode, you've overlooked a lot of high power technology that Canon is very proud of. In this part, I show you how to use some of the very cool features of the camera. The camera has Live View, which means you can compose your images through the LCD monitor. You can also capture movies in Live View mode. I show you how to use all the Live View features in this part. I also show you how to use the creative shooting modes to photograph action, wildlife, people, pets, places, and things.

# 5

# Shooting Pictures and Movies with Live View

*P*hotographers who own point-and-shoot cameras use the LCD monitor to compose their pictures, which has some definite advantages. For instance, you can place the camera close to the ground and compose an image through the monitor, or hold the camera over your head to do the same. Digital SLR (single-lens reflex) owners didn't have this option until the Live View mode began popping up on digital SLR cameras. And fortunately for you, your EOS 7D has this option. Live View mode has lots of benefits to shooting, including what you see is what you get. However, Live View mode has a few disadvantages as well. You hold the camera in front of you at arm's length, which, unless you work out at the gym five days a week, can be a bit tiring. Many people use tripods when shooting images and movies using Live View mode.

In addition to taking great pictures in Live View mode, you can also capture high-definition (HD) movies. You can specify the size of the movie and the frame rate. I own an EOS 5D MKII, which can also capture HD video; however, the video features and capabilities on the EOS 7D are far superior to those of my other camera. So if you're ready to go live, read on. In this chapter, I show you how to take pictures, capture movies, and more in the upcoming sections.

# Enabling Live View Shooting

Before you can take pictures using Live View, you have to enable the feature. You do so using a menu command. You can still shoot movies even if Live View shooting is disabled. To enable Live View shooting:

1. **Use the multi-controller button to navigate to the Shooting Settings 4 tab.**

   These are your menu options for Live View shooting.

2. **Rotate the Quick Control dial to highlight Live View Shoot (see the left side of Figure 5-1) and then press the Set button.**

   Your Live View Shoot options display on the camera LCD monitor (see the right side of Figure 5-1).

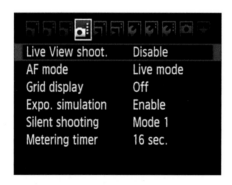
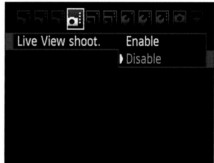

Figure 5-1: Enabling Live View.

3. **Rotate the Quick Control dial to highlight Enable and then press Set.**

   You're now ready to shoot pictures with Live View.

# Taking Pictures with Live View

Live View is the bee's knees when it comes to picture taking. You have a much larger view of your subject and you can compose pictures holding the camera low to the ground — which beats crawling on your belly — or over your head. To take pictures in Live View mode:

1. **Press the Start/Stop button.**

   What's in the lens's field of view appears on the camera monitor.

2. **Press the shutter button half-way to focus the scene (see Figure 5-2).**

   The camera inherits the current autofocus (AF) mode and AF points from standard shooting (see Chapter 7) if you use Live View Quick mode, as shown in Figure 5-2. When you use Live AF mode or Live (Face Detection) AF mode, you use a single autofocus point in the center of the frame. You can use the Quick Control dial to move the AF point in any of the Live View AF modes.

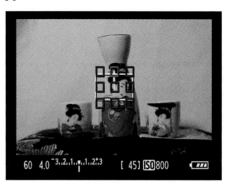

Figure 5-2: Focusing in Live View mode.

   The default autofocus mode works great when shooting in Live View mode, but I prefer using zone focus and specifying the middle zone. You can also specify the type of focusing Live View uses (see the "Focusing with Live View" section of this chapter).

   To display the electronic level while shooting pictures in Live View mode, press the Info button to cycle through the information displays until you see the level.

3. **Press the shutter button fully to take the picture.**

   The LCD monitor displays the image almost immediately. After the designated image-review time, the monitor returns to Live View mode.

4. **Press the Start/Stop button to exit Live View mode.**

   The camera automatically exits Live View mode after the time designated by auto power-off (see Chapter 1).

When you shoot in Live View mode, you hold the camera in front of you. Therefore, you can't hold the camera as steadily as you could when shooting through the viewfinder. Using a lens with image stabilization helps, but if you don't have one, shoot at a higher shutter speed than you normally would. For example, if you're taking pictures in Live View mode with a lens that's the 35mm equivalent of 85mm, use a shutter speed of 1/125 of a second or faster. Otherwise, mount the camera on a tripod.

Shooting images in Live View mode takes a toll on battery life. You'll get anywhere from 210 to 230 images on a fully charged battery depending upon the ambient temperature and the amount of images taken with flash.

When you shoot in Live View mode in hot conditions or in direct sunlight, the internal temperature of the camera increases. A warning icon appears when the internal temperature of the camera is at the danger point. Press the Start/Stop button to stop Live View as soon as you see this warning.

When shooting in Live View mode, don't point the camera directly at the sun. Because the mirror is locked during Live View, exposure to the sun can damage internal components of the camera.

## Displaying shooting information

Shooting information is important to many photographers. When you compose a picture in standard shooting mode, you have a lot of information at your disposal in the viewfinder and on the LCD panel. You can also display information when shooting in Live View mode by pressing the Info button.

Each time you press the button, the screen changes. The default screen shows the autofocus (AF) points without shooting information. Press the Info button once to display the screen, as shown in Figure 5-3.

The first level of information displays the exposure compensation scale, shots remaining on the memory card, the ISO speed setting, and the battery status. Press the shutter button halfway, and the AF points that will focus the image are illuminated in red and the shutter speed and aperture display.

Figure 5-3: Displaying exposure information while shooting in Live View mode.

To view additional information, press the Info button again. The second level of information (see Figure 5-4) displays all the information from the preceding screen with these additions: the Live View AF mode, the image format, exposure simulation, Auto Lighting Optimizer mode, picture style, and white balance. You see additional information if you've enabled features, such as flash exposure bracketing, automatic exposure bracketing, and so on. The flash icon appears if the built-in flash has popped up.

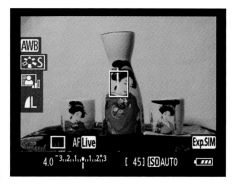

Figure 5-4: Displaying more information.

If you accept the default option of Exposure Simulation, press the button again and a histogram appears (see Figure 5-5). You can use this information to increase or decrease the exposure with exposure compensation.

## Focusing with Live View

When you shoot in Live View mode, you have three focusing options. Two options are used for taking photographs of landscapes and objects, and the other focusing mode is used to detect faces. To specify the autofocus (AF) mode:

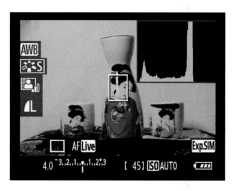

Figure 5-5: Displaying the histogram.

1. **Press the Menu button.**

2. **Use the multi-controller button to navigate to the Shooting Settings 4 tab.**

3. **Rotate the Quick Control dial to highlight AF Mode (see the left side of Figure 5-6) and then press the Set button.**

   The Live View AF mode options display on the camera LCD monitor (see the right side of Figure 5-6).

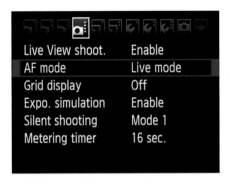 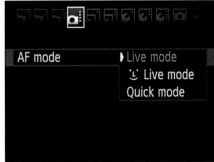

Figure 5-6: Choosing a Live View AF mode.

4. **Use the Quick Control dial to highlight one of the following options:**

   - *Live Mode:* Uses the sensor to focus. This option takes longer to focus than Quick mode.

   - *Live Mode (Face Detection):* Uses the sensor to focus but detects faces.

   - *Quick Mode:* Uses the camera AF sensor to focus the image. As the name implies, this mode is quicker than using the camera sensor. The Live View image momentarily blacks out while the camera achieves focus.

5. **Press Set.**

   The selected focusing mode is used whenever you shoot images with Live View.

After working with the camera, I find that Quick mode does the best job of focusing. Occasionally the Live View modes have problems achieving focus. If you prefer to use one of the Live View focus modes, you find the camera has a difficult time focusing, and you have a lens that lets you focus manually when in autofocus mode, twist the focus ring until the scene is close to being in focus and then the Live View focusing should snap the scene into focus.

To focus the camera while using Live Mode focusing:

1. **Press the Start/Stop button to enable Live View shooting.**

   An autofocus (AF) point appears in the center of the image.

2. **(Optional) Use the multi-controller button to move the AF point.**

Move the AF point over the part of the image that you want the camera to focus.

3. **Press the shutter button halfway.**

   When the camera achieves focus, the AF point turns green and the camera beeps.

4. **Press the shutter button fully.**

   The camera takes the picture.

To focus the camera with Live Mode (Face Detection) focusing:

1. **Press the Start/Stop button to enable Live View shooting.**

   An AF point appears in the center of the image.

2. **Press the shutter button halfway.**

   The camera sensor detects faces in front of the lens by placing a rectangular AF frame over it. When the camera achieves focus, the frame turns green and the camera beeps. If the camera detects multiple faces, an AF frame with a right- and left-pointing arrow appears. Use the multi-controller button to drag the AF frame over the person who's the center of interest and should be in focus.

3. **Press the shutter button fully.**

   The camera takes the picture.

To focus with Quick Mode focusing:

1. **Press the Start/Stop button to enable Live View shooting.**

   An autofocus frame point appears in the center of the image.

2. **Press the shutter button halfway.**

   The AF points for the autofocus point mode you specify for standard shooting appear on the camera LCD monitor. A white frame appears over the AF points. The point used to achieve focus turns red.

3. **(Optional) Use the multi-controller button to move the white autofocus frame.**

4. **Press the shutter button fully.**

   The camera takes the picture.

## Using the Quick Control menu to shoot pictures in Live View mode

When you shoot in Live View mode, you can quickly change the Auto Lighting Optimizer and the image quality through the Quick Control menu. If you're using the Quick Live View autofocus (AF) mode, you can change the AF points as well. To change Live View shooting options with the Quick Control menu:

1. **Press the Start/Stop button to enable Live View shooting and then press the Quick Control button.**

   The Quick Control menu appears on the LCD monitor (see Figure 5-7).

2. **Use the multi-controller button to navigate to and highlight an option.**

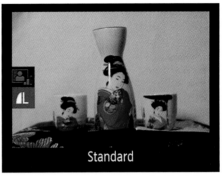

Figure 5-7: Using the Live View picture-taking Quick Control menu.

   The option icon becomes blue. In Figure 5-7, the Auto Lighting Optimizer is highlighted. The current option is Standard, as noted on the bottom of the screen.

3. **Rotate the Quick Control dial to change the option setting.**

   As you rotate the Quick Control dial, you see different icons on the screen. With the exception of the AF points at the bottom of the screen, you see text that describes what the icon represents. For example, if you're changing image quality, you see the format and size displayed.

4. **Use the multi-controller button and the Quick Control dial to change other settings as needed and then press the shutter button halfway.**

   You're ready to start shooting with your new settings.

## Displaying a grid in Live View mode

When shooting in Live View mode, you can display a grid on the LCD monitor. This grid is useful when aligning objects that are supposed to be horizontal or vertical. You can also use the grid when composing your images (see Chapter 7). You have two grids from which to choose: one with 9 squares and

another with 24 squares. To display a grid on the camera LCD monitor when shooting in Live View mode:

1. **Press the Menu button.**

   The previously used menu appears.

2. **Use the multi-controller button to navigate to the Shooting Settings 4 tab.**

3. **Rotate the Quick Control dial to highlight Grid Display (see the left side of Figure 5-8) and then press the Set button.**

   The Grid Display options display (see the right side of Figure 5-8).

4. **Rotate the Quick Control dial to highlight the desired grid.**

   In my opinion, the first grid, with nine squares, is the most useful. This is identical to the Rule of Thirds (see Chapter 8) photographers use when composing images.

5. **Press Set.**

   The selected grid displays in the monitor when you shoot in Live View mode.

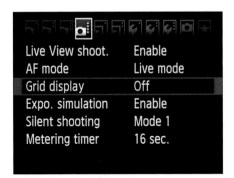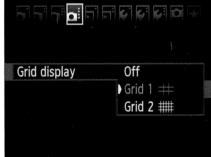

Figure 5-8: Enabling the Live View grid.

## Exploring Other Useful Live View Options

In the previous sections of this chapter, I discuss menu commands that enable Live View shooting, choose a Live View autofocus mode, and display a grid over the LCD monitor while shooting in Live View mode. You may find

other Live View menu options and one custom function (that displays a cropping grid) useful. To take a look at the other options, follow these steps:

**1. Press the Menu button.**

The previously used menu displays.

**2. Use the multi-controller button to navigate to the Shooting Settings 4 tab (see Figure 5-9).**

**3. Rotate the Quick Control dial to review these commands:**

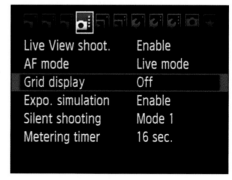

Figure 5-9: Other useful Live View menu options.

- *Expo. Simulation:* This option is selected by default and displays a histogram with one of the shooting information displays. When this command is enabled, Exposure Simulation appears on the LCD monitor when you enable Live View. Press the Info button until you see the histogram. Use the histogram to make sure the image is exposed properly.

- *Silent Shooting:* You have three options from which to choose. Mode 1 is considerably quieter than normal Live View shooting. When you choose this option, you can shoot continuously. If you choose high speed continuous shooting, you can capture images at 7 fps (frames per second). Mode 2 takes one shot when you press the shutter. Camera operation is suspended as long as the shutter button is pressed. When you release the shutter button, camera operation resumes. This mode is quieter than Mode 1. Your third option is to disable silent shooting.

You can enable a custom function that displays a cropping grid on the camera LCD monitor. You can choose a specific aspect ratio that matches the paper upon which you print your images. For example, if you're shooting an image that'll be printed on 8-x-10-photographic paper, you'd use the 4:5 aspect ratio. To display a cropping grid on the camera LCD monitor:

**1. Use the multi-controller button to navigate to the Custom Functions tab.**

**2. Rotate the Quick Control dial to highlight C.Fn IV: Operation/Others (see the left side of Figure 5-10) and then press the Set button.**

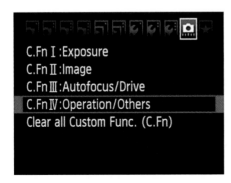 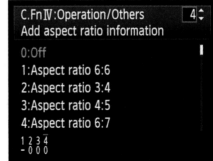

Figure 5-10: Displaying a cropping grid in Live View mode.

The last used Operation/Others custom function displays.

3. **Press the multi-controller button until the number 4 displays in the window on the right side of the menu and then press the Set button.**

The current option displays (see the right side of Figure 5-10). If you haven't used this function before, the Off option is blue.

4. **Rotate the Quick Control dial to select the desired aspect ratio.**

Use the Quick Control dial to scroll down if you don't see the aspect ratio that matches your paper size.

5. **Press Set.**

The highlighted option becomes blue.

6. **Press the shutter button halfway.**

You exit the menu and return to shooting mode. The next time you enable Live View shooting, blue lines designate the aspect ratio. As long as you keep the important information between the lines, it appears in the final image after you crop it in your image-editing application.

## Making Movies with Your Camera

With your EOS 7D, you can create high-definition (HD) video. Your camera records video in Apple's QuickTime MOV format. You can specify the size of the movies you capture and the frame rate. In the following sections, I show you how to capture video and other movie-shooting tasks with your camera.

## Recording movies

Recording movies on your EOS 7D is easy. Flip a switch and push a button and you're recording. And you see the whole movie unfold on the camera LCD monitor. When you've recorded your fill, push the button again to stop recording. You can preview the movie on the camera LCD monitor to decide whether you want to keep it. When recording movies in a shooting mode other than M (Manual), the camera automatically determines the aperture, shutter speed, and ISO speed based on the current ambient lighting conditions. Monaural sound is recorded with your movie unless you disable sound or insert a stereo microphone into the microphone in-port on the side of the camera. To record a movie:

1. **Flip the Live View/Movie Shooting switch to the left.**

   The switch stops at the red icon that looks like a movie camera. The scene in front of your lens displays on the LCD monitor. With all the shooting information displayed, the remaining recording time displays next to the video size and frame rate information.

2. **Press the shutter button halfway to achieve focus.**

   When you record movies, you use one of the Live View autofocus modes that I discuss in the "Focusing with Live View" section earlier in this chapter. If the camera can't achieve focus, switch the lens to manual focus and twist the focusing ring until your subject snaps into focus.

   You can also achieve focus with the AF-On button.

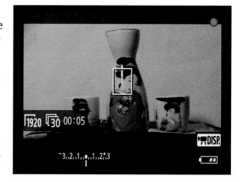

   You can lock exposure to a specific part of the scene you're recording by moving the center autofocus point over the spot that you want to lock focus and then pressing the AE Lock/ Index/Reduce button.

3. **Press the Start/Stop button.**

   A red dot appears in the upper-right corner of the LCD monitor when you're recording (see Figure 5-11), and the elapsed time appears in the lower-left

Figure 5-11: Quiet, numbskulls. You're making a movie here.

corner. A semi-transparent frame appears around the edge of the Live View image. The area inside the frame is what the camera records. Total recording time with a fully charged battery is approximately 1 hour and 20 minutes at 73 degrees Fahrenheit.

To display the electronic level while shooting video in Live View mode, press the Info button to cycle through the information displays until you see the level.

4. **Press the Start/Stop button.**

   Recording stops and the red dot disappears.

## Using manual exposure when recording a movie

You can manually expose your movies to gain complete control. When you manually expose a movie, you can set the shutter speed, aperture, and ISO speed rating. This is useful when you want to control the depth of field in a movie. For example, when you're recording a video of a scenic vista, a small aperture gives you a greater depth of field. When you manually expose a movie, use the exposure compensation scale at the bottom of the LCD monitor as a meter. To manually expose a movie:

1. **Flip the Live View/Movie Shooting switch to the left.**

   Live View video recording is enabled.

2. **Press the Info button until you see the exposure compensation scale in the lower-left corner of the Live View display.**

   Use this scale to get the correct exposure.

3. **Rotate the Mode dial to M.**

   You can manually set exposure in this mode.

4. **Point the camera toward the scene you're going to record.**

5. **Press the ISO/Flash Compensation button and then rotate the Quick Control dial to set the desired ISO speed setting.**

   Choose the lowest possible speed for the lighting conditions while maintaining an acceptable shutter speed.

6. **Rotate the Main dial to set the shutter speed and then rotate the Quick Control dial to set the aperture.**

While setting the shutter speed and aperture, look at the exposure compensation scale. A flashing bar appears below the scale when the exposure isn't perfect. If the bar is to the left of center (as shown in Figure 5-12), you need to increase exposure; if it's to the right, you need to decrease exposure. When the indicator bar is aligned perfectly with the center of the scale, the exposure is perfect for the lighting conditions.

Figure 5-12: Setting exposure manually.

**7. Press the Start/Stop button to start recording video and then press it again to stop recording.**

When you're finished recording, make sure you choose a different shooting mode or manually set exposure for the next scene you're going to record.

## Displaying video shooting information

When recording video, you can display a lot of shooting information, a little information, or no information. You can display the aperture and shutter speed, battery information, exposure compensation scale, autofocus mode, and much more, depending on which information screen you display. To display information when recording movies:

**1. Flip the Live View/Movie Shooting switch to the left.**

Live View movie recording is enabled.

**2. Press the Info button.**

A shooting information screen is displayed.

**3. Press the Info button repeatedly to display different shooting information.**

The first shooting information screen (see the top image in Figure 5-13) displays the focus frame. This is perfect for when you're going commando and want to see every subtle nuance of the scene you're recording. The second shooting screen (middle image) displays the battery information, the number

of shots remaining on the card, the shutter speed, aperture, ISO speed rating, and the exposure compensation scale. The third shooting screen (bottom image) shows everything except the kitchen sink. On this screen, you find all the information on the previous screen plus the auto-focus mode, image recording format, movie size, frame rate, Auto Lighting Optimizer, picture style, and white balance.

## Changing video dimensions and frame rate

Your camera can capture high-definition video with dimensions of up to 1920 x 1080 and a frame rate up to 60 fps. You can modify the video dimensions and frame rate to suit your intended destination. To change video dimensions and frame rate:

1. **Flip the Live View/Movie Shooting switch to the left.**

   You can change video menu options only when video recording is enabled.

2. **Press the Menu button.**

   The last used menu displays.

3. **Use the multi-controller button to navigate to the Shooting Settings 4 tab.**

   Your Live View video recording options display.

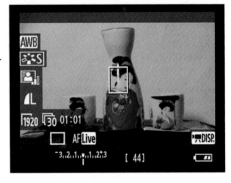

Figure 5-13: You choose how much shooting information to display.

4. **Rotate the Quick Control dial to highlight Movie Rec. Size (see the left side of Figure 5-14) and then press the Set button.**

The video dimension and frame rate options display (see the right side of Figure 5-14).

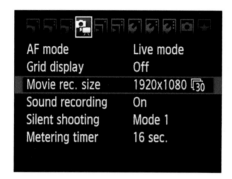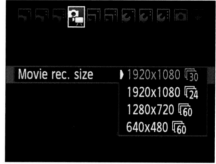

**Figure 5-14:** Changing video dimensions and frame rate.

5. **Rotate the Quick Control dial to select the desired video dimension and frame rate.**

6. **Press Set.**

   You're ready to record video with the specified dimension and frame rate.

Unfortunately, providing details about shooting video is beyond the scope of this book. For more information, check out *Digital Video For Dummies,* 4th Edition, by Keith Underdahl.

## Taking a still picture while recording a movie

You can take a picture while recording a movie. This option is handy when you're making a recording and something interesting happens that you want to save as a still picture. The still image uses the exposure information displayed in the Live View shooting information. The image is the format and quality you specify with the camera menu. To take a still picture while recording a video:

1. **Begin recording a movie.**

2. **Press the shutter button when you see something you want to record as a still image.**

The Live View turns black while the camera takes the picture. You may notice a glitch at that point in the video unless you're using a fast UDMA (Ultra Direct Memory Access) CF card.

## Using the Quick Control menu while shooting movies

You can make a few changes in video settings with the Quick Control menu. The options are limited but useful when you need to change one of the available Quick Control menu options on the fly. To use the Quick Control menu while shooting video:

1. **Flip the Live View/Movie Shooting switch to the left.**

   You're ready to shoot some video, Mr. Spielberg.

2. **Press the Quick Control button.**

   The Quick Control menu options display on the camera LCD monitor (see Figure 5-15). The currently selected option is blue. You can change the following with the Quick Control menu: Auto Lighting Optimizer setting, image format and size, video dimensions, and frame rate.

3. **Use the multi-controller button to highlight an option.**

   The highlighted item turns blue.

4. **Rotate the Quick Control dial to change the setting; then press the shutter button halfway.**

   You're ready to record video with the new settings.

Figure 5-15: Using the Quick Control menu for movies.

# Previewing Movies on the Camera LCD Monitor

You can preview movies in all their glory on the camera LCD monitor. When you preview a movie, buttons appear that let you play the movie at full speed or in slow motion, pause the movie, preview it frame by frame, and navigate to the first or last frame. You can also edit movies in the camera, which I show you how to do in Chapter 11. To preview a movie on the camera LCD monitor:

1. **Press the Playback button to navigate to the desired movie.**

   You can preview images and movies as single images or thumbnails. A movie is designated by an old-fashioned movie camera icon when you view single images (see the left side of Figure 5-16) or with a filmstrip border when you view them as thumbnails.

2. **Press the Set button.**

   Buttons appear beneath the movie (see the right side of Figure 5-16).

Figure 5-16: Previewing your movies.

3. **Rotate the Quick Control dial to select an option.**

   Choose one of the following options (from left to right in Figure 5-16):

   - *Exit:* Exits movie playing mode.
   - *Play:* Plays the movie at full speed.
   - *Slow Motion:* Plays the movie in slow motion.
   - *First Frame:* Rewinds the movie to the first frame.
   - *Previous Frame:* Rewinds the movie to the previous frame.
   - *Next Frame:* Fast-forwards to the next frame.
   - *Last Frame:* Fast-forwards to the last frame.
   - *Edit:* Edits the movie.

4. **Press Set to perform the option you choose in Step 3.**

# Tips for Movie Shooting

Your camera captures awesome video. I've used my EOS 7D to capture some beautiful video from the nearby beaches. I'll send a copy of the video to my relatives who live north of the Mason-Dixon line in January to show them how the other half lives. I've also seen some awesome videos on the Web that were shot with this camera. Here are a few movie-shooting tips:

- For the best results, consider purchasing a high speed UDMA card that writes data at a speed of 8MB per second.

- Don't point the camera directly at the sun when shooting video, which can damage the camera sensor.

- Mount the camera on a tripod; it's hard to hold a camera steady for a long time while recording video. If your tripod has a pan head, you're in business.

- Pan slowly. If you pan too fast, your video looks very amateurish.

- If you plan on doing a lot of video recording with your camera, consider purchasing a device that steadies the camera (such as SteadiCam) while you move. You can find these at your favorite camera retailer that also sells video equipment.

- Remember to push the Start/Stop button when you're finished recording. Otherwise, you get several minutes of very choppy video as you move to the next scene. Worst-case scenario, you capture video of your feet shuffling on the sidewalk.

# 6

# Getting the Most from Your Camera

Your camera has a plethora of features that are designed to enable you to capture stunning images. You can shoot images continuously, which is great for action photography. In fact, the camera has two speeds for continuous shooting. The Hi Speed Continuous mode lets you capture images at up to 8 frames per second (fps), which means you can capture a bunch of images really fast. Your camera also has modes that take you way beyond point-and-shoot photography. When you take photographs with either Aperture Priority (Av) or Shutter

Priority (Tv) mode, you supply one part of the exposure equation and your EOS 7D supplies the other part. Plus you can do all sorts of things to hedge your bet and make sure you get stellar photos from your camera. You can use exposure compensation when you need to tweak the exposure the camera meters. You can also bracket exposure and tweak the white balance.

If you're a geek photographer like me who likes complete control over every aspect of your photography, you'll love the features I show you in this chapter.

## Understanding Metering

Your camera's metering device examines the scene and determines which shutter speed and f-stop combination will yield a properly exposed image. The camera can choose a fast shutter speed and large aperture, or a slow shutter speed and small aperture.

When you take pictures in Full Auto or Creative Auto mode, the camera makes both decisions for you. But you're much smarter than the processor inside your camera. If you take control of the reins and supply one piece of the puzzle, the camera will supply the rest. When you're taking certain types of pictures, it makes sense to determine which f-stop will be best for what you're photographing. In other scenarios, it makes more sense to choose the shutter speed and let the camera determine the f-stop. In the upcoming sections, I show you how to use the creative shooting modes your camera has to offer. In Chapter 8, I show you how to use these modes for specific picture-taking situations.

## Taking Pictures with Creative Modes

You bought an EOS 7D because you're a creative photographer. The Full Auto and Creative Auto shooting modes are useful when you're getting used to the camera. But after you know where the controls are, branch out and use shooting modes in which you control the manner that your images are exposed. In the upcoming sections, I show you how to expose images with the creative shooting modes: P (Programmed Auto Exposure), Av (Aperture Priority), Tv (Shutter Priority), M (Manual), and B (Bulb).

The following list describes each mode in detail:

- **Programmed Auto Exposure mode:** This mode is like stepping out of the kid's pool into the shallow end of the deep pool. The camera still determines what shutter speed and aperture will yield a perfectly exposed image, but you can change the values to suit the type of scene you're photographing.

- **Aperture Priority mode:** When you switch to this mode, you supply the f-stop value (aperture) and the camera determines what shutter speed will result in a perfectly exposed image.

- **Shutter Priority mode:** In this mode, you determine the shutter speed and the camera does the math to determine what f-stop value (aperture) is needed to create a pixel-perfect image.

- **Manual mode:** When you decide to shoot in this mode, you supply the shutter speed and f-stop, but the camera does give you some help in determining whether the combination you provide will yield a perfectly exposed image.

- **Bulb mode:** If you've been a photographer for any length of time, you know that the Bulb mode enables you to shoot *time exposures,* which means the shutter can stay open longer than the slowest shutter speed provided by the camera, which is 30 seconds.

But before you can determine which mode is best for you, you need to understand how exposure works, which is the topic of the next section.

## Understanding how exposure works in the camera

Your EOS 7D exposes images the same way as film cameras did. Light enters the camera through the lens and is recorded on the sensor. The amount of time the shutter is open and the amount of light entering the camera determine whether the resulting image is too dark, too bright, or properly exposed.

The duration of the exposure is the *shutter speed.* Your camera has a shutter speed range from as long as 30 seconds in duration to as fast as 1/8000 of a second. A fast shutter speed stops action, and a slow shutter speed leaves the shutter open for a long time to record images in low-light situations.

The *aperture* is the opening in the lens that lets light into the camera when the shutter opens. You can change the aperture diameter to let a lot, or a small amount, of light into the camera. The *f-stop value* determines the size of the aperture. A low f-stop value (large aperture) lets a lot of light into the camera, and a high f-stop value (small aperture) lets a small amount of light into the camera. Depending on the lens you're using, the f-stop range can be from f/1.8, which sends huge gobs of light into the camera, to f/32, which lets in a miniscule splash of light into the camera. The f-stop also determines the depth of field, a concept I explain in the "Controlling depth of field" section later in this chapter.

The duration of the exposure (shutter speed) and aperture (f-stop value) combination determines the exposure. For each lighting scenario you encounter, several different combinations render a perfectly exposed photograph. Use different combinations for different types of photography. The camera's metering device examines the scene and determines which shutter speed and f-stop combination will yield a properly exposed image. The camera can choose a fast shutter speed and large aperture, or a slow shutter speed and small aperture.

## Using Programmed Auto Exposure mode

When you take pictures with the Programmed Auto Exposure mode, the camera determines the shutter speed and aperture (f-stop value) that yields a properly exposed image for the lighting conditions. Even though this sounds identical to Full Auto mode, with this mode you can change the AF (autofocus) mode, Drive mode, ISO speed, picture style, and more. You can also change the shutter speed and aperture to suit the scene you're photographing. To take pictures in Programmed Auto Exposure mode:

1. **Rotate the Mode dial to P (see Figure 6-1).**

2. **Press the ISO/Flash Compensation button and then rotate the Main dial to change the ISO speed to the desired setting.**

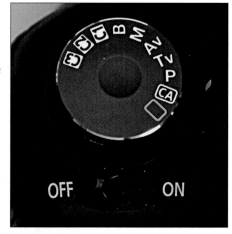

Figure 6-1: Rotating the Mode dial to P.

Higher ISO speeds make the camera sensor more sensitive to light, which is ideal when you're photographing in dim light or at night. For more information on changing ISO speed, see Chapter 7.

3. **Press the shutter button halfway to achieve focus.**

   The green dot on the right side of the viewfinder appears when the camera achieves focus. If the dot is flashing, the camera can't achieve focus and you must manually focus the camera.

4. **Check the shutter speed and aperture.**

   You can use the viewfinder or LCD panel (see Figure 6-2) to check the shutter speed and aperture. If you notice a shutter speed of 8000 and the minimum aperture for the lens blinking, the image will be overexposed. If you notice a shutter speed of 30 seconds and the maximum aperture for the lens blinking, the image will be underexposed.

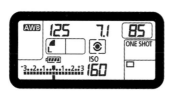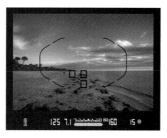

Figure 6-2: Check the shutter speed and aperture.

5. **Press the shutter button fully to take the picture.**

   The image displays almost immediately on your LCD monitor.

You can shift the exposure and choose a different shutter speed and aperture combination. Use this option when you want to shoot with a faster shutter speed to freeze action or a different aperture to control depth of field. To shift the Programmed Auto Exposure:

1. **Follow Steps 1–3 of the preceding instructions; then press the shutter button halfway.**

   The camera achieves focus.

2. **With the shutter button depressed halfway, rotate the Main dial.**

This can be a bit of a juggling act, but is manageable if you use your middle finger to press the shutter button and your forefinger to rotate the Main dial. As you rotate the dial, you see different shutter speed and aperture combinations in the viewfinder and LCD panel (see Figure 6-3). If you notice that the shutter speed is too slow for a blur-free picture, you have to put the camera on a tripod or increase the ISO speed setting.

3. **When you see the desired combination of shutter speed and aperture, press the shutter button fully to take the picture.**

   The image appears almost immediately on your LCD monitor.

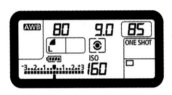 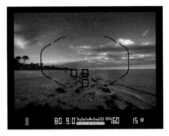

Figure 6-3: You can shift programmed exposure.

## *Using Aperture Priority mode*

If you like to photograph landscapes, Aperture Priority mode is right up your alley. When you take pictures with Aperture Priority mode, you choose the desired f-stop and the camera supplies the proper shutter speed to achieve a properly exposed image. A large aperture (small f-stop value) lets a lot of light into the camera, and a small aperture (large f-stop value) lets a small amount of light into the camera. The benefit of shooting in Aperture Priority mode is that you have complete control over the depth of field (see the "Controlling depth of field" section later in this chapter). You also have access to all the other options, such as setting the ISO speed, choosing a picture style, working in an AF mode or a Drive mode, and so on. To take pictures with Aperture Priority mode:

1. **Rotate the Mode dial to Av (see Figure 6-4).**

2. **Press the ISO/Flash Compensation button and then rotate the Main dial to change the ISO speed to the desired setting.**

When choosing an ISO speed, choose the slowest speed for the available lighting conditions. For more information on changing ISO speed, see Chapter 7.

3. **Rotate the Main dial to select the desired f-stop.**

As you change the aperture, the camera calculates the proper shutter speed to achieve a properly exposed image. The change appears in the LCD panel and the viewfinder. As you rotate the dial, monitor the shutter speed in the viewfinder (see Figure 6-5). If you notice that the shutter speed is too slow for a blur-free picture, you have to put the camera on a tripod or increase the ISO speed setting. If you see the minimum shutter speed (30 seconds) blinking, the image will be underexposed with the selected f-stop. If you see the maximum shutter speed (1/8000 second) blinking, the image will be overexposed with the selected f-stop.

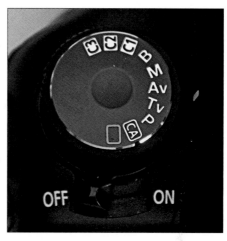

Figure 6-4: Rotating the Mode dial to Av.

Figure 6-5: Make sure the shutter speed is fast enough for a blur-free picture.

4. **Press the shutter button halfway to achieve focus.**

A green dot appears in the viewfinder when the camera achieves focus.

5. **Press the shutter button fully to take the picture.**

   The image appears on your LCD monitor almost immediately.

### Controlling depth of field

*Depth of field* determines how much of your image looks sharp and is in apparent focus in front of and behind your subject. When you're taking pictures of landscapes on a bright sunny day, you want a depth of field that produces an image in which you can see the details for miles and miles and miles . . . Other times, you want to have a very shallow depth of field in which your subject is in sharp focus but the foreground and background are a pleasant out-of-focus blur. A shallow depth of field is ideal when you're shooting a portrait.

You control the depth of field in an image by selecting the f-stop in Aperture Priority mode and letting the camera do the math to determine what shutter speed will yield a properly exposed image. You get a limited depth of field when using a small f-stop value (large aperture), which lets a lot of light into the camera. A fast lens

   ✔ Has an f-stop value of 2.8 or smaller

   ✔ Gives you the capability to shoot in low-light conditions

   ✔ Gives you a wonderfully shallow depth of field

When shooting at a lens's smallest f-stop value, you're letting the most amount of light into the camera, which is known as shooting *wide open*. The lens you use also determines how large the depth of field will be for a given f-stop. At the same f-stop, a wide-angle lens has a greater depth of field than a telephoto lens. When you're photographing a landscape, the ideal recipe is a wide-angle lens and a small aperture (large f-stop value). When you're shooting a portrait of someone, you want a shallow depth of field. Therefore, a telephoto lens with a focal length that is the 35mm equivalent of 85mm with a large aperture (small f-stop value) is the ideal solution.

Figure 6-6 shows two pictures of the same subject. The first image was shot with an exposure of 1/640 second at f/1.8, and the second image was shot with an exposure of 1/80 second at f/10. In both cases, I focused on the subject. Notice how much more of the image shot at f/10 is in focus. The detail of the flowers in the second shot distracts the viewer's attention from the subject. The first image has a shallow depth of field that draws the viewer's attention to the subject.

Figure 6-6: The f-stop you choose determines the depth of field.

## Using depth-of-field preview

When you compose a scene through your viewfinder, the camera aperture is wide open, which means you have no idea how much depth of field you'll have in the resulting image. You can preview the depth of field for a selected f-stop by pressing a button on your camera. To preview depth of field:

1. **Compose the picture and choose the desired f-stop in Aperture Priority mode.**

   See the section, "Using Aperture Priority mode," earlier in this chapter if you need help.

2. **Press the shutter button halfway to achieve focus.**

   A green dot shines solid on the right side of the viewfinder when the camera focuses on your subject.

3. **Press the Depth-of-Field Preview button (see Figure 6-7).**

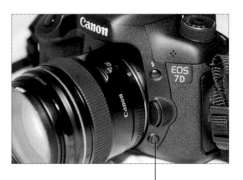

Depth-of-Field Preview button

Figure 6-7: The Depth-of-Field Preview button.

The button is conveniently located on the left-front side of the camera when your camera is pointed toward your subject. You can easily locate the button by feel. When you press the button, the image in the viewfinder may become dim, especially when you're using a small aperture (large f-stop number) that doesn't let a lot of light into the camera. Don't worry, the camera chooses the proper shutter speed to compensate for the f-stop you select.

When you use depth-of-field preview, pay attention to how much of the image is in apparent focus in front of and behind your subject. To see what the depth of field looks like with different f-stops:

   a. *Select what you think is the optimal f-stop for the scene you're photographing.*

   b. *Press the shutter button halfway to achieve focus, as I outline earlier, and then rotate the Main dial to choose different f-stop values.*

   As long as you hold down the Depth-of-Field Preview button while you're choosing different f-stops, you can see the effect each f-stop has on the depth of field.

## Using Shutter Priority mode

When your goal is to accentuate an object's motion, choose Shutter Priority mode. When you take pictures in Shutter Priority mode, you choose the shutter speed and the camera supplies the proper f-stop value to properly expose the scene. Your camera has a shutter speed range from 30 seconds to 1/8000 of a second. When you choose a slow shutter speed, the shutter is open for a long time. When you choose a fast shutter speed, the shutter is open for a short duration and you can freeze action. To take pictures in Shutter Priority mode:

1. **Rotate the Mode dial to Tv (see Figure 6-8).**

2. **Rotate the Main dial to choose the desired shutter speed.**

As you change the shutter speed, the camera determines the proper f-stop to achieve a properly exposed image. If you notice that the shutter speed is too slow for a blur-free picture, you have to put the camera on a tripod or increase the ISO speed setting. If you see the minimum aperture (largest f-stop value) for the lens blinking, the image will be underexposed with the selected shutter speed. If you see the maximum aperture (smallest f-stop number) blinking, the image will be overexposed with the selected shutter speed. If you choose a shutter speed that's

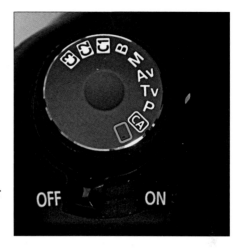

Figure 6-8: Rotating the Mode dial to Tv.

too slow for a blur-free picture, mount the camera on a tripod or choose a higher ISO speed setting.

**3. Press the ISO/Flash Compensation button and then rotate the Main dial to change the ISO speed to the desired setting.**

Choose an ISO setting that enables you to achieve the desired shutter speed. For more information on changing ISO speed, see Chapter 7.

**4. Rotate the Main dial to choose the desired shutter speed.**

As you rotate the dial, the shutter speed value changes on the LCD panel and in the viewfinder. I rarely look at the LCD panel when changing shutter speed or aperture. I like to see my subject while I make the changes.

**5. Press the shutter button halfway to achieve focus.**

A green dot appears in the right side of the viewfinder. If the dot is flashing, the camera can't achieve focus. If this occurs, switch the lens to manual focus and twist the focusing barrel until your subject snaps into focus. Figure 6-9 shows the viewfinder when working in Shutter Priority mode.

**6. Press the shutter button fully to take the picture.**

Shutter Priority mode is the way to go whenever you need to stop action or show the grace of an athlete in motion. You'd use Shutter Priority mode in lots of scenarios. Figure 6-10 shows the effects you

can achieve with different shutter speeds. The image on the left was photographed with a slow shutter speed, and the image on the right was photographed with a fast shutter speed to freeze the action. For more information on using Shutter Priority mode when photographing action, check out Chapter 8.

Figure 6-9: Adjusting the shutter speed.

Figure 6-10: A tale of two shutter speeds.

## Manually exposing images

You can also manually expose your images. When you choose this option, you supply the f-stop value and the shutter speed. You can choose from several combinations to properly expose the image for the lighting conditions. Your camera meter gives you some assistance to select the right f-stop and shutter speed combination to properly expose the image. If you fast-forwarded to this section and don't understand how your camera determines shutter speed and exposure, check out the "Understanding how exposure works in the camera" section earlier in this chapter. To manually expose your images:

1. **Rotate the Mode dial to M (see Figure 6-11) and then rotate the Main dial to set the shutter speed.**

   The shutter speed determines how long the shutter stays open. A slow shutter speed is perfect for a scene with low light. A fast shutter speed freezes action. As you change the shutter speed, review the exposure indicator in the LCD panel, or if you have the shutter button pressed halfway, in the viewfinder. When the exposure is correct for the lighting conditions, the exposure level mark aligns with the center of the scale. If the exposure level mark is to the right of center, the image will be overexposed (see Figure 6-12). If to the left of center, the image will be underexposed. Of course, you're in control. You may want to intentionally overexpose or underexpose for special effects. For example, if you slightly underexpose the image, the colors will be more saturated.

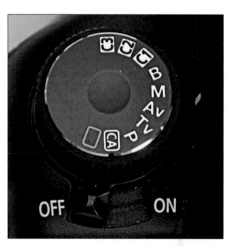

Figure 6-11: Manually exposing the image.

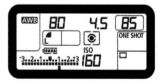

Figure 6-12: Monitor the exposure in the LCD panel.

2. **Rotate the Quick Control dial to set the f-stop value.**

The f-stop value determines how much light enters the camera. A small f-stop value, such as f/2.8, lets a lot of light into the camera and also gives a shallow depth of field. A large f-stop value lets a small amount of light into the camera and gives you a large depth of field. As you change the f-stop value, review the exposure indicator in the LCD panel, or if you have the shutter button pressed halfway, in the viewfinder. When the exposure is correct for the lighting conditions, the exposure level mark aligns with the center of the scale. If the exposure level mark is to the right of the center, the image will be overexposed. If to the left of center, the image will be underexposed.

3. **Press the shutter button halfway to achieve focus.**

   A green dot appears in the viewfinder when the camera has achieved focus. If the dot is flashing, the camera can't achieve focus and you must focus manually.

4. **Press the shutter button fully to take the picture.**

## Shooting time exposures

When you switch to Bulb mode, the shutter stays open as long as you press the shutter button. If you've ever seen night pictures in which you can actually see trails from stars that follow the curvature of the earth, you've seen a photograph that was taken with the Bulb mode. The photographer left the shutter open for a long period of time, and the earth rotated while the photograph was taken. These types of images are known as *time exposures* because the image was exposed over a long period of time. To shoot time exposures:

1. **Mount the camera on a tripod.**

   The lens will be open for a long time. The slightest movement will show up as a blur in the final image. Unless you want the image blurred for a creative effect, you need to stabilize the camera on a tripod.

2. **Rotate the Mode dial to B (see Figure 6-13).**

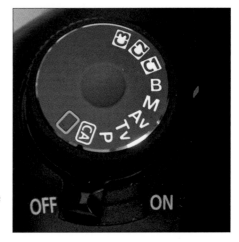

Figure 6-13: Rotate the Mode dial to B to select Bulb mode.

*B* means Bulb mode. Back in the old days of film cameras, photographers would open the shutter with a pneumatic device that looked like a bulb. The shutter opened when the photographer squeezed the device and remained open until the photographer released his grip.

**3. Rotate the Quick Control dial or the Main dial to set the f-stop value.**

A small f-stop value such as f/2.8 (large aperture) lets a lot of light into the camera and gives a shallow depth of field. A large f-stop value (small aperture), such as f/16, lets a small amount of light into the camera and gives a large depth of field. You also need to leave the shutter open longer when using a large f-stop value, which in most instances is desirable. However, a longer exposure can add digital noise to the image. When you have an exposure that leaves the shutter open for several seconds, or perhaps minutes, use an ISO speed setting of 100 to minimize digital noise.

**4. Connect a remote switch to the camera.**

If you hold the shutter button open with your finger, you'll transmit vibrations to the camera, which yields a blurry image. A remote switch, such as the Canon RS-80N3, or a remote timer and switch, such as the Canon TC-80N3, triggers the shutter remotely and no vibration is transmitted to the camera. Both plug into a port on the side of your camera (see Figure 6-14).

**5. Press the button on the remote switch to open the shutter.**

The shutter remains open as long as you hold the button. The time is noted in the LCD panel.

**6. Release the button on the remote switch to close the shutter.**

**7. Review the image on your LCD monitor.**

Insert remote switch here.

I find it useful to take one picture, note

**Figure 6-14:** Attach a Canon remote switch.

the time the lens remained open, and examine the image carefully on the LCD monitor. If I'm not pleased, I take another shot, leaving the lens open longer if the test image is underexposed or for a shorter duration if the test image is overexposed.

Time exposures can be a lot of fun. You can use them to record artistic depictions of headlight patterns on a curved stretch of road (see Figure 6-15) or capture the motion of the ocean at night. The possibilities are limited only by your imagination.

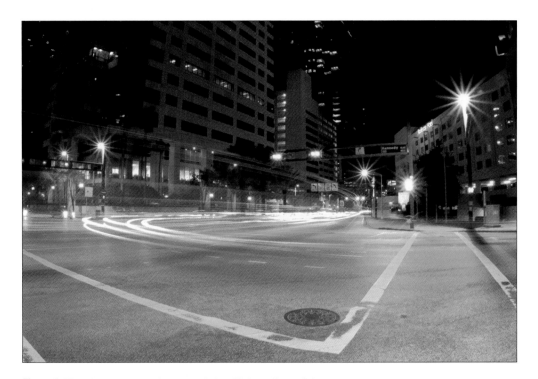

Figure 6-15: A time exposure that records headlight trails at night.

## Modifying Camera Exposure

Your camera has a built-in metering device that automatically determines the proper shutter speed and aperture to create a perfectly exposed image for most lighting scenarios. However, at times, you need to modify the exposure to suit the current lighting conditions. Modify camera exposure for individual shots, or hedge your bets and create several exposures of each shot. You can also lock focus and exposure to a specific location in the scene you're photographing. I show you how to achieve these tasks in the upcoming sections.

## Using exposure compensation

When your camera gets the exposure right, it's a wonderful thing. At times, however, the camera doesn't get it right. When you review an image on the camera LCD monitor and it's not exposed to suit your taste, you can compensate manually by increasing or decreasing exposure. To manually compensate camera exposure:

1. **Choose P, Av, or Tv from the Mode dial (see Figure 6-16).**

   Exposure compensation is available only when you take pictures with Programmed Auto Exposure, Aperture Priority, or Shutter Priority mode.

2. **Rotate the Quick Control dial while holding the shutter button halfway.**

   Rotate the dial counterclockwise to decrease exposure or clockwise to increase exposure. As you rotate the dial, you see the exposure indicator in the viewfinder and LCD panel move, which shows you the amount of exposure compensation you're applying (see Figure 6-17).

3. **Press the shutter button fully to take the picture.**

4. **To cancel exposure compensation, press the shutter button halfway and rotate the Quick Control dial until the exposure indicator is in the center of the exposure compensation scale.**

   You see the exposure compensation scale in the viewfinder and on the LCD panel.

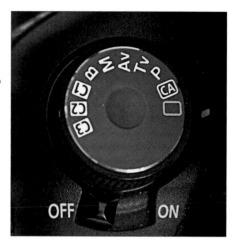

Figure 6-16: Use exposure compensation with these shooting modes.

Figure 6-17: Using exposure compensation.

Exposure compensation stays in effect even after you power off the camera. You can inadvertently add exposure compensation by accidentally rotating the Quick Control dial when you have the shutter button pressed halfway. You can safeguard against this by keeping the Quick Control switch (below the Quick Control dial) in the locked position when you don't need to use the Quick Control dial.

## *Bracketing exposure*

When you're photographing an important event, properly exposed images are a must. Many photographers get lazy and don't feel they need to get it right in the camera when they have programs like Photoshop or Photoshop Lightroom. However, you get much better results when you process an image that's been exposed correctly. Professional photographers bracket their exposures when they photograph important events or places they may never visit again. When you bracket an exposure, you take three pictures: one with the exposure as metered by the camera, one with exposure that's been decreased, and one with exposure that's been increased. You can bracket up to plus or minus 3 EV (exposure value) in ⅓ EV increments. To bracket your exposures:

1. **Press the Menu button.**

   The previously used menu displays.

2. **Use the multi-controller button to navigate to the Shooting Settings 2 tab and then rotate the Quick Control dial to highlight Expo.Comp./ AEB (automatic exposure bracketing).**

   See the left side of Figure 6-18.

3. **Press the Set button.**

   The Exposure Comp./AEB Setting menu appears.

4. **Rotate the Main dial to set the amount of bracketing.**

   When you rotate the dial, a new scale appears below the exposure compensation scale and a line appears on each side of the center of the scale (see the right side of Figure 6-18). Each mark indicates 1/3 f-stop correction.

5. **(Optional) Rotate the Quick Control dial to apply exposure compensation to the settings determined by the camera meter.**

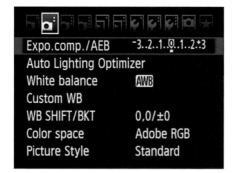
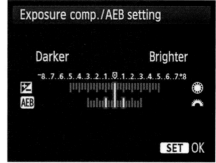

Figure 6-18: Setting automatic exposure bracketing.

This step is optional if you're comfortable with the way the camera has been setting exposure. You can use exposure compensation to increase or decrease the exposure metered by the camera. When you add exposure compensation to the mix, the automatic exposure bracketing (AEB) marks move as well. In other words, the exposure will be increased and decreased relative to the compensated exposure.

**6. Press Set.**

The settings are applied. The Expo.Comp./AEB menu option shows the amount of bracketing and exposure compensation you've applied. The AEB icon appears in the viewfinder and LCD panel (see Figure 6-19).

AEB icon

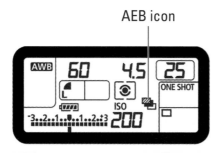
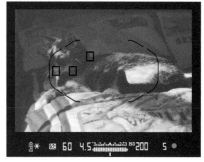

Figure 6-19: These icons appear after you set AEB.

7. **Press the AF-Drive button and rotate the Quick Control dial to choose one of the Continuous Drive modes.**

When I use AEB, I generally use the low speed Continuous mode.

8. **Press the shutter button halfway to achieve focus and then press the shutter button fully.**

When you press the shutter button, the camera creates three images: one with standard exposure, one with decreased exposure, and one with increased exposure. To cancel AEB, turn off the camera.

## Locking exposure

You can also lock exposure on a specific part of the frame, which is handy when you want a specific part of the frame exposed correctly. For example, recently I was photographing a beautiful sunset. The camera meter averaged the exposure for the scene, and the image ended up with blown-out highlights around the sun and clouds that weren't as dark and colorful as I saw them. To compensate for this, I locked exposure on the blue sky, and the picture turned out perfect. To lock exposure:

1. **Look through the viewfinder and move the camera until the center of the viewfinder is over the area to which you want to lock focus.**

2. **Press the AE Lock/Index/Reduce button.**

The autoexposure lock icon appears in the viewfinder (see Figure 6-20).

3. **Press the shutter button halfway to achieve focus.**

A green dot in the viewfinder tells you that the camera has achieved focus. You also see black rectangles that designate the areas on which the camera has focused.

4. **Press the shutter button fully to take the picture.**

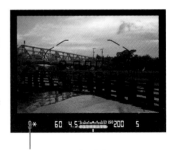

Autoexposure lock icon

**Figure 6-20:** This icon notifies that exposure lock is enabled.

# Locking Focus

You can choose from two ways to lock focus on an object that isn't in the center of the frame: the shutter button or the AF-On button. This option comes in handy when your center of interest isn't in the center of the frame.

To lock focus with the shutter button:

1. **While looking through the viewfinder, move your camera until the center of the viewfinder is over the subject that you want the camera to lock focus on.**

2. **Press the shutter button halfway.**

   Make sure that a black autofocus square appears over your subject. When I'm photographing people who aren't in the center of the frame, I switch to a single autofocus point that's in the center of the frame. For more information on selecting and modifying autofocus points, see Chapter 7. When the camera achieves focus, a green dot appears in the viewfinder.

3. **While holding the shutter button halfway, recompose your picture.**

4. **Press the shutter button fully to take the picture.**

You can also lock focus with the AF-On button on the top of your camera. This is a little easier because you don't have to hold the shutter button halfway while composing your picture. To lock focus with the AF-On button:

1. **Look through the viewfinder and move the camera until the center of the viewfinder is over the subject that you want the camera to lock focus on.**

2. **Press the AF-On button.**

   Red autofocus squares appear momentarily in the viewfinder over the subjects that the camera will lock focus on. The squares turn black after the camera achieves focus. Make sure the autofocus points that display are over the object that you want the camera to lock focus on. I find it useful to switch to a single autofocus point in the center of the frame when I'm photographing a person or subject that isn't in the center.

3. **Move the camera to recompose the picture and then press the shutter button fully.**

   An image appears almost instantaneously on the camera LCD monitor. Review the image to make sure the camera locked focus on the desired object.

## Choosing a Drive Mode

Your camera can capture multiple images when you press the shutter button in the CA (Creative Auto), P (Programmed Auto Exposure), Av (Aperture Priority), Tv (Shutter Priority), or M (Manual) shooting mode. Your camera also has a Hi Speed Continuous mode that captures images at the blindingly fast rate of 8 fps, which is ideal for any situation that requires you to capture a bunch of images in a short period of time. To specify the Drive mode, follow these steps:

1. **Choose one of the following shooting modes from the Mode dial: CA (Creative Auto), P (Programmed Auto Exposure), Av (Aperture Priority), Tv (Shutter Priority), or M (Manual).**

   When you shoot in Full Auto mode, you can capture only a single shot each time you press the shutter button. When you choose Creative Auto, you can shoot continuously at the rate of 3 fps. You can capture images at up to 8 fps when shooting in one of the other aforementioned shooting modes.

2. **Press the AF-Drive button.**

3. **Rotate the Main dial while looking at the LCD panel and then choose one of the following:**

   - *Single Shot:* You capture one picture each time you press the shutter button. (See the left side of Figure 6-21.)

   - *Hi Speed Continuous Shooting:* You can capture up to 8 fps when you press and hold the shutter button. (See the right side of Figure 6-21.)

   - *Low Speed Continuous Shooting:* You can capture up to 3 fps when you press and hold the shutter button. (See the left side of Figure 6-22.)

   - *10-Second Self-Timer/Remote Control:* Starts the 10-Second Self-Timer when you press the shutter button or trigger the shutter with a remote control unit. A light in front of the camera beeps and blinks while counting down. At the 2-second mark, the light stays on and the beeping is faster. (See the right side of Figure 6-22.)

   - *2-Second Self-Timer/Remote Control:* Starts the 2-Second Self-Timer when you press the shutter button or trigger the shutter with a remote control unit. (See Figure 6-23.)

Single shot icon          Hi speed continuous

Figure 6-21: Single Shot and Hi Speed Continuous Drive modes.

Low speed continuous          10-second self-timer

Figure 6-22: Low Speed Continuous and 10-Second Self-Timer
Drive modes.

4. **Take some pictures.**

   The Drive mode you select stays in effect
   until you change it. If you power off the
   camera, the Drive mode still stays in effect.
   Switch back to single shot mode when you no
   longer need to capture images continuously.

2-second self-timer

Figure 6-23: 2-Second Self-
Timer Drive mode.

TIP

The 2-Second Self-Timer is ideal when you're
photographing with the camera mounted to a
tripod. The 2-second delay gives the camera a
chance to stabilize from any vibration that
occurred when you pressed the shutter button.

# Using White Balance Compensation

If you find that images photographed with a custom white balance have
a colorcast, you can apply compensation to remove that colorcast. This
is pretty advanced stuff, so unless you know a lot about color correction,

color temperatures, and so on, stick to AWB (auto white balance) and do any necessary color correction in your favorite image-editing application. But if you're dying to know what it's all about, follow these steps:

1. **Press the Menu button.**

   The previously used menu displays on the camera LCD monitor.

2. **Use the multi-controller button to navigate to the Shooting Settings 2 tab.**

3. **Rotate the Quick Control dial to highlight WB Shift/BKT (see the left side of Figure 6-24) and then press the Set button.**

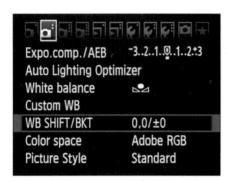
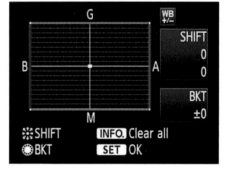

Figure 6-24: Correcting a custom white balance.

The White Balance Correction dialog box appears (see the right side of Figure 6-24). Notice there are four letters: one at the center top (*G* for green), one at the center bottom (*M* for magenta), one at the left center (*B* for blue), and one at the right center (*A* for amber).

4. **Use the multi-controller button to move the dot.**

   You can move the dot toward one color and then move it up or down to shift the white balance toward a combination of amber and green. When you move the dot, the color shift is designated in the dialog box (see Figure 6-25). In this case, the white balance has been shifted two levels toward amber and two levels toward magenta.

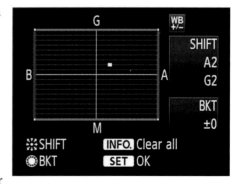

Figure 6-25: Applying a color shift to a custom white balance.

Each level represents five mirids of a color correction filter.

**5. Press Set.**

Your changes are applied.

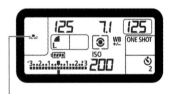

Custom white balance icon

Figure 6-26: White balance compensation in action.

**6. Press the Metering Mode/White Balance button and then rotate the Quick Control dial to select Custom White Balance.**

The custom white balance icon displays on the LCD panel (see Figure 6-26).

**7. Press the shutter button fully to take a picture.**

The color shift is applied to your custom white balance. The colorcast is no more, quoth the raven.

To remove white balance compensation, repeat the preceding Steps 1–3 and then press the Info button.

# *Bracketing White Balance*

If you're the type of photographer who likes to hedge her bets, you may consider using white balance bracketing. When you use white balance, you end up with three images: one with your custom white balance setting, and two that have color shifts applied to them. You can also apply a white balance correction to your custom white balance, which will be the new custom white balance. To bracket a custom white balance:

**1. Press the Menu button.**

The previously used menu displays on the camera LCD monitor.

**2. Use the multi-controller button to navigate to the Shooting Settings 2 tab.**

**3. Rotate the Quick Control dial to highlight WB Shift/BKT (see the left side of Figure 6-27) and then press the Set button.**

The White Balance Correction/Bracketing dialog box appears (see the right side of Figure 6-27).

**4. (Optional) Apply white balance compensation to your custom white balance, as I outline in the preceding section.**

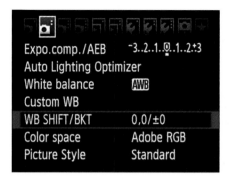
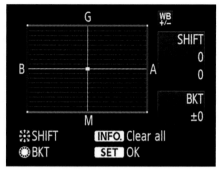

Figure 6-27: Setting up white balance bracketing.

The corrected white balance is the starting point for bracketing.

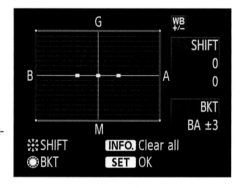

5. **Rotate the Quick Control dial to set bracketing.**

   When you move the dial, two dots appear. Each click of the dial adds another level of bracketing (see Figure 6-28). The bracketing in Figure 6-28 produces one image with a color shift of −3 BA, and one image with a color shift of +3BA.

Figure 6-28: Setting the amount of bracketing.

6. **Press Set.**

   Your changes are applied.

7. **Press the shutter button halfway to return to shooting mode.**

8. **Press the Metering Mode/White Balance button and then rotate the Quick Control dial to select the Custom White Balance option.**

   The custom white balance icon is flashing, which indicates that white balance will be bracketed.

9. **Press the AF-Drive button and then rotate the Quick Control dial to select Low Speed Continuous.**

10. **Press the shutter button halfway to achieve focus and then press the shutter button fully.**

    The camera takes three pictures with the white bracketing you specify.

# Using Custom Functions

Your camera has almost as many custom functions as there are Smiths in the New York City phone book. Well almost. At any rate, I find some custom functions extremely useful. In fact, I've already covered a couple custom functions in earlier chapters. Unfortunately, I'd have to buy my project editor a year's supply of her favorite hair-coloring product if I covered every custom function. In the upcoming sections, I cover the custom functions I think are most important. I leave it to you, dear reader, to explore the other custom functions when the weather's not conducive to photography. But then again, when the weather's bad, you may prefer to try some still-life photography on common household items instead of exploring custom functions.

## Exploring Exposure custom functions

You can choose from seven custom functions to modify exposure. I cover one — C.Fn I: Exposure — in Chapter 7. Other functions enable you to change exposure and ISO increments, but the default settings are just fine. One useful custom function is *Safety Shift.* When you shoot in Aperture Priority or Shutter Priority mode, this function shifts the exposure instantly if the lighting changes dramatically and the subject gets considerably brighter or darker. Here's how to enable it:

1. **Press the Menu button.**

   The previously used menu displays.

2. **Use the multi-controller button to navigate to the Custom Functions tab.**

   C.Fn I: Exposure is first on the hit parade (see the left side of Figure 6-29) unless you've dabbled with another custom function previously.

3. **If C.Fn I: Exposure is not highlighted, rotate the Quick Control dial to highlight the option and then press the Set button.**

   The Exposure custom functions display.

4. **Press the multi-controller button until 6 appears in the window on the right side of the dialog box and then press Set.**

   The default Safety Shift option displays (see the right side of Figure 6-29).

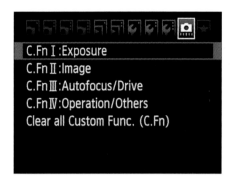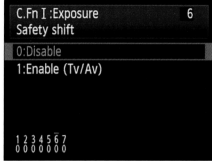

Figure 6-29: The Safety Shift options.

**5. Rotate the Quick Control dial to highlight Enable and press Set.**

The custom function is highlighted in blue and remains in effect until you disable it.

## Exploring Image custom functions

Several custom functions determine what your resulting image looks like. The first two options are for noise reduction. The following looks at each option in detail:

- **C.Fn II: Image Long Exp. Noise Reduction** is off by default. However, if you take pictures with lots of long exposures, you can choose to have this applied automatically when the camera detects noise or leave it on all the time.

- **C.Fn II: Image High ISO Noise Speed Reduction** determines how noise reduction is applied to your images. The following are options that you can choose from:

  - *Standard:* This is the default option for all images.

  - *Strong:* If you do a lot of shooting at high ISO speeds, you may find this option better suited for your photography.

  - *Low and Disable:* The other options are Low and Disable; the former provides low noise reduction, and the latter disables noise reduction for all images.

    I haven't performed extensive tests on these options. Change these custom functions at your discretion and with however many grains of salt you choose.

✓ **C.Fn II: Image Highlight Tone Priority** is very useful if you do a lot of photography in bright conditions. In essence, the camera gives priority to the bright parts of your image, which prevents them from being over-exposed. It also extends the dynamic range.

To enable C.Fn II: Image Highlight Tone Priority:

1. **Press the Menu button.**

   The previously used menu displays.

2. **Use the multi-controller button to navigate to the Custom Functions tab.**

   The last used custom function option is highlighted.

3. **Rotate the Quick Control dial to highlight C.Fn II: Image (see the left side of Figure 6-30) and then press the Set button.**

   The Image custom functions display.

4. **Press the multi-controller button until the number 3 appears in the window and then press Set.**

   The default Highlight Tone Priority Disable option is highlighted (see the right side of Figure 6-30).

5. **Rotate the Quick Control dial to highlight Enable and press Set.**

   The option is displayed in blue. Highlight Tone Priority is in effect until you disable the option or reset all custom functions.

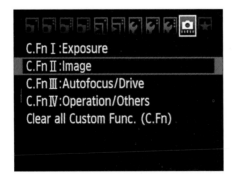 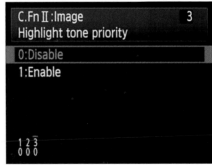

Figure 6-30: Enabling the Highlight Tone Priority custom function.

You can't use ISO expansion when Highlight Tone Priority is enabled. With this custom function, you're limited to an ISO range from 200 to 6400.

## Exploring Autofocus/Drive custom functions

You can use this set of custom functions to modify how the camera handles autofocus, point display, and so on. I've reviewed these options — all 13 of them — extensively and found that the default options are excellent in most cases. The Mirror Lockup custom function is useful if you use a long tele-photo lens. (I discuss this option in Chapter 8.) One option I do find useful for wildlife photographers is the manner in which the camera tracks a moving object in AI Servo autofocus mode (flip to Chapter 8 for this as well).

# Customizing Your Camera

Many of the buttons on your camera can be customized to perform different takes. For example, you can change the task the shutter button performs when you press it halfway. Ten buttons on the camera are customizable. You may find it useful to customize some of these buttons. Instead of going through a long, boring Niagara Falls, slowly-I-turn, step-by-step dissertation on how each button can be customized, I point you in the right direction with this short tutorial. Exploring each option for each button is another good rainy day project. If it's still rainy at night, shoot some reflections of city streets. Just make sure you're under cover when you do it so you don't damage your camera. To customize the buttons on your camera:

1. **Press the Menu button.**

   The previously used menu displays.

2. **Use the multi-controller button to navigate to the Custom Functions tab.**

   The last used custom function option is highlighted.

3. **Rotate the Quick Control dial to highlight the Custom Functions tab.**

   The last used custom functions option is highlighted.

4. **Rotate the Quick Control dial to highlight C.Fn IV: Operations/Others (see the left side of Figure 6-31).**

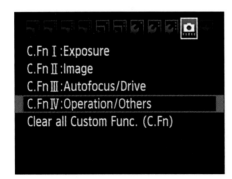 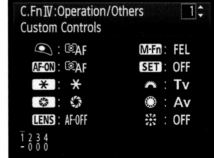

Figure 6-31: Customizing camera controls.

5. **Press the Set button.**

   The C.Fn IV: Operations/Others custom functions display. Custom Controls is the first option (see the right side of Figure 6-31). As you can see, you can customize quite a few buttons. The default option is displayed to the right of the button. For example, the default task performed by the shutter button when pressed halfway is achieving focus automatically. The following steps show you how to customize the button. The steps are similar for the other customizable buttons.

6. **Press Set.**

   The top of the camera is displayed next to the buttons that can be customized (see the left side of Figure 6-32).

7. **Rotate the Quick Control dial to highlight the button you want to customize. For this exercise, leave the shutter button highlighted.**

   When you highlight a customizable button, a dark orange rectangle surrounds it. As you select different buttons, the button is highlighted on the camera. The camera view also changes when you highlight a button that's on the front or back of the camera.

8. **After you highlight a button, press Set.**

   The options for the button display. The right side of Figure 6-32 shows the options for the shutter button. The default task for the button is highlighted with an orange border.

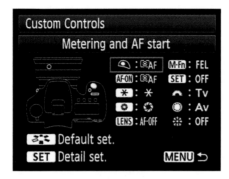
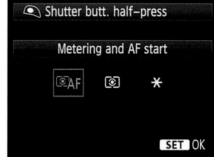

Figure 6-32: Customizing the shutter button.

9. **Rotate the Quick Control dial to highlight the desired option.**

   The task the button performs is listed above the option.

10. **Press Set to finish customizing the button and then repeat Steps 7–10 to finish customizing camera buttons.**

11. **Press the Menu button when you've finished customizing buttons.**

## Clearing Custom Functions

Enabling custom functions and customizing your camera can be quite useful. However, sometimes you get carried away and go over the top. Other times you've experimented with a bunch of custom functions and decide they no longer suit your style of photography. You can wipe out all the custom functions and any changes you've applied to camera buttons by doing the following:

1. **Press the Menu button.**

   The previously used menu displays.

2. **Use the multi-controller button to navigate to the Custom Functions tab.**

   The last used custom function option is highlighted.

3. **Rotate the Quick Control dial to highlight the Custom Functions tab.**

   The last used custom functions option is highlighted.

4. **Rotate the Quick Control dial to highlight Clear All Custom Func. (C.Fn) (see the left side of Figure 6-33) and then press the Set button.**

   A dialog box appears asking you to confirm clearing all custom functions (see the right side of Figure 6-33).

5. **Rotate the Quick Control dial to highlight OK and press Set.**

   Any custom function you've enabled has been cleared.

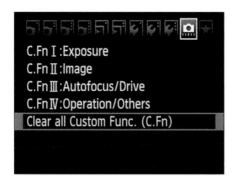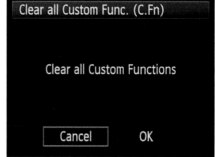

**Figure 6-33:** Clearing all custom functions.

# 7

# Using Advanced Camera Features

## In This Chapter

▶ Keeping tabs on your battery
▶ Optimizing lighting automatically
▶ Choosing a metering mode
▶ Using the grid and level
▶ Modifying autofocusing and metering
▶ Setting white balance
▶ Setting ISO speed
▶ Choosing a picture style
▶ Specifying the color space
▶ Exploring flash photography

*Y*our camera is the next step in digital photography technology: It has lots of features that enable you to take great pictures. When you shoot in one of the creative modes, you can modify lots of things. If the light is a bit dim and you don't feel like flashing your subject, you can increase the ISO speed setting. You can also change the autofocus system to suit your taste and the type of photography you do. You can also change the way the camera meters the scene before you. In short, the sky's the limit when you employ the advanced features of your camera.

To bring you up to speed on all the advanced features you can use, read the sections in this chapter in which I show you how to harness all the cool features.

## *Viewing Battery Information*

Your camera provides gobs of useful information about pictures and camera settings. You also have a *smart battery* powering your EOS 7D. For instance, you can access information about how much charge is left in your battery, how many shutter actuations have occurred since you inserted it, and the battery's condition. View the battery information on your LCD monitor. To check your battery's condition:

1. **Press the Menu button.**

   The last used menu displays.

2. **Use the multi-controller button to navigate to the Camera Settings 3 tab (see the left side of Figure 7-1).**

3. **Rotate the Quick Control dial to highlight Battery Info and then press the Set button.**

   The following battery information displays (see the right side of Figure 7-1):

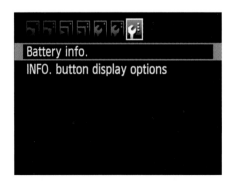
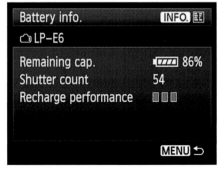

Figure 7-1: Displaying battery information.

- *Model:* Displays the battery model or household power source being used to power the camera.

- *Remaining Cap.:* Displays the remaining power capacity in 1 percent increments.

- *Shutter Count:* Displays the number of shutter actuations for the current battery. When a recharged battery is inserted, the count resets to zero.

- *Recharge Performance:* Displays the recharge performance. Three green squares indicate excellent recharging performance, two green squares indicate the recharging performance is slightly degraded, and one red square indicates poor performance. When you see one red square, think about replacing the battery.

4. **Press the shutter button halfway.**

    You're ready to take pictures.

## Using the Auto Lighting Optimizer

If you capture images in JPEG mode, you can invoke a menu command that gives you better-looking images when you're shooting in dark conditions. Instead of getting a shot with too much contrast, you end up with a brighter shot. This option may add *digital noise* to the image. Digital noise comes in two flavors:

  ✓ **Color:** Shows up as specks of color.

  ✓ **Luminance:** Shows up as random gray clumps.

Digital noise is most prevalent in areas of solid color, such as the dark shadow areas in your image. If you shoot images in the RAW format, you can adjust image brightness with Canon's Digital Photo Professional. To enable the Auto Lighting Optimizer:

1. **Press the Menu button.**

    The previously used menu displays.

2. **Use the multi-controller button to navigate to the Shooting Settings 2 tab.**

3. **Rotate the Quick Control dial to highlight Auto Lighting Optimizer (see the left side of Figure 7-2) and then press Set.**

    The Auto Lighting Optimizer menu displays (see the right side of Figure 7-2).

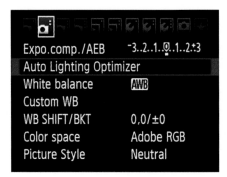
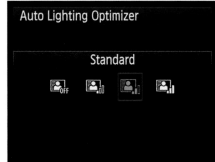

Figure 7-2: Selecting the Auto Lighting Optimizer.

4. **Rotate the Quick Control dial to highlight one of the following options:**

  • *Standard:* The default option adjusts the lighting to create a picture that brightens backlit subjects.

  • *Low:* This option adds a minimal amount of brightness to a backlit subject.

  • *Strong:* This option adds a considerable amount of brightness to a backlit subject.

  • *Disable:* Brightness and contrast isn't corrected when photographing backlit subjects.

When you pause the Quick Control dial over an option, it turns blue and the name displays above the icons.

5. **Press Set.**

  The change is applied, and you return to the Shooting Settings 2 tab.

6. **Press the shutter button halfway to return to take pictures.**

  The Auto Lighting Optimizer setting you choose remains in effect until you select a different option. In some cases, digital noise may be apparent when the Auto Lighting Optimizer is used.

## Correcting Lens Peripheral Illumination

Some lenses have a problem with light falloff toward the edge of the frame. If you've ever taken a picture and noticed that the edges of the image were dark, you've experienced this phenomenon firsthand. The amount of light

falloff depends on the lens you're using. You can, however, go a long way toward correcting this problem with a camera menu command. This feature is available only for Canon lenses. The peripheral illumination data is stored in the camera's database. To enable peripheral illumination:

1. **Press the Menu button.**

   The previously used menu displays on the camera LCD monitor.

2. **Use the multi-controller to navigate to the Shooting Settings 1 tab (see the left side of Figure 7-3).**

3. **Rotate the Quick Control dial to highlight Peripheral Illumin. Correct and then press the Set button.**

   The Peripheral Illumin. Correct options display (see the right side of Figure 7-3). If you have a Canon lens attached to the camera and data for the lens is in the camera's database, this information is noted in the dialog box. If a third-party lens is attached to the camera, a message appears telling you correction data isn't available.

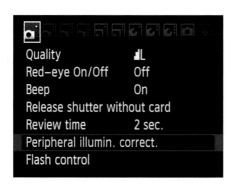
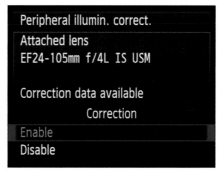

Figure 7-3: Enabling Lens Peripheral Illumination Correction.

4. **Rotate the Quick Control dial to highlight Enable and then press Set.**

   After using this command, your camera automatically corrects for any lens that has problems with light falloff at the edge of the frame. This option's effectiveness depends on the lens used, the f-stop, and the lighting conditions.

5. **Press the shutter button halfway.**

   You're ready to start shooting with Lens Peripheral Illumination Correction enabled.

## Choosing a Metering Mode

When you press the shutter button halfway, your camera meters the scene you photograph to determine the optimal exposure settings. The default metering mode (Evaluative) works well for most lighting conditions. When you shoot in Full Auto or Creative Auto mode, the Evaluative metering mode is used. To change the metering mode to suit different lighting and picture-taking situations:

1. **Press the Metering Mode/White Balance button on the top of your camera.**

   This button is in front of the LCD panel and to the left when you point the camera toward your subject.

2. **Rotate the Main dial to choose one of the following metering options:**

   • *Evaluative:* This is the default mode for your camera. You can use this mode for most of your work, including backlit scenes. The camera divides the scene into several zones and evaluates the brightness of the scene, direct light, and backlighting, factoring these variables to create the correct exposure for your subject.

   • *Partial:* This mode meters a small area in the center of the scene. This option is useful when the background is much brighter than your subject. A perfect example of this is a beach scene at sunset when you're pointing the camera toward the sun and your subject is in front of you.

   • *Center-Weighted Average:* This metering mode meters the entire scene, but gives more importance to the subject in the center. Use this mode when one part of your scene is significantly brighter than the rest; for example, when the sun is in the picture. If your bright light source is near the center of the scene, this mode prevents it from being overexposed.

   • *Spot:* This mode meters a small area in the center of the scene. Use this mode when your subject is in the center and is significantly brighter than the rest of your scene. Your camera may have the option to spot-meter where the autofocus frame is. If your camera can move the autofocus frame to your subject, you can accurately spot-meter a subject that isn't in the center of the frame.

# Displaying the Grid

The *grid* is a visual reference that appears in your camera monitor. Use the vertical and horizontal lines on the grid to ensure your camera is straight. When the gridlines are aligned with lines in the scene that you know should be vertical or horizontal, the resulting image looks correct. To display the grid:

1. **Press the Menu button.**

   The last used menu displays on the camera LCD monitor.

2. **Use the multi-controller button to navigate to the Camera Settings 2 tab.**

3. **Rotate the Quick Control dial to highlight VF Grid Display (see the left side of Figure 7-4).**

4. **Press the Set button.**

   The VF Grid Display options display in the camera LCD monitor (see the right side of Figure 7-4).

Figure 7-4: Enabling the viewfinder grid.

5. **Rotate the Quick Control dial to highlight Enable and press Set.**

   The option text is highlighted in blue.

6. **Press the shutter button halfway.**

   You're ready to take pictures with the grid displayed in your viewfinder (see Figure 7-5).

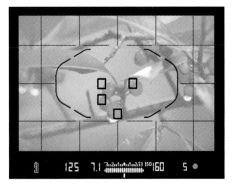

Figure 7-5: Using the VF Grid Display.

## Using the Electronic Level

The electronic level enables you to take pictures with your camera level and plumb. This ensures that the camera isn't tilted right or left, or up or down. The end result is you get images that look correct and not like they were photographed by a drunken sailor. When you're not shooting in Live View mode, the electronic level is most useful when you have the camera mounted on a tripod. To display the electronic level on your LCD monitor:

1. **Mount your camera on a tripod.**

   You can also use the electronic level when handholding the camera. However, it's more difficult to get accurate results, and you can't hold the camera as steady because it's away from your body.

2. **Press the Info button twice.**

   The electronic level displays on your LCD monitor. The left side of Figure 7-6 shows what the level looks like when the camera isn't level horizontally and not plumb.

3. **Adjust the legs of your tripod until a solid green line appears in the center of the level.**

   This tells you the camera is level and plumb (see the right side of Figure 7-6).

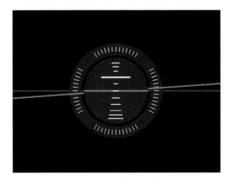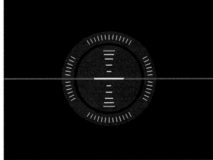

Figure 7-6: A level camera is a wonderful thing.

## Choosing the Autofocus Mode

Your camera focuses automatically on objects that intersect autofocus points. You have three autofocus modes on your camera. One is ideally suited for still objects, and another is ideally suited for objects that are

moving. You have yet a third autofocus mode, which is chameleon; you use it for still objects that may move. To choose an autofocus mode:

1. **Press the AF-Drive button on top of your camera and directly in front of the LCD panel.**

   Figure 7-7 shows the LCD panel as it appears when you're using One-Shot mode.

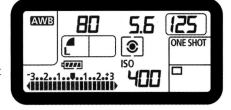

Figure 7-7: Photographing in One-Shot AF mode.

2. **Rotate the Main dial while viewing the LCD panel to select one of the following autofocus modes:**

   - *One-Shot:* Use this autofocus mode for objects that don't move. It's ideally suited for shooting portraits and landscapes.

   - *AI Focus:* Use this autofocus mode for objects that are stationary but may begin to move. The camera locks focus using One-Shot but switches to AI Servo if the subject starts moving. This option is ideally suited for macro photography of objects like flowers on a windy day. Figure 7-8 shows the LCD panel when you're shooting in AI Focus mode.

   - *AI Servo:* Use this autofocus mode for objects in motion. After the camera locks focus on the object, the camera updates the focus as the subject moves. This mode is ideally suited for objects that are moving toward or away from you. Figure 7-9 shows the LCD panel when you're shooting in AI Servo mode.

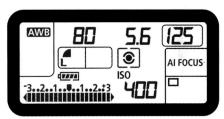

Figure 7-8: Photographing in AI Focus mode.

None of the autofocus modes are effective on fast-moving objects, such as racecars or airplanes. To capture blur-free shots of objects like these that move toward or away from you, switch the lens to manual focus and then focus on a spot your

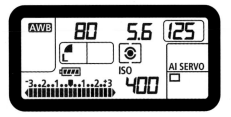

Figure 7-9: Photographing in AI Servo mode.

subject will cross. Press the shutter button shortly before your subject reaches the point on which you have focused. The amount of time varies depending on how fast your subject is moving.

# Using the M-Fn Button to Change Autofocus Points

The M-Fn button makes it possible to switch between autofocus point modes. The default autofocus mode uses 19 points to determine autofocus. You can switch to a single autofocus point when you need the camera to focus on a specific point in the frame. You can also switch to an autofocus zone that uses several autofocus points within a zone. I cover the single-point autofocus and zone autofocus in upcoming sections. However, I familiarize you with the M-Fn button here so you can switch between the default autofocus mode to zone or single autofocus zones at Will — whoever he was. To switch between autofocus point selection modes:

1. **Press the AF Point Selection/ Magnify button.**

2. **While looking in the view-finder, press the M-Fn button.**

   The default autofocus mode with 19 autofocus points displays in your viewfinder (see Figure 7-10).

3. **Press the M-Fn button again.**

   The autofocus mode that enables you to select a single autofocus point displays in your viewfinder (see Figure 7-11).

4. **Press the M-Fn button again.**

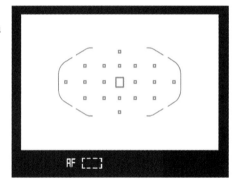

Figure 7-10: The default autofocus points.

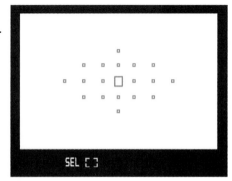

Figure 7-11: Selecting a single autofocus point.

The display changes to reflect zone autofocus points (see Figure 7-12).

# Changing the Autofocus Point

By default, your camera displays 19 autofocus points. The camera focuses on subjects that intersect these grid points. The default number of autofocus points works fine for most picture-taking situa-

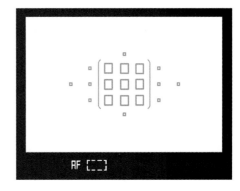

Figure 7-12: Selecting zone autofocus.

tions. However, at times, it makes sense to switch to a single autofocus point that you align with a single object. This option is useful when you want to focus selectively on a single subject in a scene that has other objects that the camera may lock focus on. Your camera also has the option to switch to an autofocus group. To change the autofocus point:

1. **Press the AF Point Selection/Magnify button.**

2. **While looking at the viewfinder, press the M-Fn button until you see a single autofocus point in the center surrounded by several smaller points.**

   This indicates the other possible points on which you can focus from.

3. **Press the multi-controller button to navigate to the desired autofocus point.**

   You can navigate to any of the autofocus targets (the small red squares) to designate the point from which the camera will focus. Figure 7-13 shows one of the side autofocus points selected. The camera focuses on an object under that autofocus point.

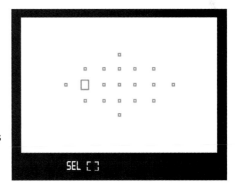

Figure 7-13: Choosing an autofocus point.

4. **Press the shutter button halfway.**

You're ready to take pictures with a single autofocus point. The auto-focus point is the default autofocus point until you use the AF Point Selection/Magnify button to designate another autofocus point, or you use the AF Point Selection/Magnify button in conjunction with the M-Fn button to select the default autofocus or zone autofocus option.

## Using Zone Autofocus

Zone autofocus lets you use several autofocus points that are in a zone. The camera focuses on any object that's directly beneath an autofocus point in the zone you specify. The camera has five autofocus zones located in the following areas: left side with four autofocus points, top center with four autofocus points, middle with nine autofocus points, bottom center with four autofocus points, and right side with four autofocus points. I find the middle zone is great for many picture-taking tasks, including portrait photography. To choose an autofocus zone:

1. **Press the AF Point Selection/Magnify button.**

2. **While looking at the view-finder, press the M-Fn button until you see nine autofocus points in the center surrounded by two brackets.**

This is the middle autofocus zone.

3. **Press the multi-controller button to select the desired autofocus zone.**

Figure 7-14 shows the top center autofocus zone selected. The zone you select remains in effect until you change it or switch to the default display.

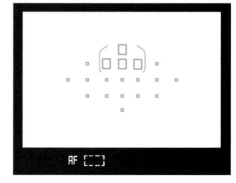

Figure 7-14: Choosing an autofocus zone.

## Choosing a Picture Style

When you photograph a scene or image, your camera sensor captures the colors and subtle nuances of shadow and light to create a faithful rendition of the scene. At times, however, you want a different type of picture. For

example, when you're photographing a landscape, you want vivid blues and greens in the image. You can choose from a variety of picture styles and create up to three custom picture styles. When you take pictures in Full Auto mode, this option isn't available. To choose a picture style:

1. **Press the Picture Style button.**

   The Picture Style options appear on your LCD monitor. Figure 7-15 shows the Standard picture style.

2. **Rotate the Quick Control dial to choose one of the following styles:**

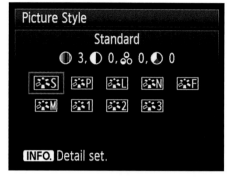

Figure 7-15: Choosing a Picture Style option.

   - *Standard:* The default style captures crisp, sharp images and is suitable for most photography situations.

   - *Portrait:* This style renders a soft image with flattering skin tones. This style is ideally suited for portraits of women and children.

   - *Landscape:* This style renders an image with vivid blues and greens. Landscape is ideally suited for — you guessed it — landscapes. I love truth in advertising.

   - *Neutral:* This style renders an image with no in-camera enhancement and is ideally suited for photographers who will be editing and enhancing their images with a computer image-editing application, such as Photoshop or Photoshop Lightroom. The resulting image has natural colors.

   - *Faithful:* This is another style ideally suited for photographers who like to edit their images with a computer image-editing application. When you photograph a subject in daylight with a color temperature of 5200K, the camera automatically adjusts the image color to match the color of your subject.

   - *Monochrome:* This style creates a black and white image. If you use this style and choose JPEG as the file format, you can't convert the image to color with your computer. If you use this style when using the JPEG format, make sure you switch back to one of the other picture styles when you want to capture images with color again.

   - *User-Created Styles:* These slots are for styles you've created. I show you how to create custom picture styles in Chapter 11.

Figure 7-16 shows a comparison of the different picture styles.

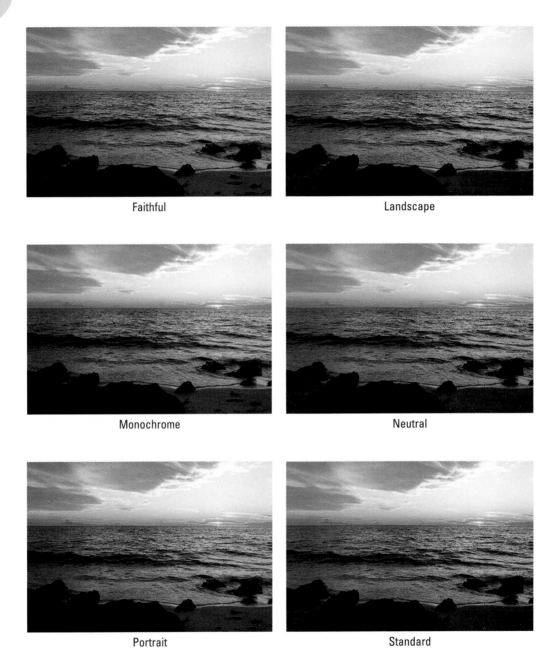

Figure 7-16: A comparison of the picture styles.

# Specifying the Color Space

Several color spaces are used in photography and image-editing applications. The *color space* determines the range of colors you have to work with. The default color space (sRGB) in your camera is ideal if you're not editing your images in an application like Photoshop or Photoshop Lightroom. However, if you do edit your images in an image-editing application and want the widest range of colors (also known as *gamut*) with which to work, you can specify Adobe RGB. To specify the color space that your camera records images with, follow these steps:

1. **Press the Menu button.**

   The last used menu displays.

2. **Use the multi-controller button to navigate to the Shooting Settings 2 tab (see the left side of Figure 7-17).**

3. **Rotate the Quick Control dial to highlight Color Space and then press the Set button.**

   The Color Space menu displays (see the right side of Figure 7-17).

4. **Rotate the Quick Control dial to highlight one of the following:**

   - *sRGB:* The default color space is ideal if you don't edit your images or do minimal editing.

   - *Adobe RGB:* Use this color space if you're editing your images in an application, such as Photoshop or Photoshop Lightroom.

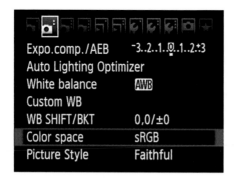
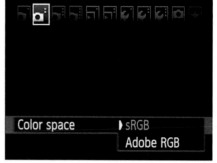

Figure 7-17: Choosing a color space.

**5. Press the shutter button halfway.**

You exit the menu and are ready to shoot pictures with your desired color space.

After you edit images that were created with the Adobe RGB color space, you must convert them to sRGB in your image-editing application before printing them or displaying them on the Web. For more information, see a *For Dummies* book about the software application you're using to edit your work.

## Setting White Balance

The human eye can see the color white without a colorcast no matter what type of light the white object is illuminated with. Your digital camera has to balance the lighting in order for white to appear as white in the captured image. Without white balance, images photographed with fluorescent light have a green colorcast and images photographed with tungsten light sources have a yellow/orange colorcast. Yup, your subject would be "green around the gills," or have some other ghastly colorcast, depending on the light sources used to illuminate the scene.

Your camera automatically sets the white balance, or you can choose a white balance setting to suit the scene you're photographing. You can also change white balance when you want to create an image with some special effects. If you shoot images with the RAW format and inadvertently choose the wrong white balance setting or your camera doesn't get it right, you can change the white balance setting in an application like Photoshop or Canon's Digital Photo Professional. To set white balance:

**1. Press the Metering Mode/ White Balance button.**

**2. Rotate the Quick Control dial while looking at your LCD panel (see Figure 7-18) and choose one of the following white balance options:**

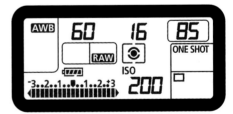

Figure 7-18: Choosing a white balance option.

- *Auto White Balance:* The camera automatically sets the white balance based on the lighting conditions.

- *Daylight:* Use this option when photographing subjects on a bright, sunny day.

- *Shade:* Use this option when photographing subjects in shaded conditions.

- *Cloudy:* Use this option when photographing subjects on a cloudy day.

- *Tungsten:* Use this option when photographing subjects illuminated by tungsten light.

- *White Fluorescent:* Use this option when photographing subjects illuminated by fluorescent lights.

- *Flash:* Use this option when photographing subjects with the on-camera flash or an auxiliary flash unit.

- *Custom:* Use when creating a custom white balance. See the "Creating a Custom White Balance" section later in this chapter.

- *K:* Use when using a color temperature specified with a menu command. See the next section, "Specifying Color Temperature."

# Specifying Color Temperature

If you use studio lighting, you can set the color temperature to the same temperature as the light emitted from your strobes. Color temperature is measured on the Kelvin scale. You can easily set the color temperature for the camera white balance to match the color temperature of your studio lights with a menu command. To specify a color temperature:

1. **Press the Menu button.**

2. **Use the multi-controller button to navigate to the Shooting Settings 2 tab.**

3. **Rotate the Quick Control dial to highlight White Balance (see the left side of Figure 7-19) and then press the Set button.**

The White Balance menu appears on the LCD monitor.

**4. Rotate the Quick Control dial to highlight K and then rotate the Main dial to specify the color temperature (see the right side of Figure 7-19).**

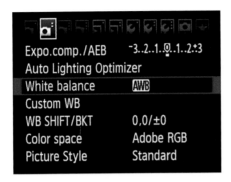
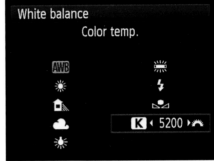

Figure 7-19: Specifying the color temperature.

The K white balance icon appears on the LCD panel (see Figure 7-20), and the specified color temperature is used whenever you choose the K option for white balance.

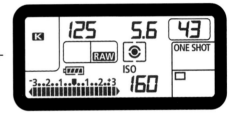

Figure 7-20: Using the K white balance mode.

## Creating a Custom White Balance

When you photograph a scene that's illuminated with several different light sources, your camera may have a hard time figuring out how to set the white balance. And if the camera has a hard time, chances are you can't use one of the presets to accurately set the white balance. You can, however, set a custom white balance by following these steps:

**1. Photograph a white object.**

Photograph the object under the light source that will be used to illuminate your scene. Photograph something that's pure white, such as a sheet of paper without lines. You won't get accurate results if you photograph

something that's off-white. You'll also get better results if you use the Neutral picture style. If you use the Monochrome picture style, you can't obtain a white balance reading.

*Note:* Some papers contain optical brighteners. If you use one of those to set your white balance, your images may be a little warmer (more reddish-orange in color) than normal.

You can purchase an 18-percent gray card from your favorite camera retailer and use this in place of a white object in Step 1. The 18-percent gray card gives you extremely accurate results.

2. **Use the multi-controller button to navigate to the Shooting Settings 2 tab and then rotate the Quick Control dial to highlight Custom WB (see the left side of Figure 7-21).**

3. **Press the Set button.**

   The image you just photographed displays onscreen (see the right side of Figure 7-21).

4. **Press Set.**

   A dialog box appears asking you to confirm that you want to use the image to set the white balance (see the left side of Figure 7-22).

5. **Rotate the Quick Control dial to highlight OK and press Set.**

   The camera calculates the color temperature for the light source. After the camera completes the calculation, a dialog box appears asking you whether you want to assign the color temperature derived from the calculation to the custom white balance setting (see the right side of Figure 7-22).

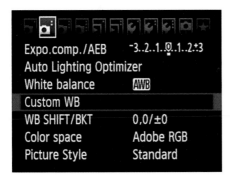

Figure 7-21: Setting a custom white balance.

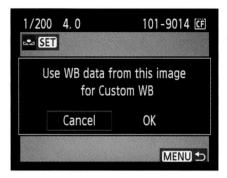 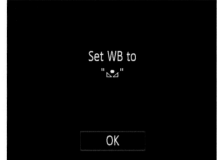

Figure 7-22: Finalizing the custom white balance.

6. **Rotate the Quick Control dial to select OK and then press Set.**

7. **When the menu reappears, press the Menu button to exit the Custom White Balance menu and then press the Metering Mode/White Balance button.**

8. **While viewing the LCD panel, rotate the Quick Control dial to select Custom White Balance (appears in a rounded rectangle on the left side of Figure 7-23).**

   Your custom white balance is used to determine white balance until you select a different white balance option.

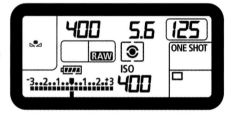

Figure 7-23: Creating a custom white balance.

The custom white balance remains in effect and is used whenever you select the Custom White Balance option. You can register only one custom white balance. When you encounter a different lighting scenario that requires a custom white balance, repeat these steps.

## Setting the ISO Speed

The ISO speed determines how sensitive your camera sensor is to light. When you specify a high ISO speed, you can capture images when in dark conditions. When you specify a high ISO speed, you run the risk of adding digital noise to your images. When you specify a higher ISO speed, you also extend the range of the camera flash. To change the ISO speed:

1. **Press the ISO/Flash Compensation button.**

2. **Rotate the Main dial to specify the ISO setting while viewing the LCD panel to see the settings as you rotate the dial.**

The default ISO for the camera is A (Automatic). You can choose an ISO setting from 100 to 6400 or use the extended ISO range (see the following section, "Extending the ISO Range"). Figure 7-24 shows the LCD panel after setting the ISO to 640.

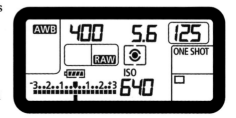

Figure 7-24: Choosing the ISO setting.

# Extending the ISO Range

Your camera has an ISO range from 100 to 6400. However, if you take pictures in very dark places and don't want to use flash, you can extend the ISO range to 12800. This setting creates digital noise in shadow areas. Before deciding whether the extended ISO range is useful for your photography, I suggest taking some test shots with this setting at night in an area that has lights and areas of complete shadow. Examine the images on your computer and zoom to 100-percent magnification. Pan to areas with lots of shadow and look for evidence of digital noise, which will show up as clumps of gray (*luminance* noise) or random areas of colored specks (*color* noise). To extend the ISO range:

1. **Use the multi-controller button to navigate to the Custom Functions tab.**

2. **Rotate the Quick Control dial to highlight c.Fn I: Exposure (see the left side of Figure 7-25) and press the Set button.**

The Exposure custom function displays.

3. **Rotate the Quick Control dial to highlight down until the number 4 appears in the window at the top of your LCD panel and then press Set.**

The Exposure ISO Expansion menu displays (see the right side of Figure 7-25).

4. **Rotate the Quick Control dial to highlight On and then press Set.**

The text turns to blue, and ISO expansion is enabled.

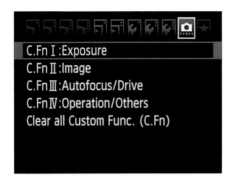 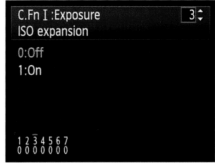

Figure 7-25: Enabling ISO expansion.

**5. Press the shutter button halfway.**

You're ready to shoot with ISO expansion enabled. This option appears as the letter H when setting the ISO speed with the Main dial.

# Flash Photography and Your EOS 7D

Your camera is equipped with a popup flash, a very intelligent popup flash. When you take pictures in Full Auto mode, the flash pops up when the camera determines that not enough light is available to properly expose the scene. When you photograph in Creative Auto mode, you can determine how the flash is used (see Chapter 2). When you take pictures using the creative modes I discuss in Chapter 6, you have full control over how the flash is used. In the upcoming sections, I show you how to use the flash unit that's built into your camera, how to use auxiliary flash units, and how to modify the amount of light your flash unit delivers.

## Using the built-in flash (high speed sync)

When you shoot in Full Auto mode, pop goes the flash unit when the camera decides extra light is needed to properly expose the scene. You also have a handy little button on the side of the camera with an icon that looks like a lightning bolt; this is how you make the flash pop up when you decide it's needed. To use your flash in Full Auto mode, you don't have to do anything because the flash is fully automatic. When you take pictures in Creative Auto mode and accept the default Auto Firing option, the flash pops up when the

camera determines additional light is needed to properly expose the image. If you choose the Flash On option, the flash pops up when you press the shutter button. The popup flash can be used to illuminate a scene or fill in the shadows. Popup flash also comes in handy when you want to warm up an image. The flowers in the top image of Figure 7-26 were taken with the ambient light. The flowers on the bottom of Figure 7-26 were illuminated with ambient light and then filled from the popup flash.

Figure 7-26: Spritzing flowers with fill flash.

To use your popup flash:

1. **Press the Flash button.**

   Pop goes the flash unit (see Figure 7-27).

2. **Compose the scene in your viewfinder and then press the shutter button halfway.**

   The camera achieves focus and fires a pre-flash to determine how much illumination is needed to properly expose the scene.

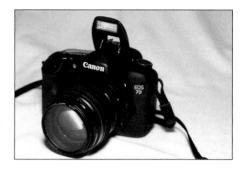

Figure 7-27: Pop goes the flash unit.

3. **Take the picture.**

   The flash fires. The flash unit remains in the locked and loaded position until you close it.

4. **Gently press your fingers on the top of the flash unit to close it.**

The effective range of the built-in flash varies depending on the ISO speed setting you use and the f-stop. Choosing a higher ISO speed setting and large aperture (small f-stop value) extends the range of the built-in flash. For example, using the flash with a 3.5 f-stop value and a 100 ISO setting yields a range of approximately 12 feet. If you use the same f-stop with an ISO setting of 6400, the range increases to approximately 90 feet.

## Changing the flash-sync speed in Av mode

When you're shooting in Aperture Priority (Av) mode, by default the camera shutter speed is set between 30 seconds and 1/250 of a second when the flash is enabled. The flash duration is very short and fires when the shutter opens, which gives you a sharp image of your subject. However, if the shutter speed is slow, you see motion trails if your subject moves during the long exposure. This can be very artistic. However, if you want to eliminate the possibility of motion trails, you can use a custom function to change the shutter speed used when a flash unit fires. Choosing one of the options that uses a higher shutter speed prevents motion trails, but the background will be dark. To change the flash-sync speed when shooting in Av mode:

1. **Press the Menu button.**

   The previously used menu displays.

2. **Use the multi-controller button to navigate to the Custom Functions tab.**

3. **Rotate the Quick Control dial to highlight C.Fn I: Exposure (see the left side of Figure 7-28) and then press the Set button.**

   The Exposure custom function displays.

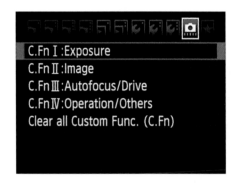
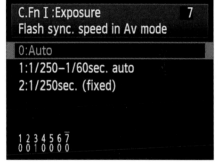

Figure 7-28: Choosing a flash-sync speed.

4. **Press the multi-controller button to select option 7: Flash Sync. Speed in Av mode.**

5. **Press Set to highlight the currently selected option (see the right side of Figure 7-28) and then rotate the Quick Control dial to highlight one of the following:**

   - *Auto:* The camera chooses a shutter speed between 30 seconds and 1/250 of a second when a flash unit is used in Av mode.

   - *1/250–1/60Sec. Auto:* The camera automatically chooses a shutter speed between 1/60 of a second and 1/250 of a second when a flash unit is used in Av mode.

   - *1/250Sec. (Fixed):* The camera sets the shutter speed to 1/250 of a second when a flash is used in Av mode.

6. **After choosing an option, press Set.**

   The text for the selected option is blue.

## Choosing second-curtain sync

The built-in flash for your camera fires when the shutter opens. This is all well and good when you're photographing people or objects that are standing still. However, when you use flash to photograph a moving object, the duration of the flash is much shorter than the shutter speed of the camera, especially when you're photographing in dim conditions or at night. The movement of the object after the flash fires shows up as a blur of motion, but the blur is going away from the object. When you enable second-curtain sync, the flash fires just before the shutter closes, creating a natural-looking motion trail that goes to the object instead of away from it. To enable second-curtain sync:

1. **Press the Menu button.**

   The previously used menu displays on the camera LCD monitor.

2. **Use the multi-controller button to navigate to the Shooting Settings 1 tab.**

3. **Rotate the Quick Control dial to highlight Flash Control (see the left side of Figure 7-29) and then press the Set button.**

   The Flash Control menu displays.

4. **Rotate the Quick Control dial to highlight Built-In Flash Func. Setting (see the right side of Figure 7-29) and then press Set.**

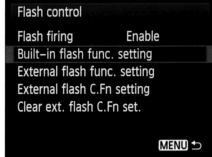

Figure 7-29: Changing built-in flash settings.

   The Built-In Flash Func. Setting menu displays.

5. **Rotate the Quick Control dial to highlight Shutter Sync. (see the left side of Figure 7-30) and then press Set.**

   The Shutter Sync. options display (see the right side of Figure 7-30).

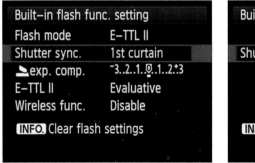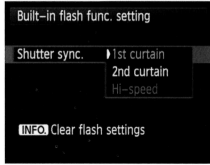

Figure 7-30: Enabling second-curtain shutter sync.

6. **Rotate the Quick Control dial to highlight 2nd Curtain and then press Set.**

   Your camera flash fires just before the shutter closes.

7. **Press the shutter button halfway.**

   You're now ready to photograph with second-curtain sync (see Figure 7-31).

Figure 7-31: Capture graceful motion trails when you enable second-curtain sync.

## Using auxiliary flash

Canon manufactures several flash units that are compatible with your EOS 7D. Some third-party units will probably also fit in your camera hot shoe. However, the camera can have an intelligent conversation with the auxiliary flash units that are dedicated to (as of this writing) the Canon EOS 5D MKII and your beloved EOS 7D. You can control the amount of illumination emitted from dedicated flash units with flash compensation (see the upcoming section, "Using flash compensation"). The following Canon Speedlites work hand in hand with your EOS 7D: 420EX, 430EX, 550EX, 580EX, and 580EX II. To attach an auxiliary flash unit to your camera, slide it in the hot shoe. Most Canon flash units have a thumbwheel that you use to firmly lock the flash unit in the hot shoe (see Figure 7-32).

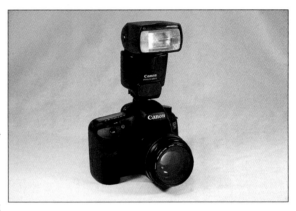

Figure 7-32: Attaching an auxiliary flash to your camera.

## Using flash compensation

You can increase or decrease the amount of illumination coming from the popup flash or a dedicated EOS flash inserted in the camera hot shoe. You can increase or decrease flash illumination by up to 3 stops in 1/3 stop increments. To use flash compensation:

1. **Press the ISO/Flash Compensation button.**

2. **Rotate the Quick Control dial while looking at the LCD panel.**

   As you move the dial, the exposure level mark moves along the exposure indicator (see Figure 7-33). Rotate the dial clockwise to increase flash exposure and counterclockwise to decrease flash exposure.

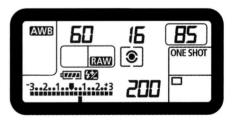

Figure 7-33: Specifying the amount of flash compensation.

3. **Press the shutter button half-way to achieve focus.**

   When flash compensation is enabled, you see the flash compensation icon in the LCD panel (see Figure 7-34).

4. **Press the Flash button.**

   The built-in flash makes a cameo appearance.

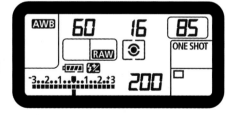

Figure 7-34: Enabling flash compensation.

5. **Press the shutter button fully to take the picture.**

   The flash fires with the amount of compensation you added or subtracted.

   *Note:* Flash compensation stays in effect even when you power off the camera. Remember to disable flash compensation when it's no longer needed.

## Locking the flash exposure

Another handy lighting option at your disposal is locking the flash exposure to a certain part of the frame. This option is handy when your main subject isn't in the center of the frame or you want to throw some extra light on a specific part of the scene you're photographing. Locking flash exposure also works when you have a Canon Speedlite in the hot shoe. To lock flash exposure:

1. **Press the Flash button.**

   The built-in flash unit pops up.

2. **Move your camera until the center autofocus point is centered over the part of the scene that you want to lock flash exposure.**

3. **Press the M-Fn button.**

   The camera fires a preflash to calculate exposure for the area over which you pointed the autofocus point. The flash icon in the viewfinder flashes on and off, and the FE lock icon appears (see Figure 7-35).

Figure 7-35: Locking flash exposure.

4. **Recompose the scene through the viewfinder and then press the shutter button halfway to achieve focus.**

A green dot appears in the right side of the viewfinder when the camera achieves focus.

5. **Press the shutter button fully to take the picture.**

The flash unit fires, properly exposing the area over which you locked flash exposure.

# Controlling External Speedlites from the Camera

The following Canon flash units can be controlled with camera menu settings: 420EX, 430EX, 430EX II, 550EX, 580EX, and 580EX II. You have more control with the EX II units that have new bells and whistles engineered for the Canon EOS 5D MKII and newer models. And yes, your camera is a newer model. But even if you own one of the older EX Speedlites, you can still do some cool stuff from the camera menu after you attach the unit to your camera hot shoe. You can also control all the aforementioned Speedlites wirelessly. That's right, you can do sophisticated stuff, such as bouncing light into shadows, bouncing the light off walls, and more.

In the upcoming sections, I show you how to control a Speedlite mounted in the hot shoe and use the built-in flash as a master to control the Speedlite wirelessly. Hmmm . . . Maybe I should've called this section, "Flashing for Fun and Profit." At any rate, a whole lot of flashing is going on in the upcoming sections.

## Controlling a flash in the hot shoe

When you mount a Canon EX Speedlite in the camera hot shoe, you can control the output with the camera menu and much more. If you have an EX II Speedlite, you have gobs of control. The following steps show the options you have available with an EX II Speedlite. The options may be different for your Canon Speedlite. Refer to your Speedlite manual for additional instructions. To control flash with camera menu commands:

1. **Insert a Canon EX or EX II Speedlite in your camera's hot shoe.**

2. **Press the Menu button.**

The last used menu displays on the camera LCD monitor.

3. **Use the multi-controller button to navigate to the Shooting Settings 1 tab.**

4. **Rotate the Quick Control dial to highlight Flash Control (see the left side of Figure 7-36) and then press the Set button.**

   The Flash Control options display.

5. **Rotate the Quick Control dial to highlight External Flash Func. Setting (see the right side of Figure 7-36) and then press Set.**

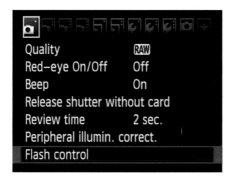
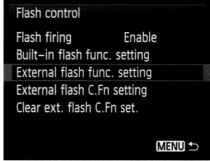

Figure 7-36: Controlling your external Speedlite with menu commands.

The options you can use to control your Speedlite display (see Figure 7-37).

6. **Rotate the Quick Control dial to highlight a command and then press Set to see the options.**

   The following is a brief rundown of each option:

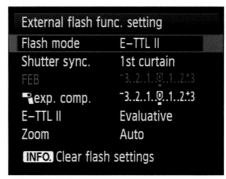

Figure 7-37: Controlling your Speedlite with camera menu commands.

• *Flash Mode:* The default option is E-TTL II on most Speedlites. The other options vary depending on the flash unit attached to the hot shoe.

- *Shutter Sync.:* Choose from 1st Curtain (the default) or 2nd Curtain shutter sync. The second-curtain sync option may not be available for your Speedlites. For more information on second-curtain sync, see the "Choosing second-curtain sync" section earlier in this chapter.

- *FEB:* This stands for *flash exposure bracketing.* This option is available only with certain Speedlites: It isn't supported on EX units or the 430EX II. If this option is available for your Speedlite, you can take three pictures with different amounts of illumination. This is similar to automatic exposure bracketing.

- *Exp. Comp.:* This option gives you the capability to increase or decrease the amount of light emitted from the flash unit. Press Set to enable the exposure compensation scale and then rotate the Quick Control dial to increase or decrease the amount of illumination from the flash unit. Each mark represents 1/3 stop.

- *E-TTL II:* This option determines how the camera meters the scene, which determines the amount of illumination the flash uses to properly expose the picture. Your options are Evaluative or Average. These options are identical to the metering options that I discuss in the "Choosing a Metering Mode" section earlier in this chapter.

- *Zoom:* Enables you to specify the flash zoom of supported EX II Speedlites from the menu. By default, the flash unit inherits the level of zoom from the camera lens. Press Set and rotate the Quick Control dial to choose an option supported by your Speedlite. This option comes in handy when you want to add a splash of light to a specific part of the scene. For example, if you're photographing someone with a lens that is the 35mm equivalent of 85mm, change the zoom setting of the flash to 105mm and you send a splash of light to a focused point in the center of the image.

7. **Press the shutter button halfway.**

   You're back in shooting mode and ready to put your new flash settings to work.

If you're really into controlling your Canon Speedlite through the camera, check out the External Flash C.Fn Setting menu. This menu has options for custom functions that you can use to gain further control over your Speedlite. The available functions vary depending on the Speedlite you own. Refer to your Speedlite manual for more information.

## *Going wireless*

The EOS 7D built-in flash can turn you into a real control freak. As I mention previously, you can control the output of the flash. With a few menu commands, you can turn the built-in flash into a control freak. The built-in flash acts as the master, and any Canon EX Speedlite capable of functioning as a slave can be fired in conjunction with it. Just think of the possibilities with multiple flash units illuminating a scene.

The possibilities are limited only by your imagination. You can even set up a portable studio with a couple Canon Speedlites and your EOS 7D. Unfortunately a detailed discussion showing you how to use Canon Speedlites as slave units is beyond the scope of this book. If you have one or more Canon Speedlites or you want to know more about flash photography with Canon Speedlites, pick up a copy of *Canon Speedlite System Digital Field Guide* by J. Dennis Thomas (published by Wiley). If you purchase that book, you can disregard the ST-E2 wireless transmitter because with a few menu commands, you can get your EOS 7D's built-in flash to act as a wireless transmitter.

The first type of wireless shooting enables you to fire one or more external Speedlites that are controlled by the built-in flash unit. The built-in flash unit fires a beam to trigger the external flash unit and also adds illumination to the exposure. With this option, you can control the ratio of the built-in flash to the off-camera flash units. In other words, you determine whether the on-camera flash fires at full power and the off-camera flash fires at half power, and so on. You can also make the off-camera flash units more powerful than the built-in flash unit. To control one or more external Speedlites with the built-in flash:

1. **Position one or more Canon Speedlites that can operate as a slave unit.**

   Canon Speedlites come with a small stand that can be screwed into a light stand. The positioning depends on where you want to add light to a scene. Some standard lighting patterns are used by portrait and fashion photographers. Unfortunately, coverage of these patterns is beyond the scope of this book.

2. **Switch the external Speedlite(s) to slave mode and then set the channel that the slave will receive instructions from the camera's built-in flash.**

   On many Canon Speedlites, you use a switch to have the unit operate as a slave. Refer to your Speedlite manual for more instructions. Make sure the external flash unit(s) sensor (the red plastic rectangle on the front of the unit) faces the camera. You can swivel the Speedlite head so that the flash is aimed at your subject and the sensor faces the camera.

3. **Press the Menu button on your camera.**

   The last used menu displays.

4. **Use the multi-controller button to navigate to the Shooting Settings 1 tab.**

5. **Rotate the Quick Control dial to highlight Flash Control (see the left side of Figure 7-38) and then press the Set button.**

   The flash options display on your LCD monitor.

6. **Rotate the Quick Control dial to highlight Built-In Flash Func. Setting (see the right side of Figure 7-38) and then press Set.**

   The settings for the built-in flash display.

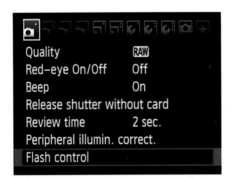
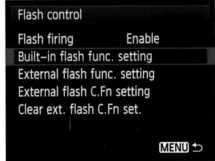

Figure 7-38: Getting control of your built-in flash unit.

7. **Rotate the Quick Control dial to highlight Wireless Func. (see the left side of Figure 7-39) and then press Set.**

   The Wireless Func. options for your built-in flash display.

8. **Rotate the Quick Control dial to select the second option (see the right side of Figure 7-39) and press Set.**

   The Channel options become available.

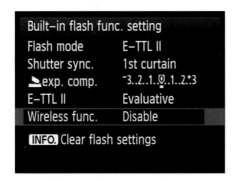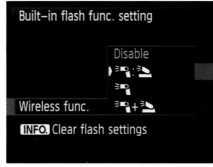

Figure 7-39: Choosing a wireless option.

9. **Rotate the Quick Control dial to highlight Channel (see the left side of Figure 7-40) and then press Set.**

   The Channel options display (see the right side of Figure 7-40).

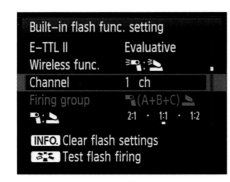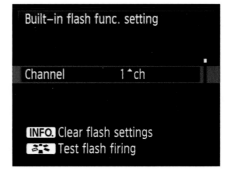

Figure 7-40: Tuning in to the right channel.

10. **Rotate the Quick Control dial to select the desired channel and then press Set.**

I know this is a no-brainer, but make sure you select the same channel as that to which you set your external Speedlite. After you press Set, the camera is set to communicate with an external Speedlite on the same channel.

11. **Rotate the Quick Control dial to highlight the Flash Ratio option (see the left side of Figure 7-41) and then press Set.**

The Flash Ratio options display on the camera LCD monitor (see the right side of Figure 7-41).

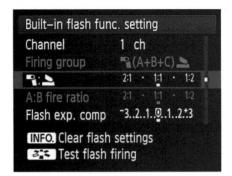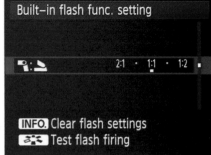

Figure 7-41: Setting the flash ratio between the built-in flash and external Speedlites.

12. **Rotate the Quick Control dial to choose a Flash Ratio option.**

The default option is 1:1, which means both the built-in flash and off-camera flash units fire at full power. If you choose a different ratio, the off-camera flash units contribute more illumination to the exposure than the built-in flash. For example, at the 2:1 ratio, the off-camera flash unit is two times as powerful as the on-camera flash unit or one additional stop of exposure.

13. **(Optional) Rotate the Quick Control dial to navigate to Flash Exp. Comp (see the left side of Figure 7-42) and then press Set.**

Follow Steps 13 and 14 only if you decide you need to increase or decrease the amount of flash illumination.

The exposure compensation scale becomes available (see the right side of Figure 7-42).

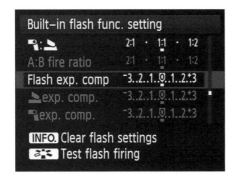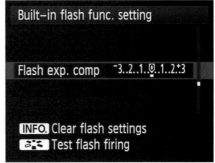

Figure 7-42: Adding flash exposure compensation.

14. **(Optional) Rotate the Quick Control dial to increase or decrease the flash exposure and then press Set to enable flash exposure compensation.**

    As you rotate the dial, the indicator moves to indicate how much you're increasing or decreasing the exposure. Each mark represents 1/3 stop.

15. **Press the Picture Style button to fire a test flash.**

    If you've set up everything correctly, your external Speedlite fires.

    If the external flash doesn't fire, make sure the sensor (the red dome on the front of the flash) can see the signal from the camera flash. If not, swivel the flash head so that it's pointing toward your subject, and the red dome is facing the camera.

16. **Press the Flash button.**

    The built-in flash pops up, and you're now ready to take a picture illuminated by one external Speedlite that's controlled by the camera's built-in flash.

17. **Take the picture.**

    When you press the shutter button, the external Speedlite(s) fires.

You can also create exposures in which the built-in flash doesn't fire and triggers the external Speedlites. When you choose this option, you can set up the external units in up to three groups and manually set the external Speedlites with the built-in menus. From the camera, you can control the ratio between two groups, plus add exposure compensation to the mix. To control two or more external Speedlites without firing the built-in flash:

1. **Follow steps 1–6 from the preceding section.**

   The only difference is when you set up the external Speedlites. If you want individual control over the external units, set them up in groups. Canon Speedlites have three groups: A, B, or C. Refer to your Speedlite manual for more information.

2. **Rotate the Quick Control dial to highlight Wireless Func. (see the left side of Figure 7-43) and then press the Set button.**

   The Wireless Func. options display.

3. **Rotate the Quick Control dial to highlight the third option (see the right side of Figure 7-43) and then press Set.**

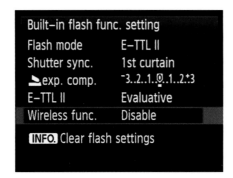
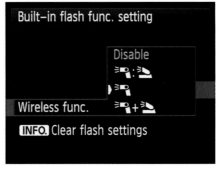

Figure 7-43: Choosing a wireless option.

   The Channel options display.

4. **Rotate the Quick Control dial to select the desired channel and then press Set.**

   Your built-in flash and external Speedlites now communicate on the same channel.

5. **Rotate the Quick Control dial to highlight the Firing Group option (see the left side of Figure 7-44) and then press Set.**

   The Firing Group options display.

6. **Rotate the Quick Control dial to highlight one of the following Firing Group options (see the right side of Figure 7-44):**

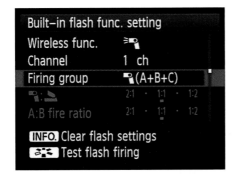 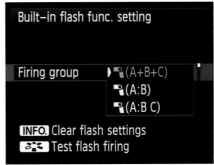

Figure 7-44: Choosing a Firing Group option.

- *A+B+C:* Up to three groups of external Speedlites fire with the same power.

- *A:B:* Two groups of Speedlites fire. You can control the ratio between the two groups.

- *A:B C:* Three groups of Speedlites fire. Use group C as backlighting to fill the shadows created by groups A and B. You can control the ratio between group A and B. You can add exposure compensation for groups A and B collectively, and add exposure compensation for group C.

7. **Press Set.**

Your firing group is cast in stone until you change it.

After setting up wireless shooting and choosing the firing group, you're ready to specify options for it. If you choose the A+B+C option, you can't control the ratio between the groups. You can, however, add flash exposure compensation, which is applied equally to all external Speedlites. If you choose one of the other Firing Group options, you have more control over the external flash units.

If you choose the A:B firing group, follow these steps:

1. **Rotate the Quick Control dial to highlight A:B Fire Ratio (see the left side of Figure 7-45) and then press the Set button.**

The A:B Fire Ratio options display (see the right side of Figure 7-45).

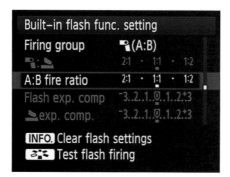 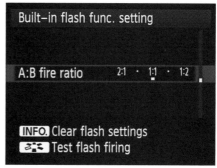

Figure 7-45: Setting the firing group ratio.

2. **Rotate the Quick Control dial to choose the desired option.**

   When you rotate the dial to the right, the B group has more power than the A group. When you rotate the dial to the left, the A group has more power than the B group. Each turn of the dial changes the ratio by 1/2 stop, so one group can be up to 3 stops more powerful than the other group.

3. **Press Set.**

   The A:B firing ratio is locked and loaded.

4. **Rotate the Quick Control dial to highlight Exp. Comp. (see the left side of Figure 7-46) and then press Set.**

   The exposure compensation scale displays on the camera LCD monitor (see the right side of Figure 7-46).

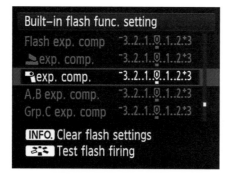 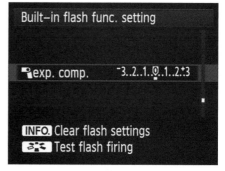

Figure 7-46: Setting exposure compensation.

5. **Rotate the Quick Control dial to set exposure compensation.**

If you choose the A:B C option, follow these steps:

1. **Rotate the Quick Control dial to highlight A:B Fire Ratio (see the left side of Figure 7-47) and then press the Set button.**

   The A:B Fire Ratio options display (see the right side of Figure 7-47).

2. **Rotate the Quick Control dial to choose the desired option.**

   When you rotate the dial to the right, the B group is more powerful than the A group. When you rotate the dial to the left, the A group has more power than the B group. Each turn of the dial changes the ratio by 1/2 stop, so one group can be up to 3 stops more powerful than the other group.

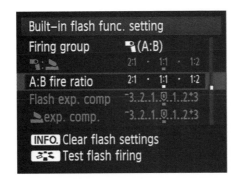 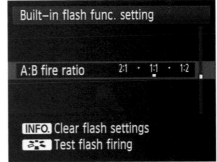

Figure 7-47: Setting the A:B options.

3. **Press Set.**

   The A:B firing ratio is set.

4. **(Optional) Rotate the Quick Control dial to highlight A,B Exp. Comp. (see the left side of Figure 7-48) and then press Set.**

   Exposure compensation is optional. I usually do a test shot without exposure compensation enabled. If I need to tweak the exposure, I open the menu, come back to these settings, and add the desired amount of exposure compensation.

   The exposure compensation scale displays (see the right side of Figure 7-48).

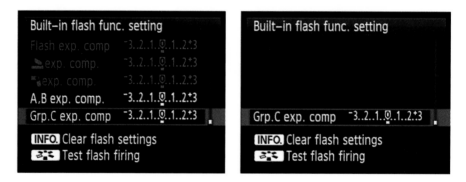

Figure 7-48: Setting Group A and B exposure compensation.

5. **(Optional) Rotate the Quick Control dial to highlight Grp. C Exp. Comp (see the left side of Figure 7-49) and then press Set.**

The exposure compensation scale displays (see the right side of Figure 7-49).

Figure 7-49: Setting Group C exposure compensation.

After you set the options for the firing groups, you're ready to fire a test shot from within the camera menu by pressing the Picture Style Selection button. The test shot tells you whether you've set up everything correctly; it also wakes the external Speedlites, if you're running them in energy conservation mode.

The final wireless option fires the built-in flash and gives you the option of individually controlling two or three groups. This is the last option on the Wireless Func. menu. When you choose this option, you still specify the channel and firing group. The only additional option you have is using exposure compensation on the built-in flash unit.

To clear all wireless flash settings, return to the Built-In Flash Func. Setting menu and press the Info button.

# Mastering Your EOS 7D

In earlier chapters, I show you all the bells and whistles on your camera that you can use in your photography. Bells and whistles are cool, but if you don't know when to ring or blow them, they don't do you much good. In this chapter, I cut to the chase and show you how to use these features for specific types of photography. Of course you may not be interested in all the types of photography I discuss in this chapter. But I like to practice several different photography disciplines.

I find that different disciplines keep me on my toes and keep my work fresh. Not to mention they help me get to know my camera better. Try diversifying — you might like it. At any rate, in this chapter, I show you what settings to use for specific types of photography. I also sprinkle in some tips that will take your photography to the next level.

## Choosing the Optimal Settings for Specific Situations

Your camera has settings for every conceivable type of photography. All you need to do is attach the right lens to the camera and you're ready for action. You can take pictures of just about any object from a small insect to a racing

car traveling at a high rate of fuel consumption. But the trick is knowing what settings to use for a specific picture-taking situation. For example, say you're photographing your significant other and want her to be the center of attention with a soft blurry background. That's easy to achieve with the right camera setting and the right lens.

In addition to the right settings, you have to be creative so your photograph of a known person, place, or thing doesn't look like someone else's photograph of the same person, place, or thing. To take great pictures you have to examine everything in the viewfinder and determine whether it's something you should include in the photograph. With a bit of thought and keen observation, you'll notice that light pole sticking out of your significant other's head and ask her to move to a different position, or you'll move to a different position.

# Photographing Action

Your camera is well-equipped to photograph action, whether your subject is a flock of flying birds or the Blue Angels in formation. When you photograph an object in motion, your goal is to portray motion artistically. The camera settings and lens you use depend on the type of subject you're photographing. If you're photographing a marathon runner, you want to depict the beauty and grace of his fluid stride and athletic body. If you're photographing a racecar, your goal is the same. You want to depict the beauty of a beautifully sculpted racecar at speed. So the type of settings you use depends on whether your subject is moving toward you or parallel to you, and whether your subject is moving very fast or very slow.

## Photographing fast-moving subjects

When people see my photographs of racecars, they always assume I'm using a fast shutter speed because the car looks so clear and they can see every detail, including the driver's name on the side of the car. But I do just the opposite. I shoot with a relatively slow shutter speed when the car is traveling parallel to me. To photograph a fast-moving subject:

1. **Attach a telephoto lens to your camera.**

   The focal length of the lens depends on how far away your subject is. When I photograph racecars, I use a Canon 70–200 mm f/4 lens. If the cars are relatively close to me, I can zoom out and still get the whole car. If they're far away, I zoom to 200mm, which on this camera is the 35mm equivalent of a 320mm lens.

2. **Point the camera where your subject will be when you take the picture and then zoom in.**

If you're photographing an automobile race, you can compose your picture a lap before you take it. I generally zoom to almost fill the frame with the car and then zoom out a little, leaving a little distance in front of the car to give the impression that the car is going somewhere.

 3. **Switch to AI Servo autofocus mode so that your camera focuses continually on your subject as it moves closer to or farther from you.**

If your camera has a hard time keeping fast-moving subjects in focus, you can focus manually on the spot where the object will be when you take the picture.

 4. **Switch to a single autofocus point in the center of the frame.**

When you use multiple autofocus points, the camera may focus on an object other than the one you want to photograph. Alternatively, you can use the middle autofocus zone. For more information on choosing an autofocus point, see Chapter 7.

 5. **Rotate the camera shooting Mode dial to Tv (Shutter Priority mode), and then rotate the Quick Control dial to select a shutter speed of 1/125 second.**

You may have to use a slightly higher shutter speed if you're using a focal length that is the 35mm equivalent of 200mm or greater. The aperture really doesn't matter with this technique. The background is stationary, but the car and camera are moving at the same relative speed. Therefore, the background will be a blur caused by the motion of the camera relative to the background.

 6. **Spread your legs slightly and move your elbows to the side of your body. Cradle the barrel of the lens with your left hand and position your right forefinger over the shutter button.**

This helps stabilize the camera as you pan with your subject. In this position, you're the human equivalent of a tripod.

 7. **Pivot from the waist toward the direction from which your subject will be coming.**

 8. **When your subject comes into view, press the shutter button halfway to achieve focus.**

Sometimes the camera has a hard time focusing on a fast-moving object, such as a fighter jet traveling several hundred miles per hour. If this is the case, switch to One-Shot AF mode, switch your lens to manual focus, and focus on the place where your subject will be when you press the shutter button. Press the shutter button just before your subject reaches the spot on which you've focused.

 9. **Pan the camera with your subject to keep it in frame.**

When you're photographing an object in motion, a good idea is to keep more space in front of the object than behind it. This shows your viewer the direction in which your subject is traveling.

10. **Press the shutter button when your subject is in the desired position and follow through.**

    If you stop panning when you press the shutter button, your subject won't be sharp. Figure 8-1 is a photograph of a racecar racing through a corner. I used the panning technique to catch the essence of speed. At this point, the car was traveling well over 100 mph.

Figure 8-1: Depicting the beauty of speed.

## Freezing action

When your subject is traveling toward or away from you at a fast rate, your goal is to freeze the action. Another time you want to freeze action is when you want the photo to depict the beauty and grace of your subject. An example of this is a closeup of a tennis player with the ball just leaving her racket or a water skier slicing through the water. To freeze action:

1. **Attach a telephoto lens to your camera.**

    The focal length of the lens depends on how far away your subject is. I generally use a focal length that is the 35mm equivalent of 300mm or longer. This puts some distance between me and the subject. A telephoto lens also does a great job of compressing the background. For example, if you're photographing a gaggle of racecars, a long focal length makes them look like they're closer to each other than they actually are.

2. **Point the camera where your subject will be when you take the picture and then zoom in.**

   When you compose the picture, leave some room in front of your subject to give the appearance that it's going somewhere. I generally try to include some of the background to give viewers an idea of the locale in which the photograph was taken.

3. **Press the AF-Drive button and then rotate the Quick Control dial to switch to AI Servo focus mode so that your camera focuses continually on your subject as it moves toward or away from you.**

   Your camera may have a hard time focusing on a fast-moving vehicle. I had this problem when photographing the start of an automobile race. The cars were traveling well over 100 mph at the place I wanted to photograph them, so I switched to manual focus and focused on an expansion joint. I snapped the shutter just before the car crossed the expansion joint. For more information on switching focus modes, see Chapter 7.

4. **Press the AF Point Selection/Magnify button and then press the M-Fn button to switch to a single autofocus point in the center of the frame.**

   With multiple autofocus points, the camera may focus on something other than your subject. For more information on switching to a single autofocus point, see Chapter 7.

5. **Rotate the shooting Mode dial to Tv (Shutter Priority mode) and then rotate the Main dial to choose a shutter speed of 1/1000 of a second.**

   Choose a higher shutter speed when trying to freeze the motion of something like a pitcher throwing a fastball. When you set the shutter speed, make note of the f-stop. If you can get a 5.6 or 7.1 f-stop, the background will be recognizable but not in sharp focus. You may have to experiment with different ISO speed settings to achieve the optimal shutter speed and aperture combination. Note that if you're shooting in low ambient light, you may see the maximum aperture (smallest f/stop number) blinking in the viewfinder, which means the image will be underexposed at the current shutter speed. Either choose a slower shutter speed, or increase the ISO until the aperture stops blinking.

6. **Press the AF-Drive button and then rotate the Quick Control dial to switch to Hi Speed Continuous mode.**

   With this mode, you can capture a sequence of images as long as your finger is on the shutter button at approximately 8 fps (frames per second). This is a great way to capture a sequence of your dog catching a Frisbee. For more information on choosing a Drive mode, see Chapter 6.

7. **Press the shutter button halfway to achieve focus.**

   A green dot appears on the right side of the viewfinder when you achieve focus. When shooting in AI Servo autofocus mode, the camera updates focus as your subject moves toward or away from you.

If the dot is flashing, the camera can't achieve focus. You may experience this when you try to focus on a subject that's traveling very fast. If this happens, switch to One-Shot AF mode, switch the lens to manual focus, and then pre-focus on the place your subject will be when you take the picture.

**8. Press the shutter button fully to take the picture.**

If you switched to manual focus, press the shutter button just before the subject moves to where you focused. Figure 8-2 was photographed at the start of an automobile race. In this case, I switched to manual focus and focused on an expansion strip in the race track, which began life as a WWII airport.

Figure 8-2: Freezing motion.

To get the knack of this technique, photograph one of your family members bouncing a ball or photograph your son or daughter throwing a knuckleball at baseball practice.

## Photographing slow-moving subjects

I cover freezing motion and capturing the essence of speed in previous sections in this chapter. Here I show you techniques to photograph things that move slower, such as horses, runners, and bicyclists. When you freeze the motion of subjects like these, the end result is kind of boring. When you photograph slow-moving subjects like runners or cyclists, use blur creatively to capture a compelling photograph of your subject. This technique also works great for photographing birds in flight. To photograph slow-moving objects:

1. **Attach a telephoto zoom lens to your camera.**

    You can do this technique with a lens with a shorter focal length of 50mm. However a longer focal length compresses the background. I like to use my 70–200mm lens when photographing slow-moving subjects.

2. **Point the camera where your subject will be when you take the picture and zoom in.**

3. **Press the AF-Drive button and then rotate the Quick Control dial to switch to AI Servo autofocus mode.**

    After the camera locks focus, your camera updates focus continually as your subject moves toward you. For more information on switching autofocus modes, see Chapter 7.

4. **Press the AF Point Selection/Magnify button and then press the M-Fn button repeatedly to switch to a single autofocus point in the center of the frame.**

    When you use multiple autofocus points, the camera may inadvertently focus on an object other than the one you want to photograph. For more information on switching to a single autofocus point, see Chapter 7.

5. **Rotate the shooting Mode dial to Tv (switch to Shutter Priority mode) and then rotate the Main dial to select a shutter speed of 1/30 second or slower.**

    This shutter speed is a good starting point, but don't be afraid to choose a slower shutter speed. I often photograph runners and bicyclists at a shutter speed of 1/6 second.

6. **Spread your legs slightly and move your elbows to the side of your body.**

    This stabilizes the camera, which is important when you're shooting at a slow shutter speed.

7. **Pivot from the waist toward the area from which your subject will be coming.**

8. **When your subject comes into view, press the shutter button halfway to achieve focus.**

   A green dot appears in the right side of your viewfinder when you achieve focus. When you shoot in AI Servo autofocus mode, the camera updates focus as your subject moves.

9. **Pan the camera with your subject and then press the shutter button when your subject is at the desired spot.**

   Remember to follow through.

When you use this technique, certain parts of your subject are in relatively sharp focus, but body parts, such as a runner's arms and legs, are a blur of motion (see Figure 8-3).

Figure 8-3: Using motion blur creatively.

## Photographing Landscapes

If you live in an area like I do where you can discover lots of lovely landscapes — thank you, Joni — capturing compelling pictures of the landscapes is an excellent way to use your camera. Landscape photography is a time-honored tradition. The fact that you own a camera capable of capturing images with an 18-megapixel resolution means that you can create some very big prints of your favorite landscapes. My home is decorated with photographs I've shot since moving to the Gulf Coast of Florida in December 2008. To photograph landscapes:

1. **Attach a wide-angle zoom lens to your camera.**

   When you're photographing landscapes, you want to capture the wide expanse. Use a lens that can zoom out to a focal length that is the 35mm equivalent of 28mm or less. My favorite lens has a focal length that is the 35mm equivalent of 17mm.

2. **Rotate the shooting Mode dial to Av (Aperture Priority mode) and then rotate the Main dial to choose the smallest aperture (highest f-stop value) possible for the lighting conditions.**

   A small aperture gives you a large depth of field. When you're photographing something like the Grand Canyon, you want to see everything from foreground to background. When I photograph landscapes, I use an aperture of f/11.0 or smaller. Keep in mind, you may have to increase the ISO speed setting when photographing in cloudy or overcast weather. For more information on Aperture Priority mode, see Chapter 6.

3. **Press the shutter button halfway to achieve focus.**

   A green light appears in the viewfinder when the camera achieves focus. Take note of which autofocus points glow red. In spite of the large depth of field you get with a small aperture, you don't want the camera focusing on items in the foreground.

4. **Press the shutter button fully to take the picture.**

Landscape photography is rewarding. The preceding steps get you started in the right direction, but the time of day is also very important. If you think morning is for eating breakfast and the time before sunset is for eating dinner, you have it all wrong. These are the times you need to be chasing the clouds with your camera in hand. And yes, I do mean "chasing the clouds" because clouds add interest to any landscape. If you have a still body of water into which the clouds can reflect, you have an even more compelling picture. The light in the morning just after sunrise and the light just before sunset is warm, almost golden in color. That's why the hour after sunrise and the hour before sunset is the *Golden Hour.* This is when you need to photograph your landscapes (see Figure 8-4).

Composition is a very important part of photography, especially when you photograph a landscape. Your goal is to draw your viewer into the image. For more information on composing your photographs, check out the "Composing Your Images" section later in this chapter.

Figure 8-4: Photographing landscapes in the Golden Hour.

## Photographing the Sunset

Sunset is an awesome time of day for photographers. The sun is low on the horizon, casting warm orange light. Add clouds to the equation and you have the recipe for great sunset pictures. When you photograph a sunset, the sun is obviously a key player, but you need other ingredients, such as clouds and an interesting landscape, for a great shot. Without clouds, you have a boring picture of an orange ball sinking in a cerulean sky. You can take pictures of sunsets with the skyline of your town in silhouette. You can get an even better sunset shot when you have a body of water such as a lake, a river, or an ocean. The water will reflect the colorful clouds.

You can get some great sunset pictures in the final few minutes before the sun sets. After the sun sets, many photographers pack up their gear and head home. This is a mistake. As long as the clouds don't go all the way to the horizon, the sun will reflect warm colors on the underside of the clouds for about 10 to 15 minutes after setting. If you want really great sunset pictures, wait a few minutes after the sunset and get ready to take some pictures when the clouds are bathed in giddy shades of pink, orange, and purple (see Figure 8-5).

Figure 8-5: Catching the perfect sunset.

The camera settings for a sunset are almost identical to those you use for landscapes, with the exception of lens choice. If you're going for the grand view, use a wide-angle lens with a minimum focal length that's the 35mm equivalent of 28 mm or less, and choose the smallest possible aperture for a large depth of field. Sometimes you may need to go the other route and choose a telephoto focal length and a fairly large aperture for a limited depth of field.

Recently I photographed a sunset at a picturesque beach a few minutes from my home. I used my Canon 24–105mm F 4.0 L lens and zoomed to 105mm, with an aperture of f/7.1. I focused on some nearby sea oats. The sea oats were in silhouette and in sharp focus, the clouds were a little soft, and the sun was a soft out-of-focus orange orb, as shown in Figure 8-6. But due to the telephoto lens, the sun is relatively large in the resulting photo, which makes it clear I took the photo as the sun was setting.

Figure 8-6: Photographing the sun.

## Developing a style

Photographers are attracted to different subjects and do things in different ways. Casual photographers tend to produce similar images, but die-hard photographers like to do things differently. Die-hards have a different way of seeing things, and therefore, produce different-looking images, even when they photograph the same subjects. They experiment with different lenses, different vantage points, different lighting, and so on.

Each year thousands of photographs are taken of Yosemite National Park, yet most of them pale in comparison with the memorable images photographed by Ansel Adams. The key to developing your own style is to study the work of the masters. If you're a landscape photographer, check out Ansel Adams's work. If you like the gritty down-to-earth street journalism style of photography, look at Henri Cartier-Bresson's work. The next step is to shoot what you love as often as you can.

When you photograph a sunset, the camera metering system may make the scene much brighter than it actually is. If you notice this when reviewing the image on the camera LCD monitor, lock exposure on the sky and then take the picture. Alternatively, you can use exposure compensation to reduce exposure by one stop or more. For more information on exposure compensation and locking focus, see Chapter 6.

When you photograph the sun, don't look directly at the sun through your viewfinder or you may damage your vision. If you photograph sunsets with Live View mode or with the mirror locked, don't point the camera at the sun for a long period of time because you may damage some of the sensitive components in your camera.

# Photographing People and Things

You have a great camera that can do many things. Photographing people and the world around you is another great way to use your camera. When you photograph people and things, your goal is to create a compelling photo of the object or person, a portrait if you will. In the upcoming sections, I offer some advice for photographing people and things.

## Photographing people and pets

With the right lens, your camera can capture stunning photos of people or pets. You can photograph formal or candid portraits, or use Live View mode to shoot from the hip. When you photograph people and pets, here are some things to keep in mind:

- Use a telephoto lens with a focal length that is the 35mm equivalent of 85mm or longer.

- Switch to Aperture Priority (Av) mode. (For more information on Aperture Priority mode, see Chapter 6.)

- Switch to a single autofocus point or the middle autofocus zone. (For more information on modifying autofocus, see Chapter 7.)

- Choose your largest aperture (smallest f-stop value). Choosing a large aperture gives you a small depth of field. Your subject is in focus, but the background is a soft, out-of-focus blur.

- If you're taking the picture indoors, photograph your subject against a solid color wall. You can also tack a solid color bedsheet to a wall and use that as a backdrop.

- If you're photographing your subject outdoors, photograph her against a nondescript background, such as distant foliage. If you photograph your subject with a telephoto lens with a large aperture and shoot *wide open* (photographer-speak for using your largest aperture), the background will be a pleasant out-of focus blur that won't distract your viewer's attention from your subject (see Figure 8-7).

- If possible, don't use the built-in flash because this produces a harsh light that isn't flattering for portraits. Available light from a window is your best bet.

- When you're shooting portraits of a friend, relative, or your pet, take lots of pictures. Your subject will give you more natural expressions as he relaxes.

**Figure 8-7:** Photographing your subject against a plain background.

✐ If you have a Canon Speedlite, mount it in the hot shoe and then bounce it off a white surface, such as a wall or the ceiling. When you bounce the flash off a large surface, you end up with a soft diffuse light similar to that of a cloudy day.

✐ When using flash to illuminate your subject, make sure she's not too close to the wall; otherwise, you'll get a nasty shadow.

✐ Use Live View mode when you want candid shots of friends or your pet. After enabling Live View, place the camera on a table with the end of the lens just off the table. When you see something interesting happen, take a picture. Your friends won't be as intimidated by the camera on the table as they would if you held the camera to your face.

✐ Never photograph pets with flash. The bright light scares them.

✐ When you photograph a person or a pet, make sure the eyes are in focus. To do so:

1. *Switch to a single autofocus point when photographing a head-and-shoulders portrait.*

2. *In the viewfinder, align the autofocus point with the person's (or pet's) eye and press the shutter button halfway to achieve focus.*

3. *Recompose the shot and take the picture.*

Remember that the eyes are the windows to the soul.

You need to consider lots of things when you photograph people and pets, much more than I can include in this book. If you want more information on portrait photography, check out *Digital Portrait Photography For Dummies* (Wiley) by yours truly.

## Exploring selective focus

When you own a camera like the EOS 7D and a lens with a large aperture of 2.8 or larger, you can create some wonderfully artistic photos by using the *selective focus* technique. When you take pictures with the largest aperture on a lens with a focal length that's the 35mm equivalent of 85mm or longer, you have a wonderfully shallow depth of field. You can use this to your advantage by focusing on one spot that will be your center of interest. The rest of the image will be out of focus, and your viewer's attention will be drawn to the point in sharpest focus. To create images with this technique:

1. **Switch to a single autofocus point and Aperture Priority mode.**

   See Chapter 7 for more on autofocus points and see Chapter 6 for more on the Aperture Priority mode.

2. **Look through the viewfinder and position the autofocus point over your center of attention.**

3. **Press the shutter button halfway to achieve focus and then recompose the image.**

   I photographed Figure 8-8 with a Canon 85mm f/1.8 lens. I switched to a single autofocus point and focused on the Harley Davidson badge.

**Figure 8-8:** The selective focus technique with a telephoto lens and a large aperture.

## Exploring macro photography

Extreme close-up photography, also known as *macro photography,* can be a tremendous source of enjoyment. With a macro lens, you can get close to small insects, flowers, and other objects that look interesting when magnified to life-size proportions. Keep the following in mind when working with macro photography:

✓ Canon makes a wonderful lens for macro photography — the 100mm EF f/2.8 lens — which works on your EOS 7D. You can also choose from lots of third-party macro lenses available for your camera.

✓ Focus is extremely important because when you use a macro lens and get very close to your subject, you're dealing with a very limited depth of field.

✓ Macro photography is almost impossible to do when the weather is windy because your subject keeps moving in and out of focus. If it's not too windy, switch the autofocus mode to AI Focus. If the camera achieves focus and the item you're photographing moves, the camera switches to AI Servo and updates focus.

✓ When you decide to get small and go macro, shoot in Aperture Priority (Av) mode (see Chapter 6) and choose the smallest aperture possible for the lighting conditions. This gives you a slightly larger depth of field.

✓ A good tripod is a handy accessory when shooting macro photography because it keeps the camera steady. If you're not using a tripod, shoot at a higher shutter speed than you normally would. Keep as steady as possible, focus, and gently squeeze the shutter when you exhale.

# Photographing Wildlife

With a camera like the EOS 7D, you can capture stunning photos of wildlife, whether the animals are moving or standing still. Photographing wildlife can be challenging, but the results are extremely rewarding. When you shoot wildlife with a camera and get a great shot, the animal lives to see another day and you have a wonderful trophy to matte and frame. The following sections offer some tips for photographing wildlife in different locations.

## Photographing animals at state parks

The easiest way to find spots to photograph wildlife near your home is to Google *state park* followed by the name of the town or county in which you live. Another good source for information are the people in your local camera store or camera club. Be nosy and ask them where their favorite wildlife photography spots are. Make friends with them and ask whether you can tag along on one of their photo shoots. I live in an area that has many state parks. I recently moved to my current stomping grounds and had the good fortune to find a photography buddy who has shown me many of the wonderful wildlife hot spots near my home. Here are some things I've figured out about photographing wildlife in a state park:

✏ **Photograph animals with a long lens.** Unless you're photographing large animals, you'll need a long lens with a focal length that is the 35mm equivalent of 300mm or greater. State parks are animal sanctuaries. Even though the animals are protected, they're wary of humans. A long lens is the only way you can get closeups of the animals.

✏ **Switch to Shutter Priority (Tv) mode (see Chapter 6) and choose the proper shutter speed.** When you're photographing wildlife with a long lens, camera shake due to operator movement is magnified. Choose a shutter speed that's equal to the reciprocal of the 35mm equivalent of the lens you're using. If you're using a lens with a focal length that is the 35mm equivalent of 300mm lens, you have to choose a shutter speed that is at least 1/300 of a second. If your lens has image stabilization, enable it when photographing wildlife. You may have to increase the ISO speed (see Chapter 7) to get the proper shutter speed, especially if you're photographing wildlife in a forest or in dense foliage. A tripod is also useful to stabilize the camera.

✏ **Use a large aperture (small f-stop number) when you create wild-life portraits.** The shallow depth of field you get with a large aperture ensures that your viewer's attention is drawn toward the animal, and not the background (see Figure 8-9).

Figure 8-9: Use a large aperture when creating wildlife portraits.

↳ **Switch to a single autofocus point (see Chapter 7) and focus on the animal's eyes.** If the eyes aren't in focus, you've missed the shot. When you're shooting wildlife with a long lens and using a large aperture, you have a very shallow depth of field, which makes accurate focus a necessity. If the animal's eyes are in focus, your viewer assumes the entire animal is in focus.

↳ **Always travel with a photo buddy.** Many of the animals in state parks are fairly benign. However, some of the inhabitants can be dangerous if you're not careful. Many state parks have bears, alligators, and other animals that can be hazardous to your health when provoked. While you're in the moment photographing a bird, your buddy can watch your back and make sure a dangerous animal like an alligator isn't sneaking up on you. Alligators can pop out of the water like a rocket.

## *Tracking wildlife*

When you photograph animals and birds in the wild, I suggest you switch to AI Servo autofocus mode (see Chapter 7). In this mode, the camera tracks moving objects, such as a deer loping across a meadow. I also suggest you switch to the middle autofocus zone (see Chapter 7). But you do have a problem with AI Servo mode when photographing wildlife. For instance, if a bird that's closer than the subject you're tracking flies into the frame, the camera switches focus to the bird. You can prevent this from happening by enabling a custom function that changes the default tracking method when using the AI Servo autofocus mode. After enabling this function, the camera continues tracking the object it initially locked focus on, regardless of what pops into the frame. Here's how you do it:

1. **Press the Menu button.**

   The last used menu displays.

2. **Use the multi-controller button to navigate to the Custom Functions tab.**

3. **Rotate the Quick Control dial to highlight C.Fn III: Autofocus/Drive (see the left side of Figure 8-10).**

4. **Press the Set button.**

   The custom functions for autofocus and drive display on the camera LCD monitor.

5. **Press the multi-controller button until the number 3 appears in the window at the top-right corner of the camera LCD monitor.**

   The AI Servo AF tracking method options display (see the right side of Figure 8-10).

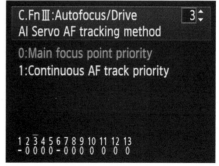

Figure 8-10: Changing the AI Servo autofocus mode tracking option.

6. **Press Set to highlight the current option.**

7. **Rotate the Quick Control dial to highlight 1: Continuous AF Track Priority and press Set.**

   The option is highlighted.

8. **Press the shutter button halfway to return to shooting mode.**

   After you enable this custom function, when you choose AI Servo auto-focus mode, your camera tracks the subject it initially locks focus on instead of tracking other objects that are closer than the object you want to photograph.

## Stabilizing the camera when using long telephoto lenses

When you photograph wildlife with a long telephoto lens, any operator movement is magnified. The simple act of pressing the shutter button, no matter how gently you do it, vibrates the camera. The vibration degrades the resulting images slightly; it doesn't appear to be tack sharp. A tripod is a huge help when using a long lens, but it doesn't stop the vibration. Here are two techniques you can use to minimize the vibration transmitted after you press the shutter button.

### Stabilizing the camera with the Self-Timer

An easy way to stop vibration from reaching the camera is to delay the shutter opening after you press the shutter button. You do this with the Self-Timer as follows:

1. **Press the AF-Drive button.**

2. **While looking at the LCD panel, rotate the Quick Control dial until the 2-second timer icon appears (see Figure 8-11).**

3. **Mount the camera on a tripod.**

4. **Compose your scene and press the shutter button halfway to achieve focus.**

   When the camera focuses on your subject, a green dot appears in the viewfinder.

5. **Press the shutter button fully.**

   Press the shutter button gently. After you press the shutter button, the timer counts down. Two seconds is enough time to stabilize any vibration transmitted to the camera.

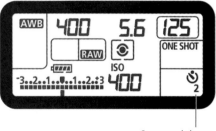

2-second timer

**Figure 8-11:** Stabilizing the camera with the 2-second timer.

### Using Mirror Lockup to stabilize the camera

Your camera can also lock the mirror in the up position before the picture is taken. This helps minimize the transmission of any vibration that occurs when the mirror moves up prior to opening the shutter. This vibration can cause your image to be less than tack sharp. You can enable Mirror Lockup using a custom function as follows:

1. **Press the Menu button.**

   The previously used menu displays.

2. **Use the multi-controller button to navigate to the Custom Functions tab.**

3. **Rotate the Quick Control dial to highlight C.Fn III: Autofocus/Drive (see the left side of Figure 8-12).**

4. **Press the Set button.**

   The custom functions for autofocus and drive display on the camera LCD monitor.

5. **Press the multi-controller button until the number 3 appears in the window near the top-right corner of the LCD monitor.**

   The Mirror Lockup options display (see the right side of Figure 8-12).

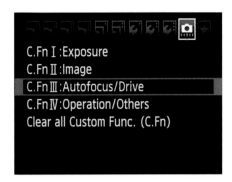
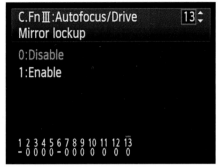

Figure 8-12: Enabling Mirror Lockup.

6. **Press Set.**

   The current Disable option is highlighted.

7. **Rotate the Quick Control dial to highlight Enable and then press Set.**

   The text color changes to blue.

8. **Press the shutter button halfway to return to shooting mode.**

9. **Compose the scene and then press the shutter button halfway to achieve focus.**

   A green dot appears in the right side of the viewfinder.

10. **Press the shutter button fully.**

    The mirror locks up.

11. **Press the shutter button again.**

    The picture is taken.

When you're using Mirror Lockup in bright conditions, press the shutter button as soon as possible after the mirror locks up. Excessive exposure to bright light or the sun can damage the sensor. Make sure you disable Mirror Lockup as soon as you no longer need it.

## Photographing animals at the zoo

If you live in a big city or don't have any nearby nature reserves, you can still get some great shots of wildlife at your local zoo. Visit the zoo on an off day when there will be fewer crowds to contend with and get there just before feeding time. The animals are likely to be more active prior to feeding time.

When you find an animal you want to photograph, make sure no humans (or other signs that you're at a zoo) are in the frame. Switch to Aperture Priority (Av) mode (see Chapter 6) and choose your largest aperture. Move around to compose the best possible picture and then zoom in on the animal. Patiently wait until the animal does something interesting and then take the picture. Stick around for a few minutes, and the animal may do something else that's interesting or amusing. If possible, compose your image so that no telltale signs, such as fence posts or signs, give away that the image was shot at a zoo. If you're forced to take pictures with these objects, crop them out in your image-editing program.

## Photographing birds

Birds run the gamut from downright ugly — the turkey vulture comes to mind — to beautiful and graceful. If you've ever witnessed a snowy egret preening, you've seen a truly elegant bird. When you photograph birds, it's almost like shooting a portrait of a person. You use a telephoto lens with a focal length that is the 35mm equivalent of 85mm or longer. Here are some tips for photographing birds with your EOS 7D:

- **If you're photographing flying birds, switch to the middle autofocus zone and switch to AI Servo autofocus mode (see Chapter 7).** When the camera achieves focus, it updates the focus as the bird flies. If you find that the AI Servo tracking deviates when another bird flies into the scene, check out the "Tracking wildlife" section earlier in this chapter.

- **If you're photographing flying birds, switch to Shutter Priority (Tv) mode (see Chapter 6), and choose a shutter speed of 1/250 of a second or faster.** This freezes the bird's motion. You can also go the other way and choose a slow shutter speed of 1/30 of a second. If you choose the slower shutter speed route, pan the camera with the bird and then the bird's wings will be blurred, giving you an artistic photograph of a bird in flight.

- **Photograph birds in the morning or late in the afternoon.** The light is warmer and more pleasing at these times of day. The harsh midday sunlight isn't a good light for any subject, even your fine feathered friends.

- **Use a long telephoto lens with a focal length that's the 35mm equivalent of 200mm or greater.** If the lens has a large aperture (small f-stop value), you're in business. The telephoto lens gets you close to your subject without spooking the bird. Even protected birds in a city park are unnerved by the sight of a human at close range. Shooting in Aperture Priority (Av) mode (see Chapter 6) and choosing a large aperture helps to blur the background. After all, you want photographs of birds, not the buildings in the background.

✔ **Crouch down to the bird's level for a more natural-looking photograph.** This often means kneeling in wet grass. Wear a pair of old jeans when you photograph wildlife and watch where you kneel; you may kneel in a great blue heron's bathroom.

✔ **Photograph birds on a cloudy day or a foggy morning.** You'll have beautiful diffuse light that won't cast harsh shadows. If the sky is completely overcast, you have no shadows. Photograph birds in heavy fog and you have no signs of civilization (see Figure 8-13). When you photograph birds in low light, you may have to increase the ISO speed setting to get a shutter speed fast enough to take pictures while holding the camera. Alternatively, you can use a tripod.

✔ **Take one shot and then move closer.** Get as close as you think you can without spooking the bird and then take a picture. With one picture in the bank, move closer and take another picture. If you approach the bird cautiously, you won't spook him and may end up getting an extreme close-up.

Figure 8-13: Photograph birds when it's cloudy or foggy.

# Enhancing Your Creativity

Great photographs are made by creative photographers who stretch the envelope. You can enhance your creativity by trying new things. Schedule a time each week when you experiment with new techniques or new equipment. Julia Cameron, author of *The Artist's Way,* calls this an "Artist's Date." When I do this, I limit myself to one or two lenses and I often visit familiar territory. When you photograph a familiar place and the goal is to enhance your creativity, do things differently. Shoot from a different vantage point and use a different lens than you'd normally use for the subject.

When I was out on a recent "Artist's Date," I spotted brilliant flowers on the trail that I was hiking. Normally I'd photograph something like this from above and zoom in. Instead I put my Lensbaby Composer on the camera with the +4 and +10 macro attachments, placed the camera on the grass, and composed the scene through the camera LCD monitor while shooting in Live View mode (see Figure 8-14).

Figure 8-14: Look at things in a new way to enhance creativity.

Great photos always inspire me to get out the camera and take some pictures. Great photos can also help you become more creative. When you see a really great photo, dissect the image and try to figure out what the photographer did to make it so compelling. Was it a camera technique, or did the photographer do some editing after the fact to make the image pop? You can find great photos on the Internet in lots of places. One of my favorite places is http://photo.net. At this Web site, you'll find many types of inspirational photographs from portraits to drop-dead gorgeous landscapes. You can even join Photo.net and upload your own images. Next time you need something to spark your creativity, look at some great photographs.

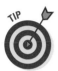

You can enhance your creativity while you're taking pictures. Stretching the envelope is a wonderful way to create interesting photographs. The following points can help you stretch your creativity:

⮐ **Simplify the scene to its lowest common denominator.** A great way to do this is to use a large aperture (small f-stop value) and focus your camera on the most important part of the scene. Or you can compose your picture so the viewer's eye is drawn to a single element in the image.

⮐ **Look for patterns.** Patterns are everywhere. For instance, birds in flight create a unique pattern; scattered leaves in the gutter create interesting random patterns; and flower petals create compelling symmetrical patterns. Of course nothing says you have to compose an image symmetrically.

⮐ **Don't fall in love with your first shot.** Before moving on, think of other ways you can capture the scene. Perhaps you can move to a different vantage point, switch lenses, or select a different aperture. Milk a scene for all it's worth and remember to look down. An interesting photograph may be beneath your feet.

⮐ **Explore your favorite subject and create a theme of photographs.** For example, if you're a cat lover, photograph your cat and then photograph the neighborhood cats. When you photograph the same subjects or places frequently, you think of new ways to create interesting pictures. Your creative juices start flowing and before you know it, you see your favorite subject in a different way. Photographing your favorite subjects and photographing them often helps you master your camera.

My favorite subject happens to be landscapes. I live near the ocean and not very far from a picturesque river, so lately this has been my theme.

## Composing Your Images

A photographer's job is to create a compelling image, an image that makes the viewer take more than a casual glance. When you compose an image properly, you draw your viewer into the image. Lots of rules exist for composing a photo. I mention many of them in this section. Your job as a photographer is to figure out which one best suits your subject. This section is designed to make you think about composition when you look through the viewfinder of your EOS 7D. You can use the camera viewfinder grid or one of the Live View grids as a visual reference. For more information on the Live View grid, see Chapter 5. For more information on the viewfinder grid, check out Chapter 7.

When you compose an image, look for naturally occurring curves that you can use to draw your viewer into the photograph. Curves are everywhere in nature: Birds have curved necks, and roads and paths have curves. The trunk of a tree curves to cope with Mother Nature like the trees in the tundra regions of the Rocky Mountain National Park. Look for naturally occurring curves and compose your image so that the curve draws the viewer's eye into the picture.

Many photographers take pictures in *Landscape* format — the image is wider than it is tall. When you're photographing a scene like a water-fall, a person, or anything that's taller than it is wide, rotate the camera 90 degrees. This is known as *Portrait* format. The photograph of the Anhinga bird in a pine tree (see Figure 8-15) is an example of shoot-ing in Portrait format. A couple other compositional elements are in this

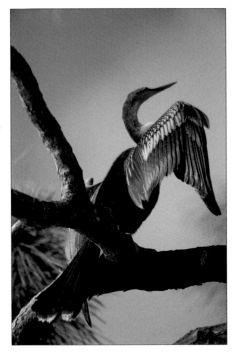

Figure 8-15: Using curves as part of your composition.

picture: The branch leads your eye into the photo, the bird's beak is diagonal to the other elements in the picture, and then there's the lovely curve of the bird's neck . . .

Many photographers place the horizon line smack-dab in the middle of the picture. Boring! When you're photographing a landscape, take a deep breath and look at the scene. Where is the most important part of the scene? That part of the scene should occupy roughly two-thirds of the image. For example, if you're photographing a mountain, the mountain base should be in the lower third of the image. When you're photographing a sunset, place the horizon line in the lower third of the image to draw your viewer's attention to the sky. In Figure 8-16, I wanted to draw the viewer's eye to the massive thunderhead in the distance, so I placed the horizon line in the lower third of the image.

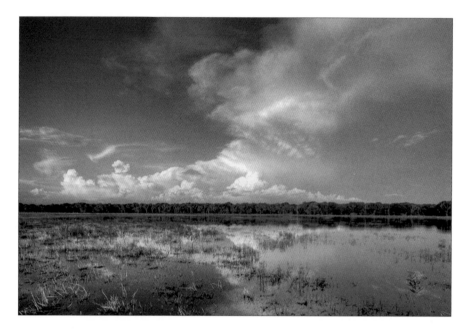

Figure 8-16: Placing the horizon line.

When you're composing an image, you want to draw the viewer's eye to a center of interest in your photo. In a composition rule known as the *Rule of Thirds,* imagine your scene is divided into thirds vertically and horizontally, creating a grid, as shown in Figure 8-17. Compose your picture so a center of interest intersects two gridlines. The grid you can enable in the viewfinder doesn't quite get the job done, but it does give you a point of reference. Figure 8-17 shows a grid overlay inside a facsimile of your EOS 7D viewfinder. Notice where the boy is placed in the sunset image.

Figure 8-17: Aligning an image according to the Rule of Thirds.

The middle of his body intersects two gridlines. This image, therefore, is composed according to the Rule of Thirds.

# Visualizing Your Images

Anybody can point a camera at something or somebody, press the shutter button, and create a photograph. The resulting photograph may or may not be good, but that's not really photography. True photography is studying your subject and then visualizing the resulting photograph in your mind's eye. When you visualize the photograph, you know the focal length needed to capture your vision, the camera settings to use, and the vantage point from which to shoot your image.

# Seeing, Thinking, and Acting

To take a good picture, you need a great camera like the EOS 7D. But even the EOS 7D doesn't guarantee you'll get a good, or even a mediocre, picture. Getting a good picture is all about you: Your unique personality, vision, and creativity is what separates your photographs from those taken by the guy down the street who also owns an EOS 7D. Have you ever looked at two photographs of the same subject, yet they look completely different? That's where the skill and unique vision of each photographer comes into play as well as the photographer's comfort level with his equipment. Compare Ansel Adams's fine art photographs of Yosemite to tourist snapshots from there, and you'll see what I mean.

## Being in the moment

Some people think of photography as a religion. They approach their equipment and their subject with reverence, awe, and wonder. I'm sure you've seen photographs that have brought out those feelings in you. There's no reason you can't create your own jaw-dropping images. One of the best skills you can develop is being *in the moment* — experiencing the present moment and not thinking about anything else but the subject you're about to photograph. If you're distracted by things you have to do later, you can't devote your total focus to the subject you're photographing. When you aren't thinking about anything in particular but are instead observing what's around you, you notice things that'd normally pass you by. When you're in the moment, you notice small details, such as the photogenic pile of leaves in the gutter or the way the sun dapples through the leaves to create an interesting pattern on the wall. You get better pictures when you're focused on what you're doing and not fretting about what you're going to cook for dinner or wear to work the next day.

## Practicing 'til your images are pixel-perfect

If you use your camera only once in a blue moon, your pictures will show it. Letting your gear gather dust in the closet won't help you become a better photographer. Instead, use your camera every chance you get. Consider joining a local camera club because networking with other photographers is a wonderful way to get new information. You can also find a mentor there. Simply strike up a friendship with an experienced photographer and tell her you want to tag along the next time she does a photo shoot.

The best way to practice photography is to take pictures of people, places, and things that interest you every chance you get. Practice your photography when you see something that inspires you, such as a compelling image in a magazine or a picture on the Web. With that inspiration fresh in your mind, grab your camera and take lots of pictures of similar subjects.

I often do a photo walkabout. I grab one or two lenses, my trusty camera, and my imagination and then drive to a part of town I haven't photographed. I then park the car and start exploring. This photo walkabout gives me a chance to learn how to use a new piece of gear or experiment with a new technique, which enhances my creativity. Figure 8-18 shows an image I captured with my Lensbaby Composer with the Creative Aperture kit.

## Becoming a student of photography

When you decide to seriously pursue photography, you can find a lot of resources. Great portrait photography is all around you. For instance, you'll find portraits of the rich and famous in magazines like *People* and *US Weekly,* or you can find great pictures of places in magazines like *Outdoor Photographer* or *National Geographic.* You can find great pictures of things in magazine advertisements. Your local newspapers and magazines are also great resources for great images.

When you see an interesting image in a magazine, study it carefully. Try to determine the type of lens the photographer used and then try to determine whether the photographer shot the picture in Aperture Priority or Shutter Priority mode. After you ascertain which shooting mode the photographer used:

- **In Shutter Priority mode,** try to determine whether the photographer used a fast or slow shutter speed.
- **In Aperture Priority mode,** try to determine whether the photographer used a large or small aperture.

Also try to determine how the photographer illuminated the subject. Did he use available light, camera flash, or fill flash. If you study great images carefully, you can get a rough idea of the settings the photographer used to take the picture.

Figure 8-18: Practice makes perfect.

Another great way to understand portrait photography is to study the masters:

- ✔ **Annie Leibovitz or Greg Gorman:** If you're into portrait photography, study their work.

- ✔ **Arnold Newman:** Google him if you like to study the work of the old portrait photography masters. He created some wonderful environmental portraits.

- ✔ **Henri Cartier-Bresson:** If you like the gritty style of street photography, Google him.

- ✔ **Ansel Adams or Clyde Butcher:** If you enjoy landscape photography, study their work. Clyde Butcher is affectionately known as the "Ansel Adams of The Everglades."

You can also find lots of examples of great photography at www.photo.net.

## Never leave home without a camera

You can't ask a photo opportunity to wait while you go home to get your camera. Photo opportunities happen when you least expect them. Therefore, never leave home without a camera, and the camera in your cellphone doesn't count.

If you're nervous about taking your expensive EOS 7D with you wherever you go, I don't blame you and I actually feel the same way. That's why I bought a relatively inexpensive point-and-shoot camera that I carry with me everywhere I go. When I see something I want to photograph, I reach in the glove box of my car, grab my trusty point-and-shoot camera, and snap the picture.

Canon makes the PowerShot G11, a wonderful point-and-shoot camera with professional features; it's a great camera to augment your EOS 7D. The G11 won't fit in your shirt pocket, but it will fit in your pants pocket, coat pocket, or your glove box.

## Waiting for the light

Landscape photographers arrive at a scene they want to photograph and often patiently wait for the right light or until a cloud moves into the frame to get the perfect picture. Sometimes they'll backtrack to a spot where they know conditions will be better. Good landscape photographers are very patient, which is a virtue that all photographers need to cultivate. When you arrive at a beautiful scene but the light is harsh, stick around a while or come back later when you know the lighting will be better.

 Also wait when you're shooting candid pictures. Minutes may pass with nothing exciting happening, but don't put away the camera yet. If you wait patiently, something will happen that piques your interest and compels you to press the shutter button.

# Defining Your Goals

Before you snap the shutter button, get a clear idea of what the final image will look like. If you don't have a goal for the picture or the photo shoot, you're wasting your time, and if you're photographing a person, you're wasting your time and your subject's time. Of course, the goal doesn't have to be a great image. You can go on a photo shoot to experiment with new ideas, master a new technique, or experiment with a new lens. After all, practice makes perfect.

When you know why you're taking the picture, you'll know what settings to use, how to light the photo, which lens to use, and so on. If you're creating an image for a friend or a client, adhere to the standard rules of composition. However, if you're creating photographs for yourself, the sky's the limit and you can get as creative as you want. You can shoot from different and unique vantage points, tilt the camera, break the composition rules, use an unorthodox lens, and so on.

## What's your center of interest?

When you create a picture of a person or place, decide what the main point of interest is and how you'll draw the viewer's eye there. For some photos, the point of interest may be a person's face or a landmark, such as the Lincoln Memorial. If you're creating a portrait of a pianist, a picture of him playing the piano would be appropriate and your center of interest could be his hands on the keys.

Sometimes, you have more than one center of interest. When this occurs, you can compose the photo in such a manner that one center of interest leads the viewer's eye to the other center of interest. For example, if you're photographing a cellist on a beach near San Francisco's Golden Gate Bridge, you have two centers of interest — the musician and the bridge. Your job is to marry these two centers of interest to create a compelling image and guide your viewer's eye through the photo. You also need to compose the photo so that one center of interest doesn't dominate the other.

## What's your best vantage point?

The decision you make on your best vantage point depends on what you're photographing. In most instances, you want to be eye to eye when photographing a person. If you're photographing a landscape and the sky or a mountain is the dominant feature, choose a vantage point that causes the sky or mountain to dominate the upper two-thirds of the image. If you're photographing a scene in which a lake or the ocean is the dominant feature, lie on your belly and compose the photo so that the water feature occupies the bottom two-thirds of the image. Yup. The old Rule of Thirds is at work. Figure 8-19 shows good composition for a scene in which the sky is the center of interest.

## What else is in the picture?

The only time you aren't bothered by other objects is when you shoot a portrait against a solid color background, such as a wall or a cloth backdrop. But even then, you have to notice everything in the viewfinder or LCD monitor. If your subject's too close to the background, you may notice wrinkles from a cloth backdrop or texture from a wall. If this happens, ask your subject to move forward and then shoot the picture in Aperture Priority mode with your largest available aperture. Focus on your subject, and the bothersome details in the background will be out of focus.

When you're taking pictures on location, you often have unwanted objects, such as telephone poles in the background. Sometimes you have to decide whether to include the distracting elements in the image and then delete them in an image-editing application, but that takes time. If you can move your subject slightly and make the distracting elements disappear, that's always your best option. You can also move to a different place in the same general area with a pleasing background and no distracting elements.

When you're photographing a landscape, take a careful look in the frame. Are power lines visible? Are ugly buildings or trash in the frame? If so, move slightly until the distracting elements are no longer in it.

## The genius of digital photography

Immediacy is the genius of digital photography. The old days of waiting for your film to be developed and returned from the lab are gone. You know if you got the shot as soon as it appears on your camera's LCD monitor. You also never have to pay for film again. Ever. But for the most part, people have made the switch to digital because they can capture their images on cards the size of a postage stamp, they don't want to worry about film expiration dates, and so on.

Figure 8-19: Using composition to draw your viewer to the center of interest.

With these advantages comes a curse: If you're not careful, the very genius of digital photography can turn you into a bad photographer. You don't pay for film, so you tend to shoot more images, which is a good thing if you take good photographs. But if you just shoot everything that pops up in front of your camera, you're going to get a lot of bad photos that end up in the trash. To take advantage of the genius of digital photography, be in the moment and do your best to make every image a keeper. Get it right in the camera and don't rely on image-editing applications to fix a bad image. Image-editing applications like Photoshop are designed to enhance a correctly exposed, well-composed image and make it better. I cringe when I hear a photographer say, "I'll Photoshop it." Photoshop is not a verb; it's a tool.

Practice also enters into the equation. When you know your camera like the back of your hand and you apply all your attention to your photography, you're well on the way to utilizing the genius of digital photography to its fullest and capturing compelling photographs.

# Part III
# Editing and Sharing Your Images

The 5th Wave By Rich Tennant

"...and here's me with Jessica Alba. And this is me with Beyonce and Heidi Klum..."

aking pictures is a lot of fun. But a time comes when you have to get them out of the camera and share them with your friends and relatives. In this part, I show you how to use Canon software to edit your images. If you let the camera process the images as JPEG files, I show you how to edit them with ZoomBrowser EX. If you shoot RAW, you get a lot of brownie points because in my humble estimation, it's the best way to go. I show you how to edit your RAW files in Canon Digital Photo Professional. I also show you how to print your files from both applications.

# 9

# Editing Your Images

*T*aking pictures is lots of fun. But eventually you fill up all your cards. Then it's time to download them to your computer and see what you have. You can do this with third-party software, such as Photoshop Lightroom and Photoshop. If you don't have an image-editing application on your computer, you can use *ZoomBrowser EX,* the software Canon provides with the camera. ZoomBrowser EX isn't as powerful as Lightroom or Photoshop, but you can get a lot done with it.

You have a two-pronged attack for organizing and editing your work. Canon ZoomBrowser EX is a utility you use to download and organize your work. You can also edit JPEG files in ZoomBrowser EX. But if you use the RAW format to capture your images, you need to bring in the heavy artillery. Canon Digital Photo Professional 3.7 gives you the tools to edit your RAW images and export them. In this chapter, I show you how to use both applications.

## Introducing the Canon ZoomBrowser EX

The Canon ZoomBrowser EX is your first weapon for organizing images. You use the utility to download your images, rate your images, rename your images, and more. If you can't get 'er done in ZoomBrowser EX, you have options to launch Canon Digital Photo Professional. All the utilities are present on the Canon EOS Digital Solution Disk, version 21. If you've installed the software, you're ready to play. If not, give your eyes a break and install the software. Figure 9-1 shows the Canon ZoomBrowser EX in all its glory.

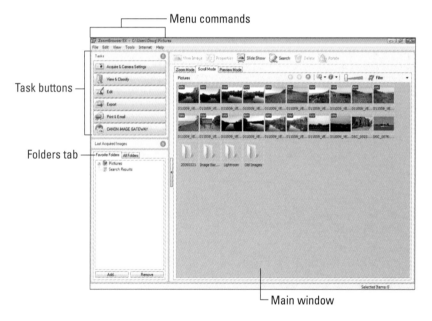

**Figure 9-1:** The Canon ZoomBrowser EX.

ZoomBrowser EX shows thumbnails of your images in a main window. The window on the left side of the application contains task buttons and two tabs to navigate through your image folders. When you select an image, you have different viewing options.

## Downloading Your Images

The first step in your image-editing journey is downloading images. You can download images directly from the camera or from a memory card reader.

I suggest the latter. A memory card reader gets the job done faster. To download images to your computer from the camera:

1. **Connect the USB (Universal Serial Bus) cable supplied with your camera to your computer and to the camera (see Figure 9-2).**

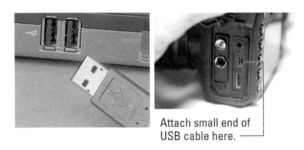

Attach small end of
USB cable here. ———

Figure 9-2: Connect your camera to the computer.

2. **Click the Acquire & Camera Settings button, which is on the left side of the workspace.**

   The button expands to show the available tasks (see Figure 9-3).

3. **Click the Connect to EOS Camera button.**

   The EOS Utility 7D application appears in the ZoomBrowser EX window (see Figure 9-4).

4. **Click Starts to Download Images.**

   A dialog box appears showing you the progress of the download, and a Quick Preview window displays each image while it downloads to your computer. The access lamp on your camera flashes while the images download.

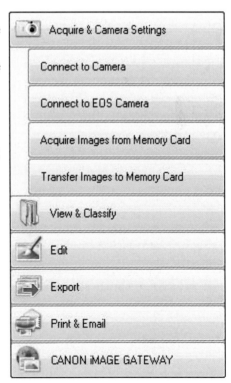

Figure 9-3: The Acquire & Camera Settings commands.

After the download is complete, the images appear in the ZoomBrowser EX's main window (see Figure 9-5).

The Scroll mode is the default viewing mode. You can switch to a different viewing mode by clicking the desired icon at the top of the window. Any images or movies you protected in the camera have a lock icon above them, indicating they're protected in ZoomBrowser EX as well.

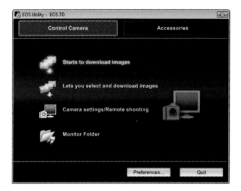

Figure 9-4: Downloading with the EOS Utility 7D application.

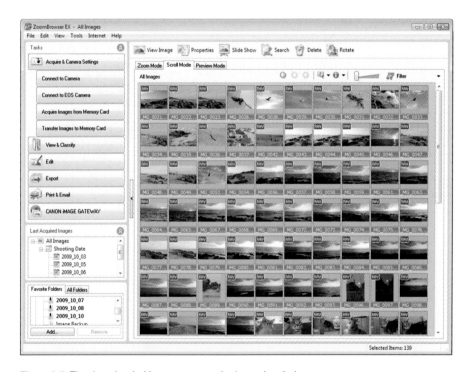

Figure 9-5: The downloaded images appear in the main window.

## Using external card readers

The USB cable that shipped with your camera makes it possible to download images to your computer; however, downloading images uses your camera's battery power. If you attempt a download with a low battery, you run the risk of corrupting images or the memory card, if the battery exhausts its power during a lengthy download. You can also download your images with an external card reader. Connect an external card reader to a computer USB port and you're ready to download images with ZoomBrowser EX or a different application. Many card readers accept multiple image card formats. For example, if you use a camera like the Canon G10 for a second point-and-shoot camera, you know that camera uses SD (Secure Digital) cards. Many card readers accept the CF (CompactFlash) cards your EOS 7D uses as well as SD cards.

*Courtesy of SanDisk*

# Rating, Renaming, and Keywording Images

ZoomBrowser EX downloads your images into folders by the date they were photographed. The application inherits the default camera name of *img* followed by a number. Of course, that makes them kind of hard to find. You bought an EOS 7D to shoot lots of pictures. Trying to find one picture out of thousands is like looking for a needle in a haystack. Fortunately, renaming a lot of images in one fell swoop is a fairly easy task in ZoomBrowser EX. You can also rate images and add keywords to images, which makes them easier to find as well.

I find it's easier to get all your housekeeping done right after you download images. The first thing you need to do is rename images. To rename images:

1. **Select all the images you downloaded.**

   To select all images, click the first image, and then Shift-click the last image. You can rename all images at once.

2. **Click the View & Classify button.**

   The menu expands to show the View & Classify options.

3. **Click the Rename Multiple Files button.**

   The application refreshes to show the renaming options (see Figure 9-6).

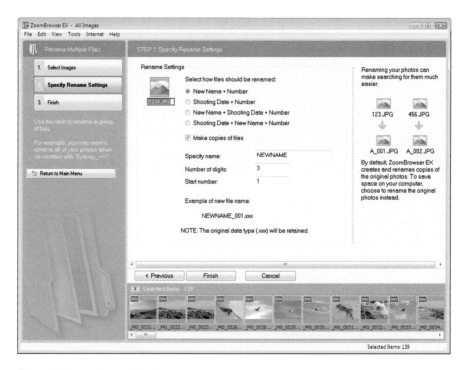

Figure 9-6: Renaming multiple images.

4. **Choose a renaming option.**

   I like to show as much information as I can with the image. Therefore, I opt for the Shooting Date + New Name + Number option.

5. **Enter a name for the images.**

   This is the base name for each image you're renaming. I generally use an abbreviation for the place where the photos were taken. For example, if I shot some photos in Sarasota, the abbreviation is SARA.

6. **Deselect the Make Copies of Files check box.**

   This is selected by default, but face it, making copies of 18-megapixel images gobbles up your hard drive in a New York minute. I always deselect this option.

7. **Click the Finish button.**

   ZoomBrowser EX renames the images. A dialog box shows the progress. This may take some time if you're renaming a lot of images. After you rename the images, you find them in the folders that were created when they were downloaded.

After renaming the images, rank them and add keywords. In the days of film, photographers would put their slides on a light box and give them a rating from one to five stars, with five-star images being the best of the lot. ZoomBrowser EX assigns a default rating of two stars to each image you download. You can assign each image a rating of up to three stars.

Using keywords is another method of identifying images. You can add a keyword to an image that reflects the type of photography, the place in which the image was photographed, the name of the person in the photograph, and so on.

If you're like me, you shoot a lot of images at the same place, and they have the same basic keywords. You can add keywords to multiple images as follows:

1. **Click the folder into which the images were downloaded.**

   You find the folders listed by date in the All Folders tab.

2. **Select the images that you want to add keywords to.**

   You can select contiguous images in the ZoomBrowser EX window by pressing the Shift key, clicking the first image you want to select, and then clicking the last image you want to select.

3. **Click the Properties button.**

   The Properties dialog box appears (see Figure 9-7).

**4. Click the View/Modify Keywords button.**

The View/Modify Keywords dialog box appears (see Figure 9-8). Notice that you have four categories into which you can add keywords. You can apply multiple keywords to each image you've selected.

**5. In the text box under the applicable category, type a keyword that helps you identify the image.**

I generally start with adding the town where I shot the image to the Places category.

**6. Click the plus (+) button.**

The keyword is added to the list.

**7. Repeat Steps 4 and 5 to add any additional keywords that help describe the photographs.**

You could add the person's name, the word *sunset* if it was a sunset shot, and so on.

**8. After you finish adding keywords, click the blank box to the left of each keyword.**

A check mark appears next to the keywords (see Figure 9-9).

**9. Click the desired rank for the selected images.**

If all the images don't deserve the same rank, don't change the default ZoomBrowser EX rank yet.

Figure 9-7: Adding keywords to multiple images.

10. **Click OK to apply the keywords to the selected images and then close the Properties dialog box.**

11. **Select the images that deserve the same rank, repeat Steps 1–4, choose the desired rank for the images, and then click OK.**

    ZoomBrowser EX assigns the keywords and ranks the images in one operation. How cool is that?

Figure 9-8: Adding keywords to the list.

Figure 9-9: Adding keywords to multiple images.

## Adding Comments to Images

You can also add comments, which appear as *metadata,* to images. Metadata is data, such as shooting information, that's recorded with the image when you shoot it and data you add, such as keywords and comments. You can add whatever comment you want that will help you remember the image. To add a comment to an image:

1. **Select the image in ZoomBrowser EX and then click the Properties button.**

   The Properties dialog box appears.

2. **Click the Comment down arrow.**

   The Comment text box appears (see Figure 9-10).

3. **Type the comment and then close the Properties dialog box.**

   The comment is applied to the image.

You can also apply comments to several selected images, but you have to apply one comment at a time. When you select multiple images and open the Properties dialog box, Next and Previous buttons appear at the bottom of the dialog box. Apply a comment to one image, and then click Next to view the properties of the next image and apply a comment to it. Continue until you've applied comments to the desired images.

Figure 9-10: Applying a comment to an image.

# Changing Your View

ZoomBrowser EX is quite versatile. You have three different ways to view your images. You can view images in Zoom mode, Scroll mode, and Preview mode. The mode you choose depends on the task you're performing. You can perform all tasks in Zoom and Scroll mode. In Zoom and Scroll mode, you can perform changes to multiple images. In Preview mode, you work on one image at a time.

To view images in Zoom mode:

1. **Click the Zoom Mode tab.**

   The view shows very small thumbnails (see Figure 9-11). Pause your cursor over a thumbnail to reveal a larger image.

Figure 9-11: Viewing images in Zoom mode.

2. **Drag the Zoom slider to increase magnification.**

   The thumbnails become bigger, and a Navigator window appears (see Figure 9-12).

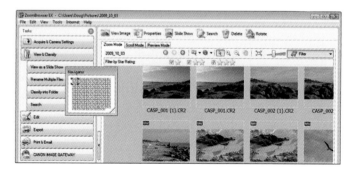

Figure 9-12: Using the Navigator.

3. **Click an area inside the Navigator and then drag to view a different set of images.**

   As you drag inside the Navigator, the main window refreshes to show different thumbnails.

4. **Double-click the thumbnail to view it the Preview window.**

To view images in Scroll mode:

1. **Click the Scroll Mode tab.**

   The view shows larger thumbnails (see Figure 9-13).

2. **Drag the Zoom slider to increase magnification.**

   The thumbnails become larger.

3. **Filter the images by star rating by selecting the applicable check box.**

   One-, two-, and three-star images are shown by default. Click a check box to deselect it and hide images with a specific rating.

4. **Click the Filter drop-down list.**

   You can reveal all images, or by star rating.

To view images in Preview mode:

1. **Click the Preview Mode tab.**

   One image displays with information (see Figure 9-14). Notice you can also add a comment, change the star rating, and protect the image.

**Figure 9-13:** Viewing images in Scroll mode.

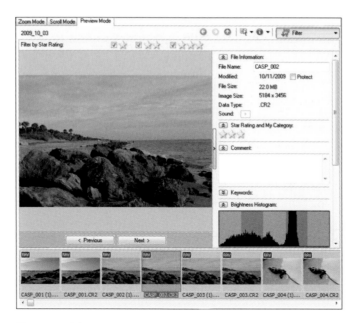

**Figure 9-14:** Viewing images in Preview mode.

2. **Scroll down to reveal additional information about the image.**

   When you see a down arrow, click it to reveal additional information about the image. Figure 9-15 shows shooting information, which is metadata that's recorded with the image when you take the picture.

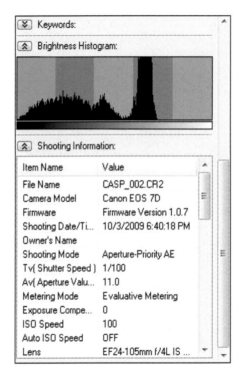

Figure 9-15: Displaying additional information.

# Comparing Multiple Images

When you're sorting through lots of images from a photo shoot, some of the images will look very similar. This is when it's helpful to view them side by side, or in groups. In ZoomBrowser EX, you can view two, three, or four images at once. Just follow these steps:

1. **In Zoom mode or Scroll mode, select the number of images you want to compare.**

   You can compare two, three, or four images.

2. **Click the View Image button.**

   The first image appears in another window (see Figure 9-16).

Show buttons

Figure 9-16: Viewing an image in another window.

3. **Click the applicable Show button at the top of the browser.**

   You can view two images split horizontally (ideal for images shot with the camera held horizontally), two images side by side (ideal for images shot with the camera held vertically), three images side by side, or four images. Figure 9-17 shows the three-image display.

Figure 9-17: Comparing images.

# Backing Up Your Work

You work hard to capture great photographs with your EOS 7D. Your work in ZoomBrowser EX and Canon Digital Photo Professional fine-tunes your images, but a computer crash or hard drive failure will wipe out all your images in a heartbeat. Canon lets you save images to a CD, but that's 700MB, less than a memory card. I suggest you invest in a good external hard drive and use an application to back up your work. I back up my images to a 1TB hard drive. After I back up the images, the hard drive is offline until my next backup, which minimizes wear and tear on the hard drive.

I know some photographers who leave their external hard drives online all the time. And some of them have paid the price when the drive crashed and burned. I use the SyncBackSE program to back up my work: It's quick, easy to use, and very intuitive. For more information on SyncBackSE, visit `www.2brightsparks.com/syncback/sbse-features.html`.

# Organizing Your Images

By default, your images are downloaded into the Pictures folder. You can, however, organize your work by creating new folders, moving images into different folders, and deleting images.

To create a new image folder:

1. **In the ZoomBrowser EX All Folders tab on the left side of the workspace, select the root folder into which you want to create a subfolder.**

2. **Choose File⇨New Folder.**

   The New Folder dialog box appears (see Figure 9-18).

3. **Enter a name for the folder and then click OK.**

   A new folder is born.

Figure 9-18: Creating a new folder.

To move images to another folder:

1. **Click the Zoom tab to switch to Zoom mode.**

   Your new folder and the images in the root folder display.

2. **Drag images from the root folder into the other folder**.

   Alternatively, you can select the image and drag it into the desired folder, as displayed in the All Folders tab.

To delete one or more images:

1. **Select the images and press the Delete key.**

   A dialog box appears asking you to confirm deletion.

2. **Click OK.**

   The images are deleted.

# Editing JPEG Images in ZoomBrowser EX

You can view all images you download in ZoomBrowser EX, but you can edit only JPEG images. You can select RAW images in ZoomBrowser EX and then edit them in Canon Digital Photo Professional. When you opt to edit a JPEG

image in ZoomBrowser, you can correct red-eye, adjust sharpness, trim the image, apply an auto-adjustment, and insert text. Alternatively, you can edit the image in another application. I can't cover all the image-editing tools in ZoomBrowser EX — doing so is beyond the scope of this book. However, in the following sections, I cover the most important ones.

You can adjust the color of a JPEG image in ZoomBrowser EX. You can also change the brightness, saturation, and contrast. You can even adjust the RGB (Red, Green, Blue) channels and levels as well as use the Tone Curves Adjustment menu option to adjust brightness for different tone values. To adjust image color:

1. **Select the image you want to edit and then click the Edit button.**

   The menu drops down to reveal the editing options.

2. **Click Edit Image.**

   The Pick Editor dialog box appears (see Figure 9-19).

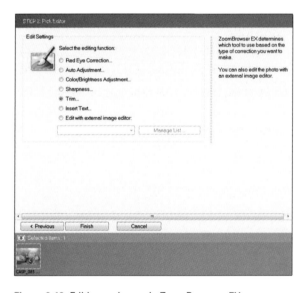

Figure 9-19: Editing an image in ZoomBrowser EX.

3. **Select the Color/Brightness Adjustment option and then click the Finish button.**

   The Color/Brightness Adjustment dialog box appears (see Figure 9-20).

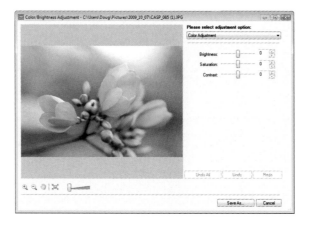

**Figure 9-20:** Adjusting image brightness, saturation, and contrast.

4. **Drag the sliders to adjust brightness, saturation, and contrast.**

   The settings you choose are a matter of personal taste. Don't go too far over the top with saturation though because you might create some colors that can't be printed.

5. **After you make your adjustments, click the Save As button.**

   The Save As dialog box appears (see Figure 9-21).

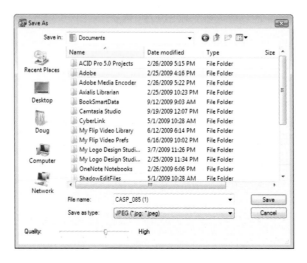

**Figure 9-21:** Saving your edited image.

**6. Choose a format from the Save as Type drop-down list.**

You can save the image as a JPEG or TIFF file. If you save the image as a JPEG file, you can specify image quality. A higher image quality creates a better-looking image at the expense of a larger file size. If you save the image as a TIFF file, you can use lossless compression to minimize the file size or specify no compression.

**7. Enter a filename and specify the folder that the image will be saved to.**

TIP

Image editing is destructive. I urge you to give the image a different filename and store it in a different folder. That ensures you'll have the original image to edit at a later date.

In addition to adjusting the brightness, saturation, and contrast, you can adjust the color for the red, green, and blue channels by choosing an option from the Color Adjustment drop-down list, as shown in Figure 9-20. This is fairly advanced image editing, as is one of the other options on the list, Levels. The Tone Curve Adjustment option lets you adjust tonality in specific brightness ranges. This option is useful and fairly easy to master. To adjust the tone curve of a JPEG image:

**1. Follow Steps 1–4 from the preceding steps.**

You're in the Color/Brightness Adjustment dialog box.

**2. Choose Tone Curve Adjustment from the Please Select Adjustment Option drop-down list.**

The dialog box refreshes to show the Tone Curve dialog box (see Figure 9-22). The diagonal line is the tone curve. The line isn't a curve now because it's applying brightness information in a linear fashion from shadows (the left side of the curve), midtones (the middle section of the curve), and highlights (the right end of the curve). When you add points for different tonal values along the curve and drag them to adjust brightness, you see a curve.

**3. Click a point on the curve to make an adjustment for that tonal value.**

Click a point near the bottom of the curve to modify the brightness of shadow areas, a point in the middle of the curve to change the brightness of the midtones, and a point near the top of the curve to change the brightness level for highlights. After you click a point, you see values in the Input and Output text boxes (see Figure 9-23).

**4. To adjust a point, drag it up to make the tonal range brighter or down to make the tonal range darker.**

You can also change the value in the Output text box. A typical use for a tone curve is to apply more contrast to the image, with one point near the bottom of the curve, one point in the middle of the curve, and one point near the top of the curve. Study Figure 9-23 and note the input and output values for the shadow, midtone, and highlight points.

I haven't changed the value for the middle point, which is smack-dab in the middle of the tonal value range. Doing so would increase the overall brightness of the image. Brightening the highlights and darkening the shadows increase image contrast.

5. **After you make your adjustments, click Save As and then in the Save As dialog box, follow the prompts to save the image.**

Figure 9-22: The Tone Curve dialog box.

Figure 9-23: Adjusting the tone curve.

## Sharpening an Image

You can sharpen an image in ZoomBrowser EX. When you sharpen an image, the application locates image edges and applies additional contrast to make the image appear sharper. To sharpen a JPEG image:

1. **Select the image you want to edit and then click the Edit button.**

   The menu drops down to reveal the editing options.

2. **Click Edit Image.**

   The Pick Editor dialog box appears.

3. **Select the Sharpness option and click the Finish button.**

   The Sharpness dialog box appears (see Figure 9-24).

Figure 9-24: Sharpening an image.

***Note:*** You also see a tab for Unsharp Mask. This is an advanced image-editing technique and beyond the scope of this book. However, if you're interested in knowing more about how to use this method of sharpening, click that tab. In the upper-right corner of the tab, you see a button with a question mark (?) icon. Click the button to summon help.

4. **Drag the slider to sharpen the image.**

You can oversharpen an image. As you drag the slider, pay attention to the edges. If you see something that looks like a halo, you've gone too far, Jamie.

# Working with RAW Files in Digital Photo Professional

When you capture an image with the RAW file format, you have more data to work with. The images have a greater bit depth than JPEG images, which means you have more colors to work with. I use Adobe Photoshop Lightroom to edit and sort my RAW images. I find it's very intuitive, and I can edit a massive amount of images in a short amount of time.

Adobe Photoshop and Adobe Photoshop Elements have a Camera RAW editor that enables you to edit RAW images. If you're just experimenting with the RAW format or don't have one of the aforementioned applications, you can edit your work in Canon Digital Photo Professional. You can jump from ZoomBrowser EX directly to Canon Digital Photo Professional, or launch the application and begin editing.

The following steps show you how to edit RAW files in Canon's Digital Photo Professional:

1. **Launch Digital Photo Professional.**

   When you install Canon software, several shortcuts are sprinkled on your desktop. You can either click the Digital Photo Professional shortcut or launch the application from your computer menu. In Windows, you'll find Digital Photo Professional in the Canon Utilities Folder on your Start menu.

   Any of those methods launches Digital Photo Professional (see Figure 9-25). The application displays thumbnails for all images that reside in the same folder as the image you select in ZoomBrowser EX. A complete tutorial of Digital Photo Professional is beyond the scope of this book; however, the following steps show you how to process a RAW image in the application.

2. **Select the image you want to edit.**

   The images you download with ZoomBrowser EX are stored in subfolders of the Pictures folder. The default name of the folder is the date that the image was photographed. You'll find the folders on the left side of the interface.

3. **Choose File⇨Open in Edit Window.**

   The image opens in another window. Notice the menus on top of the
   Edit window (see Figure 9-26). These are your commands for editing an
   image in Canon Digital Photo Professional. In the Tools menu, you find
   a Start Stamp tool that enables you to clone pixels from one part of the
   image to another. There's also a command to trim the image.

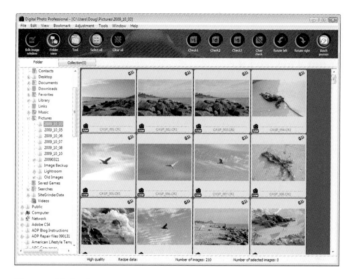

Figure 9-25: Editing RAW images in Digital Photo Professional.

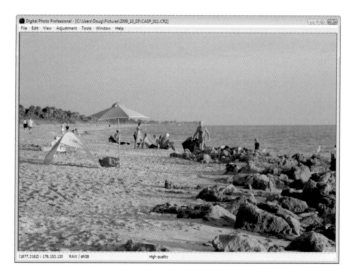

Figure 9-26: Editing an image in the Edit window.

Unfortunately a detailed tutorial of every command is beyond the scope of this book. The application does offer help that you can use if you decide to explore some of the more esoteric commands. The following steps show you how to tweak an image with the application.

4. **Choose View⇨Tool Palette.**

A floating Tool palette appears above the Edit window (see Figure 9-27).

5. **Drag the Brightness Adjustment slider to brighten or darken the image.**

As you drag the slider, you see the image change in real time.

6. **To quickly adjust the white balance, click the eyedropper in the White Balance section, and then click an area inside the image that should be pure white, black, or gray.**

After you click inside the image, the white balance changes. If you don't like the results, click again. Alternatively, you can click the drop-down arrow and choose an option from the White Balance Adjustment drop-down list. You can choose As Shot to return the image to the white balance determined by the camera or choose Auto to let Digital Photo Professional adjust the white balance. The same options found on your camera — Daylight, Cloudy, Shade, and so on — are also found in this drop-down list.

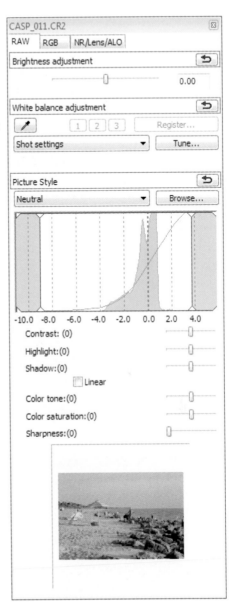

Figure 9-27: Using the Tool palette.

If you're really adventurous, click the Tune button to open a color wheel that you use to fine-tune the white balance and remove any colorcast. You may not get great results, so use this at your own risk.

7. **Choose an option from the Picture Style drop-down list.**

   The picture style the image was photographed with displays in the window. But these are RAW files, which can be folded, spindled, and mutilated. You can choose a different picture style from the drop-down list to change the look of the image.

8. **Drag the Contrast, Highlight, and Shadow sliders to fine-tune these tonal areas.**

   You can increase or decrease contrast for all tonal ranges. As you make your changes, the image updates in real time and the curve in the window above the sliders updates as well.

9. **Adjust the Color Tone and Color Saturation sliders.**

   Drag the sliders while reviewing the thumbnail.

10. **Adjust image sharpness with the Sharpness slider.**

    Drag the slider to increase image sharpness.

11. **After you make your adjustments, close the Tool palette.**

Digital Photo Professional doesn't store the changes after you close the application. Therefore, you need to save the changes in another file format. When you launch Digital Photo Professional again, you can apply different edits to the RAW file and save the image with the new changes using a different filename. To save your edited work:

1. **Choose File⇨Convert and Save.**

   The Convert and Save dialog box appears (see Figure 9-28).

2. **Enter a filename and location for the edited image.**

   If desired, you can use the same filename. The file format in which you can save the image won't overwrite the RAW file. You can save the file in the same folder or create a new folder in which to store your edited images.

3. **Choose a file type.**

You can save the file in any of the following formats:

- *Exif-JPEG:* Saves the edited image as a JPEG file.

- *Exif-TIFF (8Bit):* Saves the edited image as an 8-bit TIFF file.

- *TIFF (16Bit):* Saves the edited image as a 16-bit TIFF file. The file size of this format is considerably larger than the 8-bit TIFF format, but you have more information to work with if you edit the image in an application like Photoshop.

- *Exif-TIFF (8Bit) + Exif-JPEG:* Saves an 8-bit TIFF file and JPEG file.

- *TIFF (16Bit) + Exif-JPEG:* Saves a 16-bit TIFF file and an 8-bit JPEG file.

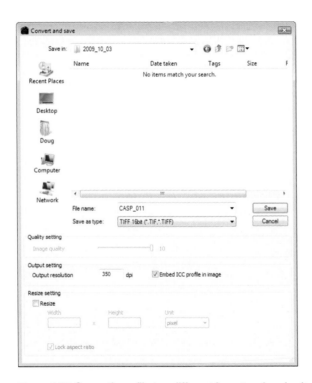

Figure 9-28: Converting a file to a different format and saving it.

If you choose a JPEG option, you can specify the quality.

4. **Accept the default JPEG quality of 10 or drag the slider to specify a different quality.**

The default setting of 10 produces a high-quality image at the expense of a large file size. If you specify a lower quality, the image quality is poorer and the file size is smaller. When you specify a lower quality, Digital Photo Professional compresses the file and data is lost.

5. **Accept the default resolution of 350 dpi (dots per inch) or enter a different resolution.**

With most printers, you can get by with a resolution of 300 dpi.

6. **Accept the default option to embed the ICC (International Color Consortium) profile or click the check box to reject the option.**

Your best option is to embed the profile with the image.

7. **(Optional) Select the Resize check box.**

If you use this option, the Width and Height text boxes appear with the current dimensions of the image. The Lock Aspect Ratio check box is selected by default. If you deselect this option and change one value, the other value won't change and the image won't look right.

8. **(Optional) Enter a new value for width or height.**

When you enter one value, Digital Photo Professional does the math and supplies the other value.

9. **Click Save.**

Your changes to the image(s) are saved.

## Using External Image Editors

You can edit images from ZoomBrowser EX in an external image-editing application, such as Photoshop. If you use ZoomBrowser EX to organize and download your images but want to use a more robust image-editing application to edit your images, this is the ideal solution. You can also edit RAW images from Digital Photo Professional in Photoshop. This section shows you how to do both.

To launch Photoshop from ZoomBrowser EX:

1. **Select the JPEG image you want to edit, click the Edit button, and then click Edit Image.**

   The Pick Editor window appears.

2. **Select the Edit with External Image Editor option (see Figure 9-29).**

   Notice there are no options for the external editor. You need to show ZoomBrowser EX the location of your preferred image editor.

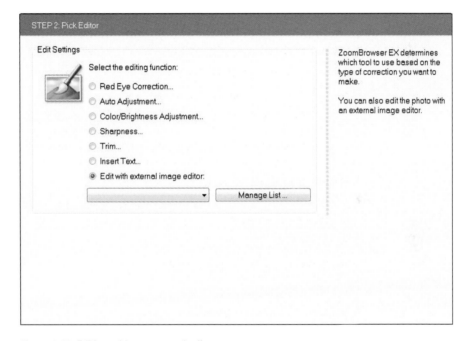

Figure 9-29: Editing with an external editor.

3. **Click the Manage List button.**

   The Manage Editing Tools dialog box appears (see Figure 9-30).

Figure 9-30: Managing your editing tools.

4. **Click the Add button.**

   The Open dialog box appears.

5. **Navigate to the EXE file for your favorite image-editing application, as shown in Figure 9-31, and then click the Open button.**

   The EXE file is listed on the Manage Editing Tools dialog box.

6. **Click OK.**

   Your favorite image-editing application appears on the External Image Editor button (see Figure 9-32). You can add additional image editors by following Steps 3–6. The additional editors appear on the drop-down list.

7. **Click the External Image Editor button.**

Your image opens in your preferred image-editing application.

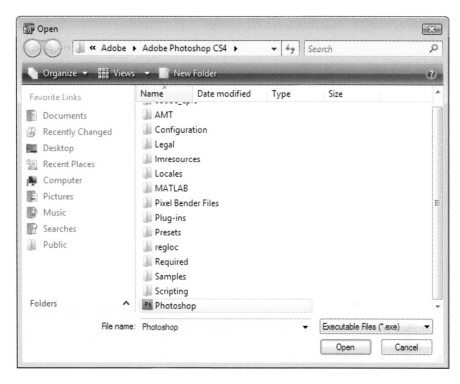

**Figure 9-31:** Adding an image editor to your editing tools.

When you install Digital Photo Professional, it detects applications, such as Photoshop, and adds the ability to edit the image in that application as a menu command. If you have an application that Digital Photo Professional recognizes, it appears on the menu. I have Photoshop installed on my computer so that's the application Digital Photo Professional recognized. All I have to do to edit an image in Photoshop that I select in Digital Photo Professional is choose Tools⇨Transfer to Photoshop. This opens the file as a 16-bit TIFF file in Photoshop.

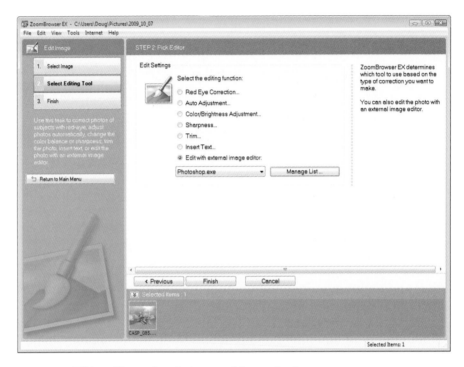

Figure 9-32: Editing with your favorite image-editing application.

# Creating Prints from Your Images

*P*rinters have come a long way. Back when I started printing my own images, printer ink cartridges had three inks. Then printers graduated to cartridges with six inks. Now the really good printers have eight cartridges, which print stunning color as well as black and white prints. You can also get prints made at a wide variety of sources from your local drugstore or supermarket to an online printer that specializes in creating beautiful prints in sizes from 4 x 6 inches to as large as 36 x 24 inches.

Your camera has an 18-megapixel capture, which means you can create very large prints. In this chapter, I explore the wonderful world of printing the images you capture in your EOS 7D.

## To Print or Not To Print?

Modern photo-quality printers are a wonderful thing. They print rich, wonderful colors with crisp delineation among them. But good photo-quality printers don't come cheap, and neither do the ink cartridges. Modern printers have multiple cartridges. If you've been printing a lot of images that use say, red or cyan ink, you'll exhaust that cartridge much sooner than the other cartridges in your printer. And you never seem to have a spare cartridge of the color that runs out.

In addition to the problem of running out of ink at an inopportune moment, don't forget the expense involved. If you use a third-party fine art paper, it soaks up ink like a sponge. Then when you run out of one color cartridge in the middle of a print job, you have a double whammy: You've wasted lots of ink and a sheet of very expensive paper. Fortunately you can get good color prints in lots of other ways. The following list shows a few options:

- **Superstore printing services:** Many superstores, such as Costco and Sam's Club, have do-it-yourself printing. Simply bring a memory card to the store, put it in the machine, and review the images on the card. Many of the in-store kiosks have options like cropping images to a specific size. After you select images, you can place your order. In many instances, you can do your shopping in-store and come back an hour later for your prints.

- **Drugstores:** Many drugstores offer the printing of digital images. Simply bring your memory card to the store, insert it in their machine, choose the images you want to print, and place your order.

- **Online printing services:** Lots of online printing services offer many services. If you want standard prints, no problem. A full online printing service can print anything from wallet-size images to huge wall posters. You say you want to put a picture of your cat on a coffee mug? No problem. Upload the image and you'll get your cat's mug on a mug within a matter of days. Other services include photo books, images on mouse pads, and so on. One of my favorite online printing sources is Mpix (www.mpix.com). They offer all the aforementioned services and much more.

## Calibrating Your Monitor

When you make decisions regarding white balance, colorcasts, and other color issues with your images, you rely on what you see on your monitor. However, your monitor changes over time, which can result in a slight color shift. Yet you still rely on the monitor to accurately portray red, green, and blue in your photos. Then, you print the images on your computer printer or send them to an online printer, and the resulting print doesn't look like what you saw on your monitor. That's because your monitor isn't accurately reproducing color and needs to be calibrated.

A lot of products are on the market for calibrating monitors. When you calibrate a monitor, you start the calibration software and then attach a colorimeter device to your screen. The software analyzes your monitor and compares the colors it generates to the accepted standards for red, green,

and blue as stored with the software. After the software does its thing, it creates a profile that you use to get your monitor to accurately represent color. When you calibrate your monitor, do so with the same lighting conditions you normally work in. After the initial calibration, recalibrate your monitor every two or three months to compensate for changes as your monitor ages. One popular monitor calibration kit is Pantone's huey (see Figure 10-1). As of this writing, the huey retails for $89.

Figure 10-1: Calibrating your monitor.

# Finding Images

After you download lots of images and edit them, you end up with lots of images in lots of folders. Even though the folders are organized by date and they have the date as the actual folder name and even though you've renamed the images, looking for a single image, or group of images, is like looking for the proverbial needle in the haystack. You can search for images by date photographed, date modified, star rating, comments, and keywords. You can choose any or all the criteria listed in the dialog box. However, you can easily find images with ZoomBrowser EX (see Chapter 9) by following these steps:

1. **Choose Tools⇨Search.**

   The Search dialog box appears (see Figure 10-2).

2. **Select the Match All Conditions or Match Any Condition option.**

   If you choose the first option, ZoomBrowser EX returns images that match every criterion you enter. If you choose the latter, you find more images.

3. **Select the Star Rating check box to search for images by star rating.**

After you choose this option, a drop-down list becomes available. You can choose to search for one-, two-, or three-star images, one- and two-star images, two- and three-star images, or one- and three-star images.

4. **Select the Modification Date check box to search for images by the date they were modified.**

   When you choose this option, you specify the start and end dates. You can manually enter the dates in each text box in the mm/dd/yyyy format or click the drop-down arrow to the right of each text box to reveal a calendar, which you use to specify the date.

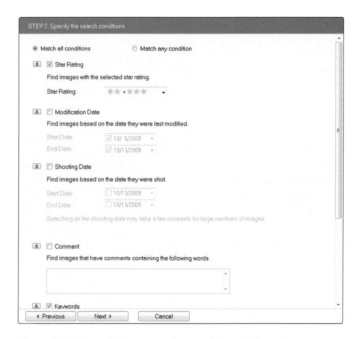

Figure 10-2: Where did I put that picture of Aunt Millicent?

5. **Select the Shooting Date check box to search for images based on the day they were photographed.**

   You specify the start and end dates the same way you do for the modification date.

6. **Select the Comment check box to search for images based on comments you entered.**

   When you enable this option, you enter words that are contained in the comments of the images you want to find.

7. **Select the Keywords check box to search by keyword.**

When you choose this option, the keywords you've used appear below the Keyword option. Select the check box to the left of a keyword to search for images that contain that keyword. You can search for multiple keywords.

**8. Click the Next button.**

ZoomBrowser EX searches for images based on the criteria you choose. This may take a while if you're using several search options to find your images. A progress bar appears while ZoomBrowser EX searches. When the search is concluded, the images display in the dialog box.

**9. Click the Finish button.**

The images returned by the search display in a window. You can review your images in the Zoom, Scroll, or Preview mode. The results are stored in the Search Results folder, which you find at the bottom of the folder tree in the All Folders tab. The contents of the Search Results folder change each time you perform a search.

## Leaving Some Breathing Room

Your EOS 7D produces images with an aspect ratio of 3:2, which is perfect if you print your images on 4-x-6-inch photo paper. However, if you print your images on different-size papers, the aspect ratio of those papers doesn't match the aspect ratio of your camera. For example, if you print images on 8-x-10-inch paper, the aspect ratio is 4:5. If you take a picture and don't leave any breathing room at the edges, you can't crop to 8 x 10 without cutting out part of your subject. When you take pictures, keep this in mind. Leave a little breathing room and you can crop to different aspect ratios without losing important parts of your image. Figure 10-3 shows an image that has plenty of breathing room. The complete image is perfect for a 4 x 6 print. The red rectangle shows the image cropped for a 5-x-7-inch print, and the blue lines show the image cropped for an 8-x-10 inch print. Breathing room is a wonderful thing.

Figure 10-3: Leave a little wiggle room for different aspect ratios.

# Creating photo books at Blurb

If you want to see your images in a custom photo book, you can make this a reality by visiting Blurb (www.blurb.com). Blurb is a popular online Web site for creating and selling photo books. You can create a great-looking photo book with Blurb's free BookSmart software, which you can download for free from www.blurb.com/make/booksmart. After you use the software to create your book, you can upload the photos to Blurb directly from the BookSmart software. You can also create a custom book in an application like Adobe InDesign and then upload it to Blurb as a PDF (Portable Document Format). After you upload the book, you have 14 days to order at least one copy of it. If you don't order a copy within 14 days, Blurb removes it from the Web site. Blurb offers hardcover and softcover books in the following sizes (in inches): 7 x 7, 10 x 8, 12 x 12,

and 13 x 10. You can also upgrade to premium paper, which looks absolutely stunning with high-resolution images. The minimum number of pages is 20, and the maximum number of pages you can put in a book is 440. You can put multiple photos on a page with BookSmart templates.

You can also choose to make your book public after you order one copy. When you make a book available to the public, you can specify the selling price. The following image is a copy of the book cover I created from images I shot at a local car show. Quite a few copies of this book have been ordered online. When your book sells, Blurb sends you the difference between your selling price and its established price minus a small handling fee.

## Image size and resolution considerations

Whether you print an image on your home computer printer or use an online printing company, it's important that you send them an image that's large enough to print on the media size you choose. Also important, match the resolution of the printer as closely as possible. To find the ideal resolution, check with the company that's doing your printing or check your computer printer manual. If you're printing the image, a resolution of 200 dots per inch (dpi) gives you acceptable results. If you choose a resolution of 300 dpi, you'll get a better-looking image because the pixels are smaller and you'll get a better color variation. So how does this equate to image size? If you want to print an 8-x-10-inch image at 200 dpi, the image dimensions must be 1600 x 2000 pixels, and of course, the image must have a resolution of 200 dpi. If you want to print an 8-x-10-inch image at 300 dpi, your image must be 2400 x 300 pixels. To do the math for a different image resolution, multiply the size in inches by the resolution to get the document size in pixels. Your image should be larger than this. Unfortunately, neither ZoomBrowser EX nor Digital Professional Pro has a menu command to change the image size. If you have Photoshop Elements, you can easily perform this task. *Photoshop Elements 8 For Dummies,* by Barbara Obermeier and Ted Padova (Wiley), is a good book to reference.

# Trimming an Image in ZoomBrowser EX

You can trim an image to get rid of unwanted pixels. When you crop an image, you end up with a smaller image size as well. To trim an image in ZoomBrowser EX:

1. **Select the image you want to edit and then click the Edit button.**

   The menu drops down to reveal the editing options.

2. **Click Edit Image.**

   The Editing dialog box appears.

3. **Select the Trim option and click the Finish button.**

   The Trim Image dialog box appears (see Figure 10-4). You have two methods of trimming an image. The first is to simply drag the handles until you've cropped away any unwanted pixels. This method is fine when you create an image for the Web or to send via e-mail. However, when you want to print an image on photo paper with set dimensions, you need to use the second method — crop to an aspect ratio from the Advanced Options choices. The following steps show you how to crop manually.

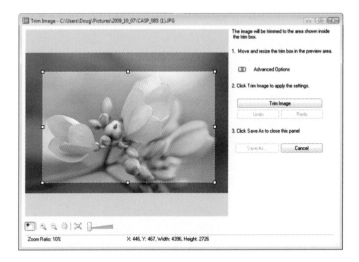

Figure 10-4: Trimming an image.

4. **Drag the handles.**

   Drag any handle to trim the image to a different size. Click inside the trim box and then drag to move the box to trim to a different area of the image.

5. **Click the Trim Image button.**

   The image trims to size.

6. **Click the Save As button and then in the Save As dialog box, follow the prompts to save the image.**

Trimming an image in ZoomBrowser EX is an inexact science. Even if you use the advanced options, you can't trim to a specific aspect ratio. If you need to trim your images to a specific size, trim them in Digital Professional Pro, as I outline in the following section.

## Trimming an Image in Digital Professional Pro

When you need to trim an image to a specific aspect ratio, you can get the job done in Digital Professional Pro (which comes with your camera). In addition, you can trim RAW images, which isn't possible in ZoomBrowser EX. To trim an image in Digital Professional Pro:

1. **Select the image you want to trim and then choose Tools⇨Start Trimming Tool.**

   The image appears in the Trimming Tool dialog box (see Figure 10-5).

Figure 10-5: Trimming an image in Digital Professional Pro.

2. **Click the Aspect Ratio drop-down arrow.**

   The Aspect Ratio menu displays (see Figure 10-6).

3. **Choose the desired ratio.**

   Choose 2:3 for 4-x-6-inch images, or 4:5 for 8-x-10-inch images. After you choose an aspect ratio, trimming handles (*cropping* for you purists) appear around the image. If you need a different aspect ratio, choose Custom. This opens two text boxes beneath the Aspect Ratio button, into which you enter the desired aspect ratio. For example, to trim for printing on 5-x-7-inch stock, enter **5** and **7**.

Figure 10-6: The Aspect Ratio menu.

4. **Click and drag to define the area of the image that you want to trim.**

   Trim handles appear around the selected area. The area that will be trimmed away has a semitransparent black mask (see Figure 10-7).

Figure 10-7: A little off the top, and a trim around the edges, please.

5. **Fine-tune the area that the image will trim.**

   You can drag any of the handles to change the size of the trim rectangle. Click inside the rectangle and you can drag it to another position.

6. **Click OK.**

   The image is trimmed to the desired area.

# Printing an Image

After you trim an image to size, time to print it. If you're printing the image on your local printer, you can do so from within ZoomBrowser EX or Digital Photo Professional. You can print a single image or a contact sheet. I show you how in the upcoming sections.

## Printing an image from ZoomBrowser EX

You can print an image you select in ZoomBrowser EX on your local printer. As I mention earlier, ZoomBrowser EX doesn't let you trim to a specific aspect ratio, so your results may not be what you expect. To print an image from ZoomBrowser EX:

1. **Launch ZoomBrowser EX and then select the image you want to print.**

   You can select the image while viewing a folder in Zoom or Scroll mode. You can also print a single image you're viewing in Preview mode.

2. **Click the Print and E-Mail button and then click the Photo Print button.**

   The Photo Print dialog box appears (see Figure 10-8).

Figure 10-8: Printing an image.

3. **Click the Name drop-down arrow and choose the desired printer.**

   Your default printer appears on the button.

4. **Click the Properties button.**

   A dialog box with properties for your printer appears. Use this to match the media size to what you have in your printer tray, page layout, and so on. The options vary depending on the printer you use. Choose the desired options and close the dialog box.

5. **(Optional) To display the shooting date and time on the image, click the Shooting Date/Time drop-down arrow.**

   A menu appears with the different options. Personally, I never print the date and time on a photo. The date and time are with the image metadata.

6. **(Optional) Click the Trim Image button if you want to trim the image.**

   The Trim dialog box opens. The options are similar to those I discuss in the "Trimming an Image in ZoomBrowser EX" section earlier in this chapter.

7. **Click the Insert Text button to add text to the image.**

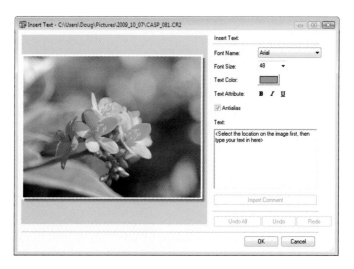

Figure 10-9: Adding text to the image.

   The Insert Text dialog box opens (see Figure 10-9).

8. **Accept the default font type as well as size and color, or specify different options.**

9. **Click inside the image where you want the text to appear and then type the text in the text box.**

   Four handles appear around the text box. The text box resizes while you type.

10. **Click inside the text box and drag it to the desired position and then click OK.**

    You return to the Photo Print dialog box.

11. **Click the Print button.**

    The selected printer prints the image.

## Printing an image in Digital Photo Professional

If you want to print RAW images, you can do so from Digital Photo Professional. The process is pretty straightforward. You can specify the printer and then modify the printer properties to suit the media you're using. To print an image from Digital Photo Professional:

1. **Launch Digital Photo Professional, select the image you want to print, and then choose File⇨Print.**

   The Print dialog box appears (see Figure 10-10).

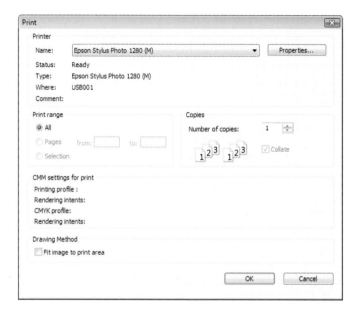

Figure 10-10: Printing an image from Digital Photo Professional.

2. **Choose the desired printer from the Name drop-down list.**

   This menu shows every available printer on your computer or in your network.

3. **Click the Properties button.**

   A dialog box opens with the properties for your printer. You can specify the media being used, the layout, and so on. The dialog box varies depending on the printer you use.

4. **After choosing the desired options, close the dialog box.**

5. **Specify the number of copies to print.**

6. **If the image is larger than the media, select the Fit Image to Print Area check box, and then click the OK button.**

   The selected printer prints your image.

## Printing an Index Sheet in ZoomBrowser EX

You can print a *contact sheet* (known as an *index sheet* in ZoomBrowser EX) of selected images. The contact sheet is a handy reference that shows information about the photos as well as a thumbnail image for each photo. Many photographers file these as reference material. They're also useful for showing images to prospective clients. After all, looking at an image tells you a lot more than looking at a filename. To print an index sheet in ZoomBrowser EX:

1. **Launch ZoomBrowser EX and then select the images you want to include on the index sheet.**

   If you choose RAW images, ZoomBrowser EX uses the thumbnail image for the index sheet because ZoomBrowser EX can't decode RAW files. This may result in poor image quality.

2. **Click the Print and E-Mail button, and then click the Index Print button.**

   The Index Print dialog box appears (see Figure 10-11).

3. **Choose a printer from the Name drop-down list.**

   Your default printer is listed on the button.

4. **Click the Properties button.**

   A dialog box with the printer properties appears. The properties differ depending on what type of printer you use.

5. **Set the printer properties and then click OK.**

   The dialog box closes.

6. **Enter the number of copies in the Copies text box.**

   Alternatively, you can click the spinner buttons to specify the number of copies.

7. **In the Page Layout Settings section, enter the desired number in the Columns and Rows text boxes.**

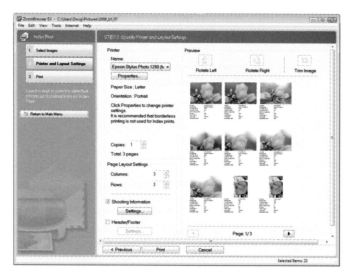

Figure 10-11: Printing an index sheet.

This setting determines how the images display on the sheet. The default setting gives you three rows and three columns. If you choose a larger number, the images will be smaller.

8. **(Optional) Deselect the Shooting Information check box (it's enabled by default) so that only images appear on the sheet.**

If you deselect this check box, skip to Step 12.

9. **If you left the Shooting Information check box selected, click the Settings button.**

The Shooting Information Settings dialog box appears (see Figure 10-12).

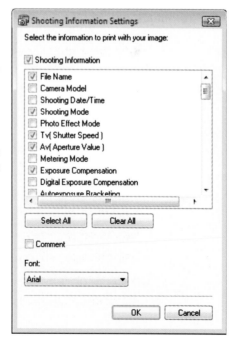

Figure 10-12: Modifying Shooting Information options.

10. **Select the Shooting settings you want displayed under each image and then select the Comment check box to print any image comments on the index sheet.**

11. **Accept the default font (Arial) or choose a different font from the drop-down list and then click OK.**

    The Shooting Information Settings dialog box closes.

12. **(Optional) Select the Header/Footer check box to include a header and footer on each sheet.**

    If you don't select the Header/Footer check box, skip to Step 15.

13. **If you selected the Header/Footer check box, click the Settings button.**

    The Header/Footer Settings dialog box appears (see Figure 10-13).

14. **Type the desired text in the Header and Footer text boxes, and then click OK.**

    The Header/Footer Settings dialog box closes.

15. **Click the Print button.**

    The selected printer prints the index sheet.

Figure 10-13: Entering information for the index sheet header and footer.

# Printing a Contact Sheet in Digital Photo Professional

If you need to print a contact sheet of RAW images, you can easily do so in Digital Photo Professional. You can specify how many rows and columns are on the sheet and much more. To print a contact sheet in Digital Photo Professional:

1. **Launch Digital Photo Professional and then choose File⇨Contact Sheet Prints.**

   The Contact Sheet dialog box appears (see Figure 10-14).

2. **Choose a printer from the Printer drop-down list.**

   Your default printer is listed.

**Figure 10-14:** Printing a contact sheet.

3. **Click the Properties button.**

   A dialog box with the printer properties appears. The properties differ depending on what type of printer you use.

4. **Set the printer properties and then click OK.**

   This closes the Properties dialog box.

5. **From the Media drop-down list, choose the desired paper size.**

6. **Accept the default orientation (Portrait) or select Landscape.**

   This option determines whether the sheet is taller than it is wide *(portrait),* or wider than it is tall *(landscape).*

7. **Click the CMS Settings button.**

   The Color Match Settings dialog box opens. This lets you specify a printer profile or CMYK (Cyan, Magenta, Yellow, Black) simulation profile.

8. **Select the desired options from the drop-down list and then click OK to exit the Color Match Settings dialog box and return to the Contact Sheet dialog box.**

9. **Click the Image tab (see Figure 10-15), and then enter the desired value in the Columns and Rows text boxes.**

   These settings determine how many rows and columns of images appear on your contact sheet.

10. **Choose the desired layout.**

    Your options are Vertical or Horizontal.

11. **Click the Text tab (see Figure 10-16) and then enter the desired information in the Header and Footer boxes.**

    Alternatively, you can display the page number, or you can display the page number and the total number of pages.

12. **Accept the default font and size for the header/footer, or click the ellipsis (. . .) button to the right to specify a different font face and size.**

13. **(Optional) Choose an option in the Caption section.**

    You can display the serial number or the filename.

    If you don't choose a Caption option, skip to Step 15.

Figure 10-15: Specifying image options.

14. **Accept the default font face and size for the caption, or click the ellipsis (. . .) button to specify a different font face and size.**

15. **Click the Settings tab (see Figure 10-17).**

16. **(Optional) Click the Unit drop-down list and choose Inches as the unit of measurement.**

    Don't do this if your preferred unit of measure is millimeters.

17. **(Optional) Select the Print Background in Black check box.**

    Choose this option, and the background behind the images is black.

Figure 10-16: Specifying text options.

Figure 10-17: Specifying the final settings.

18. **(Optional) Accept the default Rotate Images to Match Main Window Orientation.**

   If you deselect this option, images aren't rotated if they don't have the same orientation.

19. **Click the Print button.**

   The selected printer prints the contact sheet.

## Using third-party papers

Lots of companies manufacture paper for printing digital images. Some of them are more economical than the paper available from your printer manufacturer, and others are available to create fine art prints. For example, papers with a high rag content make your images look like artwork instead of photos. When you print images from an application, such as Photoshop Elements, the printer determines how much of each ink is laid on the paper to create the resulting image. However, when you use *third-party* paper (paper not manufactured by the company that made your printer), your printer has no way of knowing how much ink to lay to replicate what you see on your computer screen. When this is the case, you need to get an ICC (International Color Consortium) profile for the paper and your printer. Many manufacturers of fine art photo paper, such as Ilford and Hahnemuhle, have profiles you can download for your printer and their paper. They also supply instructions on where the profile needs to be stored on your system and how to use the profile with many popular image-editing applications, such as Photoshop and Photoshop Elements.

# Part IV
# The Part of Tens

The 5th Wave     By Rich Tennant

"If you don't mind, my kid's got a new digital camera and he's looking for fun things to photograph for school..."

*A*h yes, the beloved Part of Tens has two chapters with ten tidbits in each chapter about your camera and photography. So by my abacus that's 20 tidbits to chew on. In this part, I show you how to create custom menus, register user settings, add copyright information to images, and more.

My Menu settings

Register
Sort
Delete
Delete all items
Display from My Menu        Disable

**MENU** ↩

# Ten (Plus One) Tips and Tricks

*In This Chapter*

▶ Creating custom menus

▶ Adding copyright info and author name to your camera

▶ Cleaning your sensor and camera

▶ Creating and registering picture styles

▶ Editing movies

▶ Updating your firmware

▶ Registering and restoring camera settings

▶ Preserving memory cards

*W*hen the weather is dismal and you're fresh out of ideas for shooting macro or still life photography in your house, you can always photograph your pet rock. Or better yet, you can do some cool things with your camera, such as creating a custom menu or a custom picture style. In this chapter, I show you more than a handful of tips and tricks that you can do on a rainy day.

## Creating a Custom Menu

Do you have a set of menu commands you use frequently? How cool would it be not to have to sift through all 4,000 commands in your camera menu? That's right, you can cut to the chase and create your own custom menu with your very own favorite commands. If I've piqued your curiosity, read on. To create a custom camera menu:

**1. Click the Menu button.**

The last used menu displays.

**2. Use the Quick Control dial to navigate to the My Menu Settings tab (see the left side of Figure 11-1).**

**3. Press the Set button.**

The My Menu Settings dialog box displays. The Register option is high-lighted when you first open the menu (see the right side of Figure 11-1).

Figure 11-1: Gonna make your very own menu.

**4. Press Set.**

A list of menu commands displays (see the left side of Figure 11-2).

**5. Rotate the Quick Control dial to highlight a command and then press Set to register it.**

A dialog box appears asking whether you want to register the command in your custom menu (see the right side of Figure 11-2).

**6. Rotate the Quick Control dial to highlight OK and then press Set.**

The command is grayed out on the list.

**7. Repeat Steps 5 and 6 to add other commands to your menu.**

**8. After registering commands to your menu, press the Menu button.**

You're returned to the My Menu Settings dialog box (see the left side of Figure 11-3). You have the following commands at your disposal:

- *Sort:* Press Set and then your menu commands display. Select a menu command and press Set to display an up and down arrow next to the command. Use the multi-controller button to move the command up or down in the list and then press Set when the com-mand is in the desired position. Repeat for other commands you want to move. Press the Menu button when finished.

Figure 11-2: Choosing commands to register.

- *Delete:* Press Set to display all commands on your menu. Rotate the Quick Control dial to highlight a command and then press Set to delete it from the list. This opens a dialog box asking you to confirm deletion. Rotate the Quick Control dial to highlight OK and then press Set. Press the Menu button to return to the My Menu Settings dialog box.

- *Delete All Items:* Press Set to reveal a dialog box asking you to confirm deletion of all registered items. Rotate the Quick Control dial to highlight OK and then press Set to finish the task.

- *Display from My Menu:* Press Set to reveal the options. Rotate the Quick Control dial to highlight Enable and then press Set. The My Menu tab is selected. The last menu used opens first by default. However, if you put all your frequently used commands on a custom menu, you won't have to use the other menu tabs very often. The right side of Figure 11-3 shows a custom menu.

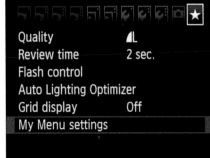

Figure 11-3: Setting My Menu Settings options.

## Adding Copyright Information to the Camera

You can add your copyright information to the camera. The data you enter will be added to the EXIF metadata recorded with each image. To add copyright information to the camera:

1. **Press the Menu button.**

   The previously used menu displays.

2. **Use the multi-controller button to navigate to the Camera Settings 3 tab.**

3. **Rotate the Quick Control dial to highlight Copyright Information (see the left side of Figure 11-4) and then press the Set button.**

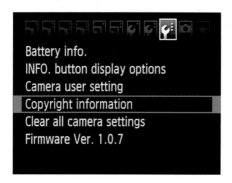
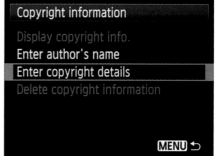

Figure 11-4: Adding your copyright to the camera.

The Copyright Information menu displays.

4. **Rotate the Quick Control dial to highlight Enter Copyright Details (see the right side of Figure 11-4) and then press Set.**

   The Enter Copyright Details dialog box appears (see the left side of Figure 11-5).

5. **Press the Picture Style Selection button to enter the text selection box.**

   Use the Picture Style button to navigate between the text box and the text selection box.

6. **Use the multi-controller button to navigate to a letter or number.**

   The character is highlighted with a gold rectangle.

**7. Press Set.**

The character appears in the text box.

**8. Continue adding characters to complete your copyright information.**

Your completed copyright information appears in the text box (see the right side of Figure 11-5).

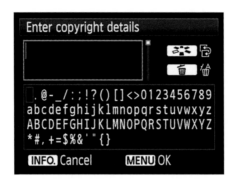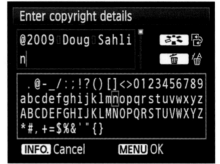

Figure 11-5: Entering copyright information.

**9. Press the Menu button.**

Your copyright information is registered with the camera and is added as EXIF (Exchangeable Image File Format) data when you take your next picture.

To edit your copyright information:

**1. Press the Picture Style Selection button to enter the text box and then use the multi-controller button to move the cursor.**

**2. Position the cursor before a character you want to delete and then press the Erase button.**

# Adding Author Name to the Camera

You can add your name as the author of each image you capture with your camera. The information is added as EXIF data to each picture you take. To register your author information with the camera:

**1. Press the Menu button.**

The previously used menu displays.

2. **Use the multi-controller button to navigate to the Camera Settings 3 tab.**

3. **Rotate the Quick Control dial to highlight Copyright Information (see the left side of Figure 11-6) and then press the Set button.**

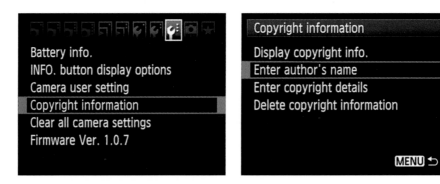

Figure 11-6: Adding your name to the camera information.

The Copyright Information menu displays.

4. **Rotate the Quick Control dial to highlight Enter Author's Name (see the right side of Figure 11-6) and then press Set.**

The Enter Author's Name dialog box appears (see the left side of Figure 11-7).

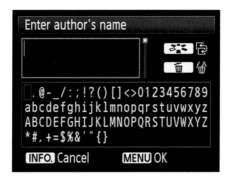
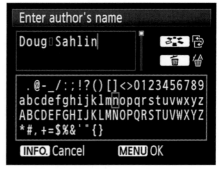

Figure 11-7: Registering your name with the camera.

5. **Press the Picture Style Selection button to enter the text selection box.**

   Use the Picture Style Selection button to navigate between the text box and the text selection box.

6. **Use the multi-controller button to navigate to a letter or a number.**

   The character is highlighted with a gold rectangle.

7. **Press Set.**

   The character appears in the text box.

8. **Continue adding characters to complete your name.**

   Your completed author information appears in the text box (see the right side of Figure 11-7).

9. **Press the Menu button.**

   Your name is registered with the camera and is added as EXIF data when you take your next picture.

You can edit your name with the techniques from the preceding section.

# Manually Cleaning Your Sensor

Your camera has a self-cleaning sensor; however, you may inadvertently get a stubborn piece of dust that develops a magnetic attraction to your sensor and needs to be cleaned manually. To determine whether you have dust on your sensor, follow these steps:

1. **Switch to Av (Aperture Priority) mode and choose your smallest aperture.**

   For further information on using Aperture Priority mode and manually setting your aperture, see Chapter 6.

2. **Switch the lens to manual focus and rack the focus to its nearest point.**

   That's right, you want the sky to be out of focus. That way the dust specks will show up as black dots.

3. **Take a picture of a clear blue sky, download the picture to your computer, and review it in your image-editing program at 100 percent magnification.**

   If you see black specks in the image, you have dust on your sensor.

# Using sensor cleaning equipment

If you're a DIY (do-it-yourself) kind of photographer, you may want to consider cleaning your sensor with commercially available products. Lots of products — brushes, swabs, and chemicals — that you use to manually clean the camera sensor are on the market. Yes, that does mean you physically touch the sensor with a product. Therefore, the product you choose needs to be made from material that can't scratch the camera sensor. You must also have a very steady hand when using these products.

I've used sensor cleaning products manufactured by VisibleDust (www.visibledust.com). VisibleDust manufactures a lighted sensor loupe that you place over the lens opening to examine the sensor for any visible dust — hence, the company name. The loupe is made of glass and makes it easy to see any specs of dust on your lens. VisibleDust also manufactures an Arctic Butterfly brush, which runs on two AAA batteries. To use this brush:

1. **Push a button to spin the brush.**

   This gives the brush a static electricity charge.

2. **Brush the sensor once with the charged brush.**

   Dust particles are attracted to the brush.

3. **Remove the brush from the camera body and then press the button to spin the brush again.**

This discharges the particles in the air.

4. **Use the brush as needed to remove any dust that may have accumulated on the sensor.**

I've used both products with a good outcome on my cameras. For more information, visit www.visibledust.com or ask your favorite camera retailer for information about these products.

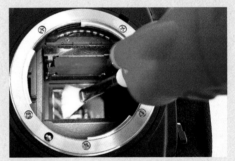

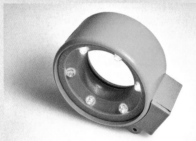

The best way to clean dust off your sensor is to blow it off with a powerful bulb blower. Several blowers are on the market with generic names like Hurricane or Rocket. The Giottos Rocket Blaster is shown in Figure 11-8.

A good blower is made of natural rubber and features a small opening at the tip that enables you to direct a strong current of air with pinpoint accuracy.

To clean the sensor manually, take the lens off the camera and then choose the Sensor Cleaning option from your camera menu. This flips up the mirror, giving you access to the sensor. Squeeze the bulb blower several times to send a rush of air to the sensor that hopefully dislodges the dust and sends it floating to the ground. I always point the camera down when cleaning the sensor, which lets the dust drop out of the camera after it's dislodged.

 Never touch the sensor with the blower. Never use a blower with a $CO_2$ cartridge. $CO_2$ cartridges contain propellants that can foul your sensor.

Figure 11-8: Use a bulb blower to clean your camera sensor.

## Creating and Registering a Picture Style

If you like to use picture styles in your photography, you'll be glad to know that you can customize your favorite picture style. After customizing the picture style, you can register it as a User Defined picture style and it's available whenever you want to use it for pictures. To customize a picture style:

1. **Press the shutter button halfway.**

   You're in picture-taking mode.

 2. **Press the Picture Style Selection button.**

   The picture styles display on the camera LCD monitor.

 3. **Rotate the Quick Control dial to select one of the User Defined picture styles (see the left side of Figure 11-9).**

 4. **Press the Info button.**

   The Detail Set. dialog box displays (see the right side of Figure 11-9). The Picture Style option at the top of the menu enables you to select the style that is the basis for your custom style.

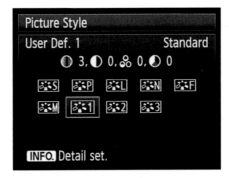

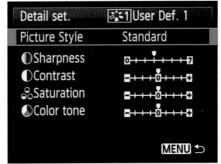

Figure 11-9: Customizing a picture style.

5. **Press the Set button.**

The Picture Style option appears on the screen, and two arrows display to the right of Standard (see the left side of Figure 11-10).

6. **Rotate the Quick Control dial to select the picture set that's the basis for your custom style and then press Set.**

The details for the picture set display on the camera LCD monitor (see the right side of Figure 11-10). You can customize the following:

- *Sharpness:* You can increase or decrease image sharpness.

- *Contrast:* You can increase or decrease the amount of contrast in the image.

- *Saturation:* You can increase or decrease color saturation.

- *Color Tone:* You can change the skin tone of people you photograph. You can make skin tones more yellow by moving the indicator to the left side of the scale, or more red by moving the indicator to the right side of the scale.

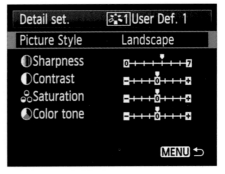

Figure 11-10: Customizing a picture style.

7. **Customize image sharpness (the first on the list), or rotate the Quick Control dial to highlight another detail, and then press Set.**

   The selected detail appears on the camera LCD monitor. You can now customize it (see the left side of Figure 11-11).

Figure 11-11: Customizing a picture style.

8. **Rotate the Quick Control dial to increase or decrease the amount of the detail.**

   Rotate the dial right to increase, or left to decrease.

9. **Press Set.**

   The change is applied, and you're returned to the Detail Set menu.

10. **Repeat Steps 5–9 to customize the other details in the picture style.**

   Customize the details that make sense to the style you're customizing. For example, you wouldn't change Color Tones when customizing the Landscape picture style. The right side of Figure 11-11 shows a customized set that's ready to be registered with the camera.

11. **Press the Menu button.**

   Your custom picture style is registered. The text above the style shows the style on which your style is based; it also shows the changes you've made to the base style in blue.

You can also customize a Standard picture style. Follow the preceding steps but instead of selecting one of the User Defined styles, select one of the Standard styles and then press the Info button. Follow Steps 7–9 to customize the picture style to suit your taste.

## Editing Movies in the Camera

When you review movies in your camera, they may need to be trimmed. You can cut footage from the beginning or end of a movie clip in the camera by following these steps:

1. **Press the Playback button repeatedly until you navigate to the movie you want to edit.**

   You can press the AE Lock/Index/Reduce button to view four or nine thumbnails. Movies have a filmstrip icon around the border of the thumbnail.

2. **Select the movie you want to edit and then press the Set button.**

   The playback controls display.

3. **Rotate the Quick Control dial to select the Edit icon that looks like a pair of scissors (see the left side of Figure 11-12) and then press Set.**

   The editing controls display (see the right side of Figure 11-12). Cut Beginning is the first icon. This icon enables you to trim footage from the beginning of the movie clip.

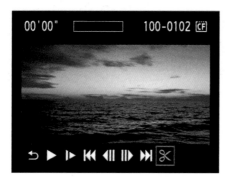
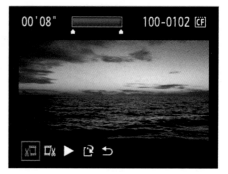

Figure 11-12: Editing a movie in camera.

4. **Press Set.**

   The Cut Beginning edit tool is available.

5. **Press the multi-controller button right to fast-forward to the spot where you want the clip to begin and then press Set.**

   The icon that indicates where the movie begins displays above the clip.

6. **Rotate the Quick Control dial to highlight the Cut End icon and then press Set.**

   The tools for trimming from the end of the movie display.

7. **Press the multi-controller button left to rewind the movie to where you want the clip to end and then press Set.**

   The revised starting and ending points for the movie display above the clip (see the left side of Figure 11-13).

8. **Rotate the Quick Control dial to Save and then press Set.**

   The Save button is the icon to the right of the Play button in the image on the left side of Figure 11-13. After pressing the icon, a dialog box appears asking you whether you want to create a new file or overwrite the existing file (see the right side of Figure 11-13). If you still have footage on the original file you want to keep, make sure you create a new file.

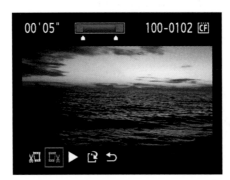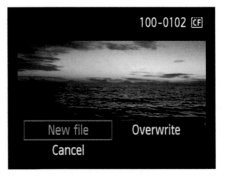

Figure 11-13: Trimming the beginning and ending of a movie clip.

9. **Rotate the Quick Control dial to highlight the desired option and then press Set.**

   Your movie clip is on the cutting room floor.

# Cleaning Your Camera

I address cleaning your camera sensor in the section, "Manually Cleaning Your Sensor," earlier in this chapter; however, you also need to keep your lenses clean. I always inspect my equipment before a shoot, which is also when I clean the lenses I'll be using. If a lens has smudges, fingerprints, or a

fine coating of dust and pollutants, your pictures won't be crystal clear. Use a brush with fine hairs to dislodge any particles of dust and then gently rub a microfiber cloth over the lens. Make sure you purchase a good quality microfiber cloth that's designed to clean precision optics. I've purchased several lens cloths from Photosilk (www.photosilk.com).

Microfiber is 10 times thinner than silk, and 100 times thinner than a human hair. Photosilk's cloths do an excellent job of keeping lenses clean. The cloths have a photo imprinted on one side. In fact, you can order Photosilk's cloths with your own photographs printed on them. I've ordered several with my company logo emblazoned on the microfiber. Another option is to purchase a camera cleaning kit (see Figure 11-14) at your favorite camera retailer that comes with a blower, lens cleaning cloth, lens cleaning solution, and lens swabs.

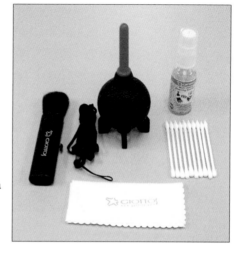

**Figure 11-14:** Keep it clean.

You may also get some grime on your camera body. To clean your camera body, gently rub a damp nonabrasive cloth over the grime. Never use a solvent on your camera body because it may damage the material. If you use your camera in a salty environment, such as the beach, thoroughly soak a cloth with fresh water and then wring it until it's almost dry. Gently rub the slightly damp cloth over the camera body and lens.

## Updating Your Camera's Firmware

Canon is constantly making changes to make its cameras better. Canon locates any potential problems based on user input and its own tests, and then takes this information and modifies the camera's firmware. *Firmware* is like the operating system for your computer. If you've registered your camera, Canon notifies you by e-mail when a firmware update is available. You can register your camera online or mail in the card provided with the camera documents. If you mail in the card, make sure you fill in the E-Mail section of the form to be notified of any changes. When you get the notification, follow the link to the firmware. You can also find out online if your camera has a firmware update. Open your favorite Web browser and navigate to

```
www.usa.canon.com/consumer/controller?act=ModelInfoAct&tabact=DownloadDetail
TabAct&fcategoryid=314&modelid=19356
```

Look at the Firmware section and you'll see whether any updates are available for your camera. If an update is available, follow the prompts to download the information to your computer. You then transfer the firmware program to a CF (CompactFlash) card to install it on your camera. Canon posts detailed instructions on how to install the firmware on one of the Web pages associated with the download.

Make sure you have a fully charged battery in your camera when you update firmware. If the battery exhausts itself during the firmware upgrade, you may permanently damage your camera.

# Registering Camera User Settings

Everybody has a preferred way of working. That's why you have preferences in computer programs and why you can register user settings to the Mode dial. The settings are available whenever you select a user setting on the camera Mode dial. For example, you may have custom settings that you use when you do flash photography, settings you use often but don't use every day. You can register these settings and they'll be there, even if you clear all camera settings. To register your favorite settings:

1. **Use the camera menu to choose the settings you use frequently.**

   For example, you can specify the image format and size, set up exposure compensation, or set any other settings you use frequently.

2. **Rotate the Mode dial to select your preferred shooting mode.**

   For example, you can rotate the dial to Av, if your favorite mode is Aperture Priority. After you select all your favorites, you're ready to register them.

3. **Press the Menu button.**

   The previously used menu displays.

4. **Use the multi-controller button to navigate to the Camera Settings 3 tab.**

5. **Rotate the Quick Control dial to highlight Camera User Setting (see the left side of Figure 11-15) and then press the Set button.**

   The Camera User Setting menu appears with the Register option highlighted (see the right side of Figure 11-15).

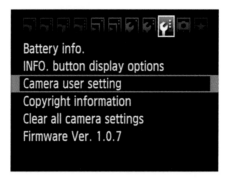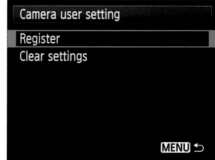

Figure 11-15: Preparing to register a setting.

6. **Press Set.**

   The Register menu appears (see the left side of Figure 11-16).

7. **Rotate the Quick Control dial to highlight the desired mode dial.**

   A dialog box appears asking whether you want to register your settings to the selected mode dial (see the right side of Figure 11-16). If you have registered settings to a button previously, make sure you don't select that button or you'll override the previous settings.

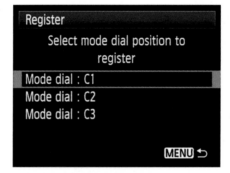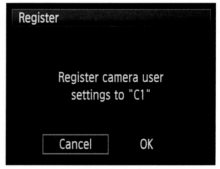

Figure 11-16: Registering user settings.

8. **Rotate the Quick Control dial to highlight OK and then press Set.**

   Your settings are registered to the selected mode dial.

To erase user settings:

1. **Follow Steps 3–5, select Clear Settings, and then press the Set button.**

2. **Select the mode dial you want to clear from the next menu and then press Set.**

3. **Highlight OK from the Clear Settings menu and then press Set to complete the task.**

# Restoring Your Camera Settings

Sometimes you need to do some spring cleaning and wipe the slate clean. If you have more stuff on your camera than you care to deal with, or even know about, you can restore camera settings to factory defaults. This wipes out all your menu changes, your custom menu, and any picture styles you've registered or customized. So think twice before doing this. To restore your camera settings to the factory default:

1. **Press the Menu button.**

   The previously used menu displays.

2. **Use the multi-controller button to navigate to the Camera Settings 3 tab.**

3. **Rotate the Quick Control dial to select Clear All Camera Settings (see the left side of Figure 11-17) and then press Set.**

   A dialog box appears asking you to confirm that you want to clear all settings (see the right side of Figure 11-17).

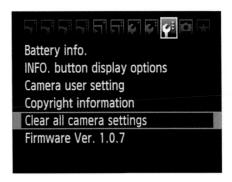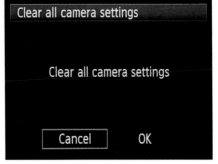

Figure 11-17: Clearing all your camera settings.

**4. Rotate the Quick Control dial to highlight OK and then press Set.**

A dialog box appears telling you the camera is busy. When it stops, the camera settings have been cleared.

## Keeping Your Memory Cards in Good Working Order

Memory cards are the digital equivalent of film that you use over and over again. But like any other piece of equipment, a memory card can fail. Here are a few tips to keep your cards in good working order:

- ✔ **Always turn off the camera before removing a card.** Removing a card with the power on could potentially damage the card.

- ✔ **Make sure your camera has finished writing to the card before turning off the camera and removing the card.** If the camera hasn't finished storing the image on the card, you'll lose the photo or worse yet, corrupt the card.

- ✔ **Always format your cards in the camera.** Many image-editing applications let you format a card after downloading images; however, don't accept this option. Your camera is best equipped to optimally format the card. Also, if for some reason your images didn't download correctly, you still have the originals on your card. If you let the image-editing application format the card and a glitch occurs in the download, your prized images are gone.

- ✔ **Don't run down your battery to a minimum charge.** When your camera flashes a low battery warning, change the battery. If the camera battery becomes fully exhausted while the camera is writing data to the card, you may end up with a card full of corrupt data.

# Ten (Plus One) Cool Projects

*A*h, another Part of Tens chapter. You guessed it; a list about stuff you can do with your camera and the software that came with it. In this chapter, I show you some interesting things, such as adding text to images, creating abstract images, editing your images, and more. So if you're up for extra bits of useful information, prop up your feet, get comfortable, and read on.

## Adding Text to Images

You can add text to JPEG images with ZoomBrowser EX. When you add text, you can specify the font family, font size, and color. To add text to an image:

1. **Launch ZoomBrowser EX and then select a JPEG image.**

2. **Click the Edit button and then click Edit Image.**

   The Editing dialog box appears.

3. **Select the Insert Text option and then click the Finish button.**

   The Insert Text dialog box appears (see Figure 12-1).

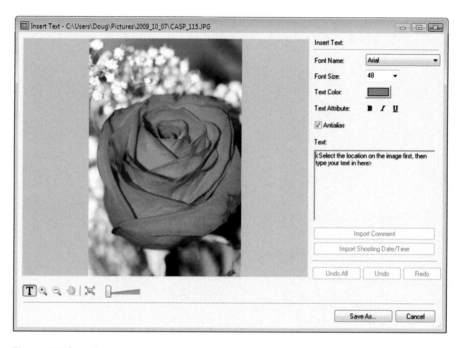

Figure 12-1: Inserting text.

4. **Choose a font face from the Font Name drop-down list.**

   The menu shows every font you have installed on your computer.

5. **Choose a font size from the Font Size drop-down list.**

   Alternatively, you can type the desired size in the text box.

6. **Choose a color for the text by clicking the color swatch and then choosing a color from the Color Picker that appears.**

7. **Click inside the image where you want the text to appear and then type the text in the text box.**

   The text appears inside the image surrounded by a bounding box. *Note:* After you add text to the image, the Import Comment and Import Shooting Date/Time buttons become available. Click the Import Comment button to add a comment associated with the image to the text box. Click the Import Shooting Date/Time button to add the date and time the photo was taken to the text box.

8. **Click the bounding box and drag it to the desired location (see Figure 12-2).**

9. **Click the Save As button.**

   The Save As dialog box appears.

10. **Follow the prompts to save the image.**

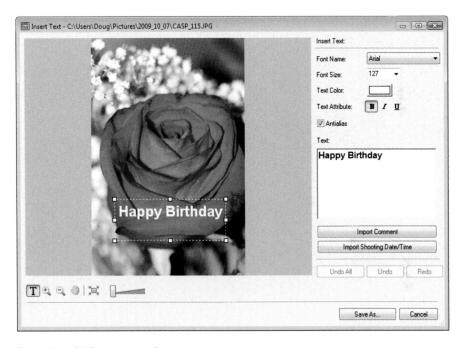

Figure 12-2: Adding text to an image.

## Saving Images to a CD

You can save images from ZoomBrowser EX to a CD. This is a convenient way to send photos to friends and relatives. To save images to a CD:

1. **Launch ZoomBrowser EX and then select the images you want to save to CD.**

2. **Click the Export button and then click the Backup to CD button.**

   The Backup to CD dialog box appears (see Figure 12-3).

3. **Enter a title for the CD.**

   The title appears when you insert the CD in a CD drive.

4. **Choose an option from the Speed drop-down list and then click the Finish button.**

   ZoomBrowser EX writes the selected files to disc.

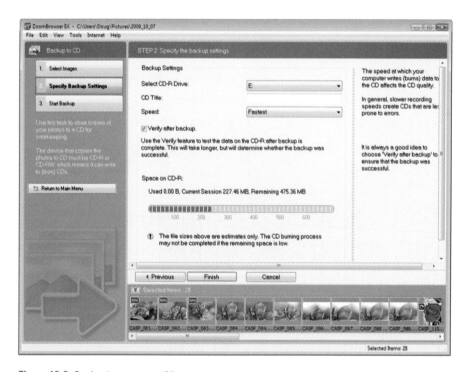

**Figure 12-3:** Saving images to a CD.

# Sending Images via E-Mail

E-mail is a great way to share your photos with friends. From within ZoomBrowser EX, you can attach images to an e-mail by using a supported e-mail application. To send images via e-mail, follow these steps:

1. **Launch ZoomBrowser EX and then select the image you want to send via e-mail.**

2. **Click the Print and Email button and then click the Email Images button.**

   The Email Images dialog box appears (see Figure 12-4).

3. **Accept the recommended settings, or select the Using Custom Settings option and then click the Custom Settings button.**

   The second option enables the Custom Settings button, which opens a dialog box that enables you to resize the image and then close the dialog box. The dialog box is self-explanatory, so I don't waste any paper covering it.

4. **Click the Calculate button.**

   ZoomBrowser EX calculates the file size of the attachment.

5. **Click the Attach to Email button.**

   ZoomBrowser EX opens a blank e-mail from your default e-mail application, if supported. All you need to do is add an e-mail address, subject, and message and then the image is ready to fly, Sly.

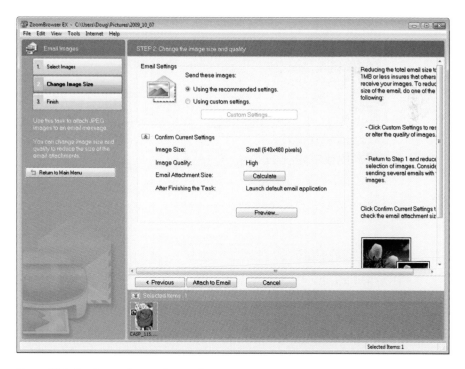

Figure 12-4: Sending an image via e-mail.

## Exporting Shooting Properties

You can export the shooting properties of an image as a text file. This option is useful when you want to send a photo to another photographer and show him how you created the image. The shooting information is from the camera metadata, so you can send as much or as little information as you want. The information is exported as a text file. To export shooting properties:

1. **Launch ZoomBrowser EX and then select the image from which you want to export shooting properties.**

2. **Click the Export button and then click the Export Shooting Properties button.**

   The Export Shooting Properties dialog box appears (see Figure 12-5). All properties are selected by default.

3. **Deselect any properties you don't want to export and then click the Finish button.**

   ZoomBrowser EX exports the data as a text file.

**Figure 12-5:** Exporting shooting properties.

# Creating Computer Wallpaper

Photographers shouldn't use the wallpaper that comes with their computers. The images you capture with your EOS 7D are bound to be much better than anything that shipped with your operating system. You can export wallpaper from any image you create. To create computer wallpaper from ZoomBrowser EX:

1. **Launch ZoomBrowser EX and then select the desired image.**

2. **Click the Export button and then click the Export as Wallpaper button.**

   The Export as a Wallpaper dialog box opens (see Figure 12-6).

3. **Choose an installation setting.**

   You can install the wallpaper centered on your screen, stretched to fit, or tiled; or you can choose not to install the wallpaper at all. If you choose the latter, the wallpaper is saved in the default directory in which your operating system stores wallpaper.

Figure 12-6: Exporting an image as wallpaper.

4. **Accept the default filename, or select the Specify File Name and Folder option.**

   If you select the latter, the Save As button becomes enabled. When you select this option, you can save the file in your default wallpaper directory but create several wallpaper files with different names. If you accepted the default filename, skip to Step 6.

5. **Click the Save As button, and in the Save As dialog box that appears, accept the default location, enter the desired filename, and click Save.**

   The default location is where your operating system looks for wallpaper.

6. **Click the Finish button.**

   You have new wallpaper from your image (see Figure 12-7).

Figure 12-7: Fast-moving wallpaper in action.

## Creating a Computer Screensaver

Every computer uses a screensaver to prevent the screen burning the monitor, although this isn't much of an issue if you use an LCD monitor. Still, screensavers are cool things for your cat to look at while you're away from your computer. (Just be careful not to create a screensaver with pictures of fish, lest your cat render your monitor into a smoldering heap while trying to catch the elusive fish on the monitor screen.) With ZoomBrowser EX, you can create a screensaver with your favorite images. Here's how:

1. **Launch ZoomBrowser EX and then select the desired images.**

2. **Click the Export button and then click the Export as a Screen Saver button.**

   The Export as a Screen Saver dialog box appears (see Figure 12-8).

Figure 12-8: Exporting images as a screensaver.

3. **Choose an option from the Resize Images drop-down list.**

   Choose a size that's slightly smaller than your desktop.

4. **Click the Preview Screen Saver button.**

   ZoomBrowser EX teases you and flashes the first image. At least this gives you an idea of how large the screensaver will be.

5. **Accept the default filename or click Save As.**

   ZoomBrowser EX detects other screensavers it has created and appends the last filename with the next number.

6. **Click the Finish button.**

   ZoomBrowser EX creates your screensaver.

## Creating a Slide Show

When you're reviewing images in ZoomBrowser EX, you may find it beneficial to view several images as a slide show. As the slide show runs, you see the images with a black background. To create a slide show in ZoomBrowser EX:

1. **Launch ZoomBrowser EX and then select the desired images.**

2. **Click the View and Classify button and then click the View as Slide Show button.**

   The Slide Show Setup dialog box appears (see Figure 12-9).

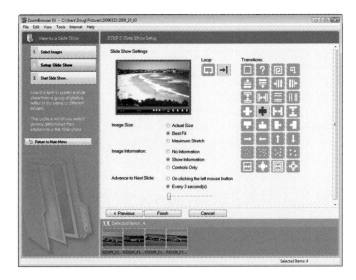

Figure 12-9: Creating a slide show.

3. **Choose whether to loop the slide show.**

   The default option plays the slide show one time. If you choose loop, it plays endlessly until you press the Esc key.

4. **Choose a transition.**

   This is the transition from one slide to the next. Click a transition and you'll see a preview in the small image window.

5. **Select an Image Size option.**

   Best Fit is the best option. Your EOS 7D images are larger than any desktop size I've encountered.

6. **Select an Image Information option.**

   You can display no information, show image information such as star ratings, or show slide show controls only.

7. **Select an Advance to Next Slide option.**

   If you're showing the slide show to friends, choose the mouse left-click option. This gives you a chance to talk about the image before you advance to the next slide. If you prefer the silent approach, accept the default three-second option. If you want the show to play longer, drag the slider to the right so that the display duration becomes longer.

8. **Click the Finish button.**

   The slide show starts playing. You can use the controls to pause, resume, advance to the next or previous slide, and exit the slide show.

## Creating a Makeshift Tripod

Your EOS 7D can capture images in very low-light conditions. However, at times, you absolutely can't do without a tripod. But what do you do when you've left home without one? Here are some ways you can steady your camera without a tripod:

- **Switch to Live View mode and place the camera near the edge of a table.** If you can see the tabletop in the viewfinder or LCD monitor, move the camera closer to the edge.

- **Hold the camera against a wall.** Use this technique when you rotate the camera 90 degrees (also known as *Portrait mode*).

- **Lean against a wall and spread your legs slightly.** This is known as the *human tripod*. Press the shutter button gently when you exhale.

✔ **Use a small beanbag to steady the camera.** You can just throw the beanbag in your camera bag; it doesn't take up much space. Place your camera on the beanbag and move it to achieve the desired composition. You can purchase beanbags at your local camera store.

As an alternative to the bean bag, you can carry a baggie filled with uncooked rice (cooked rice is messy and will spoil) in your camera bag. Place your camera on the bag and move it until you achieve the desired composition.

In addition to using one of these techniques, use the 2-Second Self-Timer. This gives the camera a chance to stabilize from any vibration that occurs when you press the shutter button. These techniques are also great when you're on vacation and don't have the room to carry a tripod in your baggage.

## Creating Abstract Images in the Camera

When you stretch the envelope, you can create some very cool images with your camera. I read an article about a technique where the photographer walked with the camera while taking a picture at a very slow shutter speed. I loved the technique and decided to take it to the next level. I've dubbed this technique Drive-By Shooting. This technique involves creating a photo while you're a passenger in a vehicle. To create an abstract image:

1. **Ask a friend or relative to drive you somewhere.**

   This technique works best after the sun's set. Choose a place with a lot of traffic. You're after the headlight patterns.

2. **Attach the desired lens to the camera.**

   Don't use a wide-angle lens; this would include part of the car interior in your shot. Choose a lens with a focal length that's the 35mm equivalent of 80mm or greater.

3. **Rotate the Mode dial to Av (Aperture Priority).**

   You're using the aperture to control how long the shutter is open.

 4. **Press the ISO/Flash Compensation button and then rotate the Main dial to set the ISO speed to 100.**

   You want the shutter to be open for a long time. The lowest ISO setting makes the camera less sensitive to light requiring a longer shutter speed.

5. **Rotate the Main dial to specify the smallest aperture (highest f-stop value) for the lens you're using.**

   This ensures the shutter will be open for a long time.

6. **Wait until your friend drives near a lot of traffic that's moving.**

   You want lots of lights in the image. You can try this technique on a busy city street or a freeway. Another option is to take the picture when your friend drives away from a traffic light.

7. **Press the shutter button halfway.**

   The camera achieves focus. If the camera can't achieve focus, switch the lens to manual focus and then focus by rotating the focus ring on the lens.

8. **Press the shutter button fully.**

   The shutter opens, and the picture is taken. Depending on the ambient light, your lens may be open for several seconds.

9. **Rotate the camera.**

   This is painting with light. When you rotate the camera, or move it up and down or from side to side, you create abstract patterns (see Figure 12-10).

Figure 12-10: Creating an abstract image in camera.

**10. Edit your pictures.**

When you edit images in an application like Photoshop or Photoshop Elements, you can use filters to tweak the images. Figure 12-11 shows an abstract image created using this technique and edited in Photoshop.

HORSE LATITUDES

Figure 12-11: A tweaked abstract image.

# Editing Your Images in Photoshop Elements

The software Canon provided with your EOS 7D will get the job done. But if you want a really powerful image-editing application on a beer budget, consider purchasing Adobe Photoshop Elements 8.0. This image-editing powerhouse gives you the power to manage your images, work with multiple keywords, find images, and much more. And that's just the Organizer (Windows) or Bridge (Macintosh). Elements also has a module editing tool that is three pronged and powerful: Guided Edit Panel, Edit Quick mode, and

Full Edit mode. If you're new to image editing, the Guided Edit panel guides you through the image-editing process. If you want the quick, down, and *Dirty Harry* version of the Editor, use the Edit Quick mode. As the title implies, this version enables you to quickly edit an image. If you want the full-course treatment from soup to nuts, edit your images in the Edit Full mode.

Photoshop Elements 8.0 gives you the power to crop, resize, color-correct, and adjust your image. If you're in an artsy-farsty state of mind, you'll find a plethora of filters you can use to edit your images. You can also use third-party filters, such as Nik Software, Alien Skin, and so on. Photoshop Elements 8.0 is too cool for school (see Figure 12-12). As of this writing, the application sells for a meager $79.99. So much power for such a small investment is a great deal, Lucille.

Figure 12-12: Editing images in Photoshop Elements 8.0.

## Strutting Your Stuff Online

Everybody likes to show off their work, and you can do this online in quite a few places. The Granddaddy of photo-sharing sites is Flickr (www.flickr. com). This site enables you to post your images online, but it's more than just a photo-sharing site; it's a community, as well. You can send your Flickr URL to other photographers to show off your work. Other members of the Flickr community can comment on your work. You can set up a free account and start uploading images to your personal gallery (see Figure 12-13).

Figure 12-13: Showing your stuff on Flickr.

Another great photo-sharing Web site is SmugMug (www.smugmug.com). This site isn't free, but it's very reasonable. As of this writing, you can set up a Standard SmugMug gallery for $39.95 per year. Other options are the Power gallery for $59.95 per year or the Pro gallery for $149.95 per year. Figure 12-14 shows an example of a Power gallery. For more information on SmugMug, visit www.smugmug.com.

Figure 12-14: A SmugMug Power gallery.

# Index

## Business/Accounting & Bookkeeping

Bookkeeping For Dummies
978-0-7645-9848-7

eBay Business
All-in-One For Dummies,
2nd Edition
978-0-470-38536-4

Job Interviews
For Dummies,
3rd Edition
978-0-470-17748-8

Resumes For Dummies,
5th Edition
978-0-470-08037-5

Stock Investing
For Dummies,
3rd Edition
978-0-470-40114-9

Successful Time
Management
For Dummies
978-0-470-29034-7

## Computer Hardware

BlackBerry For Dummies,
3rd Edition
978-0-470-45762-7

Computers For Seniors
For Dummies
978-0-470-24055-7

iPhone For Dummies,
2nd Edition
978-0-470-42342-4

Laptops For Dummies,
3rd Edition
978-0-470-27759-1

Macs For Dummies,
10th Edition
978-0-470-27817-8

## Cooking & Entertaining

Cooking Basics
For Dummies,
3rd Edition
978-0-7645-7206-7

Wine For Dummies,
4th Edition
978-0-470-04579-4

## Diet & Nutrition

Dieting For Dummies,
2nd Edition
978-0-7645-4149-0

Nutrition For Dummies,
4th Edition
978-0-471-79868-2

Weight Training
For Dummies,
3rd Edition
978-0-471-76845-6

## Digital Photography

Digital Photography
For Dummies,
6th Edition
978-0-470-25074-7

Photoshop Elements 7
For Dummies
978-0-470-39700-8

## Gardening

Gardening Basics
For Dummies
978-0-470-03749-2

Organic Gardening
For Dummies,
2nd Edition
978-0-470-43067-5

## Green/Sustainable

Green Building
& Remodeling
For Dummies
978-0-470-17559-0

Green Cleaning
For Dummies
978-0-470-39106-8

Green IT For Dummies
978-0-470-38688-0

## Health

Diabetes For Dummies,
3rd Edition
978-0-470-27086-8

Food Allergies
For Dummies
978-0-470-09584-3

Living Gluten-Free
For Dummies
978-0-471-77383-2

## Hobbies/General

Chess For Dummies,
2nd Edition
978-0-7645-8404-6

Drawing For Dummies
978-0-7645-5476-6

Knitting For Dummies,
2nd Edition
978-0-470-28747-7

Organizing For Dummies
978-0-7645-5300-4

SuDoku For Dummies
978-0-470-01892-7

## Home Improvement

Energy Efficient Homes
For Dummies
978-0-470-37602-7

Home Theater
For Dummies,
3rd Edition
978-0-470-41189-6

Living the Country Lifestyle
All-in-One For Dummies
978-0-470-43061-3

Solar Power Your Home
For Dummies
978-0-470-17569-9

## Internet
Blogging For Dummies,
2nd Edition
978-0-470-23017-6

eBay For Dummies,
6th Edition
978-0-470-49741-8

Facebook For Dummies
978-0-470-26273-3

Google Blogger
For Dummies
978-0-470-40742-4

Web Marketing
For Dummies,
2nd Edition
978-0-470-37181-7

WordPress For Dummies,
2nd Edition
978-0-470-40296-2

## Language & Foreign Language
French For Dummies
978-0-7645-5193-2

Italian Phrases
For Dummies
978-0-7645-7203-6

Spanish For Dummies
978-0-7645-5194-9

Spanish For Dummies,
Audio Set
978-0-470-09585-0

## Macintosh
Mac OS X Snow Leopard
For Dummies
978-0-470-43543-4

## Math & Science
Algebra I For Dummies
978-0-7645-5325-7

Biology For Dummies
978-0-7645-5326-4

Calculus For Dummies
978-0-7645-2498-1

Chemistry For Dummies
978-0-7645-5430-8

## Microsoft Office
Excel 2007 For Dummies
978-0-470-03737-9

Office 2007 All-in-One
Desk Reference
For Dummies
978-0-471-78279-7

## Music
Guitar For Dummies,
2nd Edition
978-0-7645-9904-0

iPod & iTunes
For Dummies,
6th Edition
978-0-470-39062-7

## Piano Exercises
For Dummies
978-0-470-38765-8

## Parenting & Education
Parenting For Dummies,
2nd Edition
978-0-7645-5418-6

Type 1 Diabetes
For Dummies
978-0-470-17811-9

## Pets
Cats For Dummies,
2nd Edition
978-0-7645-5275-5

Dog Training For Dummies,
2nd Edition
978-0-7645-8418-3

Puppies For Dummies,
2nd Edition
978-0-470-03717-1

## Religion & Inspiration
The Bible For Dummies
978-0-7645-5296-0

Catholicism For Dummies
978-0-7645-5391-2

Women in the Bible
For Dummies
978-0-7645-8475-6

## Self-Help & Relationship
Anger Management
For Dummies
978-0-470-03715-7

Overcoming Anxiety
For Dummies
978-0-7645-5447-6

## Sports
Baseball For Dummies,
3rd Edition
978-0-7645-7537-2

Basketball For Dummies,
2nd Edition
978-0-7645-5248-9

Golf For Dummies,
3rd Edition
978-0-471-76871-5

## Web Development
Web Design All-in-One
For Dummies
978-0-470-41796-6

## Windows Vista
Windows Vista
For Dummies
978-0-471-75421-3